I·LEONARDO

SUMMIT BOOKS
NEW YORK

I·LEONARDO

Ralph Steadman

Acknowledgments

Special thanks to IAN CRAIG for his tyrannical zeal and outrageous overseeing of the unstinting design of this book. To ANNA, my dear wife, for her loving support and amazing grace as she struggled to control the boring old fart she had married as he turned into a raging genius, and to NORMA KITSON who bravely typed on through dry ribbons and shredded carbon paper with no Tippex during actual live and fiery creative dictations and who has a way with stony librarians at the end of telephone receivers in her relentless pursuit of knowledge and the very things I needed. Not forgetting DEBORAH SHEPHERD, my editor, who helped me often over a literary impasse on gilded crutches. Nor TOM MASCHLER who never seemed to doubt that this book could be done.

Published by SUMMIT BOOKS
A Division of Simon & Schuster, Inc.
Simon & Schuster Building
1230 Avenue of the Americas
New York, New York 10020
SUMMIT BOOKS and colophon are trademarks of Simon & Schuster, Inc.

1 2 3 4 5 6 7 8 9 10
First American Edition

Library of Congress Cataloging in Publication Data

ISBN 0-671-43759-3

Printed in Italy by New Interlitho, SpA, Milan

For Michael Dempsey — who would have liked this book

Introduction

I F THE DUNG of llamas could be of especial interest to the sun-worshipping Incas as oracles in which they discovered omens for the future, then it is not difficult to imagine that in another part of the world people believed that the earth rested on the backs of four elephants.

In the Middle Ages the world was still flat, the centre of the universe, ruled by villainous warlords, witchcraft and alchemy, superstition and disease. Few dared ask the question 'What are the elephants standing on?' for fear of being soundly whipped and told to shut up and keep rowing. Helpless wretches wandered the streets or huddled in bundles waiting to be destroyed. Not a good time to be born poor, though no worse if you were born a bastard, rich or poor.

In the wake of such chastening scourges as the Black Death of 1348, those few who could read – mainly within the church – would have found captive audiences of contrite sinners crawling all over the place to whom they could relate the alarming imagery of Dante's *Inferno* in as lurid a way as they were capable. If it was like this in this world what in God's name was it going to be like in the next?

Church zealots were looking back to ancient times and finding that classical Rome had much to offer. Latin and Greek were used naturally as the languages of a movement known as 'humanism' and because Italy was at the very centre of the Mediterranean trade routes and wars were the national pastime, these rediscovered ideas spread. With the help of printing they germinated and a new spirit of optimism arose. The philosophy and politics of Plato and Aristotle took on fresh significance. Aristotle's teaching that reason and not simply faith was the way to knowledge, unpopular with the church and banned in the thirteenth century, could no longer be ignored. It became a cornerstone of the Renaissance, as did Plato's teaching that the universe had a mathematical configuration. All this provided rich soil for heretics, who could still be burned at the stake. The humanists, however, stuck to the fundamental belief that man could improve himself. Theories of ideal government were expressed and found an outlet through the princes and kings of Europe who encouraged them for their own ends. The rulers became the patrons of this new breed of men and their ever grander castles and palaces were festooned with paintings and sculptures carefully orchestrated to promote them as the leaders of the new spirit. Better get your own big walls covered in panoramas of entries on horseback, otherwise you were nothing. Better still, have your glory immortalised in the newly perfected process of fresco drawn right into the plaster itself to last a thousand years. Ancient Greek sculpture, which epitomised ideal man untouched, pure and free from disease, was the inspiration of Michelangelo's work and he the sublime exponent of its principles.

Leonardo da Vinci was born twenty years before Michelangelo in 1452. Knowledge through experience was his maxim and his experience showed him that man was not what he appeared to be, despite the prevailing atmosphere of fine thoughts and high aspirations. Yet the purity of his painting set the divine standard of Renaissance art – and *any* art for that matter. I believe he preserved intact a part of his private self which found an outlet in his more personal notes and drawings. He was no company man like Michelangelo, who despised Leonardo's apparent lack of drive and direction. Leonardo had no need to create a larger-than-life world of monstrous muscle-bound faggots. In a cunning display of subtle contempt he contrived never to finish a single painting to his own satisfaction or else he spent such inordinately long periods of time on work that it was never delivered. The patron either lost interest, lost power or simply died. But the quality and the nature of Leonardo remained. The wealth of his activities overpowered those who revered him, so that they were virtually unable to employ him. If that were not disability enough, his most beloved disciple kept from the world his inheritance, the notebooks which contained the essence of his master's spirit. Like a guard dog he hoarded them all his life. After his death they were dismembered and dispersed, only to be rediscovered four hundred years later in a world where Leonardo's ideas had already come about.

As Sigmund Freud said: 'Leonardo da Vinci was a man who woke up in the dark.'

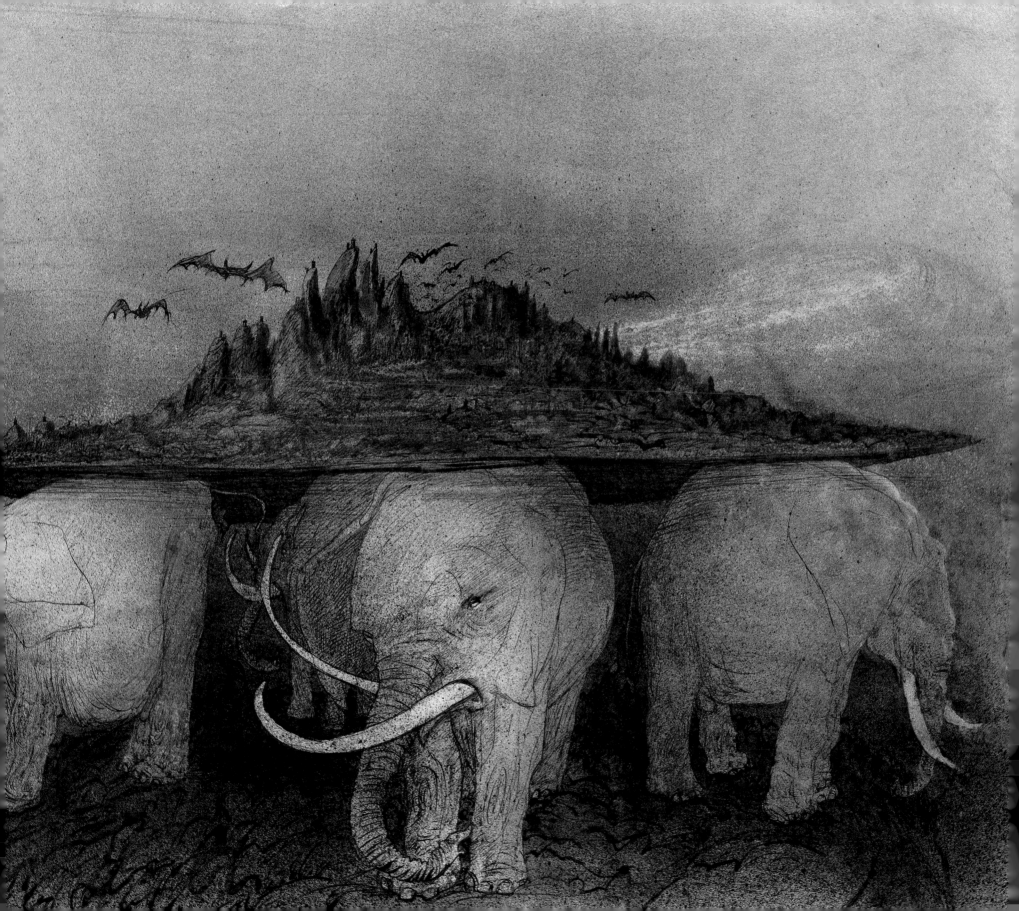

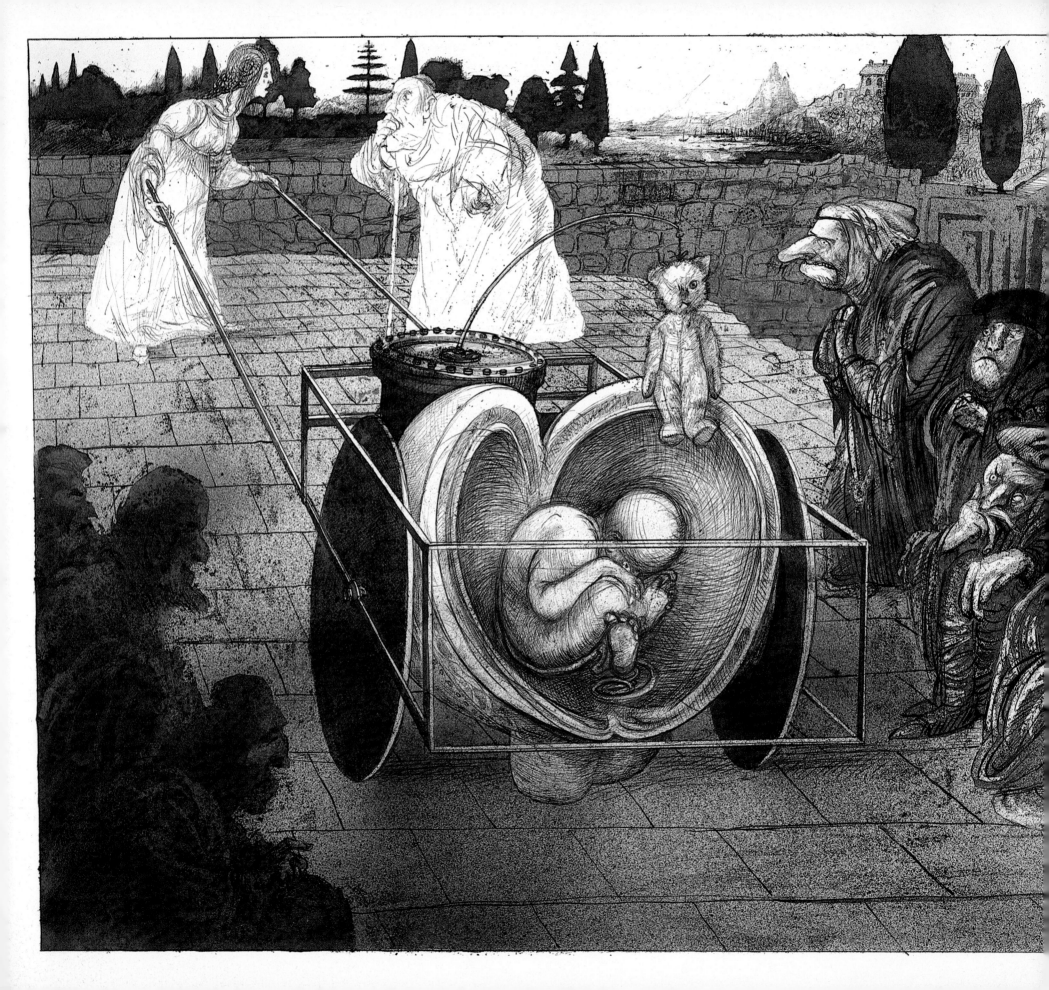

I remember little of my mother before birth save the inside of her womb which served me well for nine months long. A closed, comforting world of darkness and warmth which finally delivered me into another world of darkness and uncertainty. She could give me no succour and I was wet-nursed by a goat.

I loved my mother. She spoke with gentle reasoning of right and wrong. She rarely talked of family as of some impenetrable bastion. These were people she knew, that was all – even my father, Ser Piero – but she was not blind either to their virtues or their faults. She instilled in me a sense of openness – a larger world than family confines – a place of possibilities.

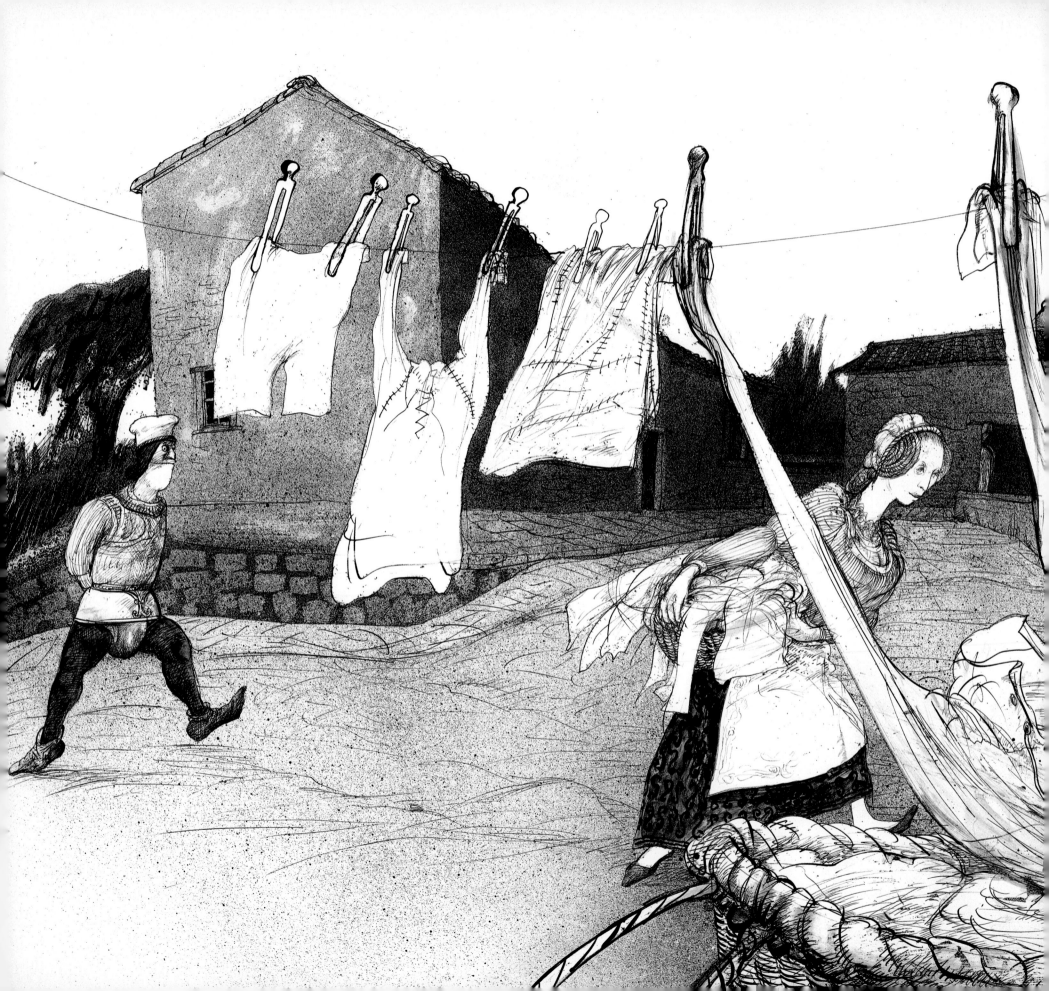

I rarely saw my father. He did not live with us. My mother, Caterina, would often take me down the hill away from our small house in a village called Anchiano and into the nearby town of Vinci. Perhaps she hoped to see my father. I don't really know.

She spoke to people on the street then pushed me back home again.

Occasionally, we would have a visitor. Usually the same one. My mother seemed to like him. She would even wash his rough shirts and hang them outside to dry.

I have few clear recollections of that time. But I remember the flapping of washed clothes as they dried in the wind.

Often the clothes would flap noisily across my cradle and such a thing came to me and opened my mouth with its tail and struck me several times inside my lips.

I was blessed with strong limbs, a sturdy heart and my complexion was not unpleasing. I nurtured my own solitude for I rarely found a friend among people of my own age. I enjoyed the company of my uncle Francesco, my father's brother, who spent many of his days maintaining a family connection where none seemed to exist.

I loved him well and gathered strength in his sustaining friendship.

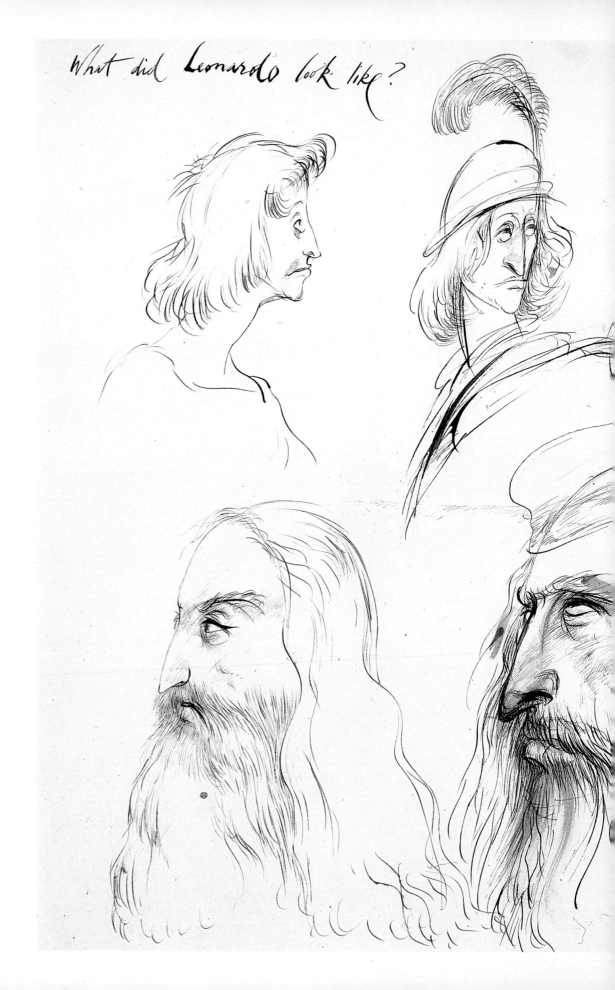

What did Leonardo look like?

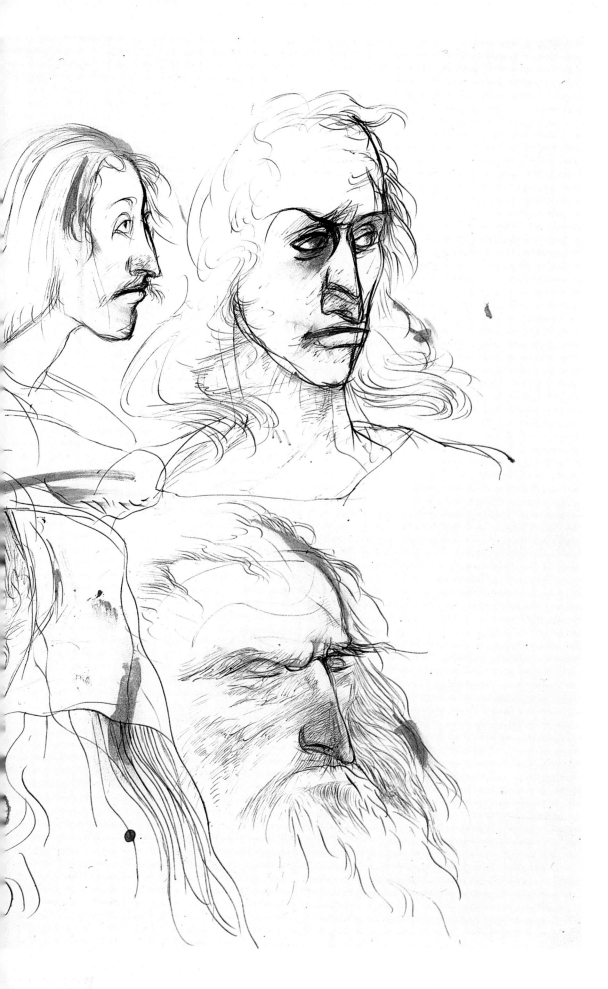

I roamed the countryside searching for answers to things I did not understand. Why shells existed on the tops of mountains along with the imprints of coral and plants and seaweed usually found in the sea. Why the thunder lasts for a longer time than that which causes it and why immediately on its creation the lightning becomes visible to the eye while thunder requires time to travel. How the various circles of the water form around the spot which has been struck by a stone and why a bird sustains itself upon the air.

These questions and other strange phenomena engaged my thoughts throughout my life. I perceived that perhaps the waters of the sea once covered those places which are now high up and mountainous.

The water wears away the mountains and fills up the valleys and if it had the power it would reduce the earth to a perfect sphere.

I found shingle all stuck together and lying in layers at different altitudes upon the high mountains – and this shingle is nothing but pieces of stone which have lost their sharp edges from having been rolled over and over for a long time, and from various blows and falls which they have met with during the passage of the waters which have brought them to this spot.

I found dark caverns of rock strewn with the bones of creatures long since gone, convincing my mind of the earth's eternity . . . But I digress.

I fear at that time I neglected my schoolbooks and spent my days roaming the hills with charcoal pencils and such paper as I could find to record the wondrous things I saw. I gained some skill in arithmetic, algebra, geometry and mechanics from one Biagio da Ravenna who was engaged on architectural work on a nearby villa. It was then I resolved always to seek knowledge through experience – though my mother found much to her distress within my course.

I was filled with such desires as to move mountains and invented machines for these feats, thus bringing my mother close to despair.

Heavy was the retribution for my apparent follies. My experiments led me to trespass where I should not.

I tried hard to think of boyish things to impress the few friends I had and contrived to help them in their aspirations with simple and effective devices for overcoming obstacles. In such times an efficient means of escape was an essential part.

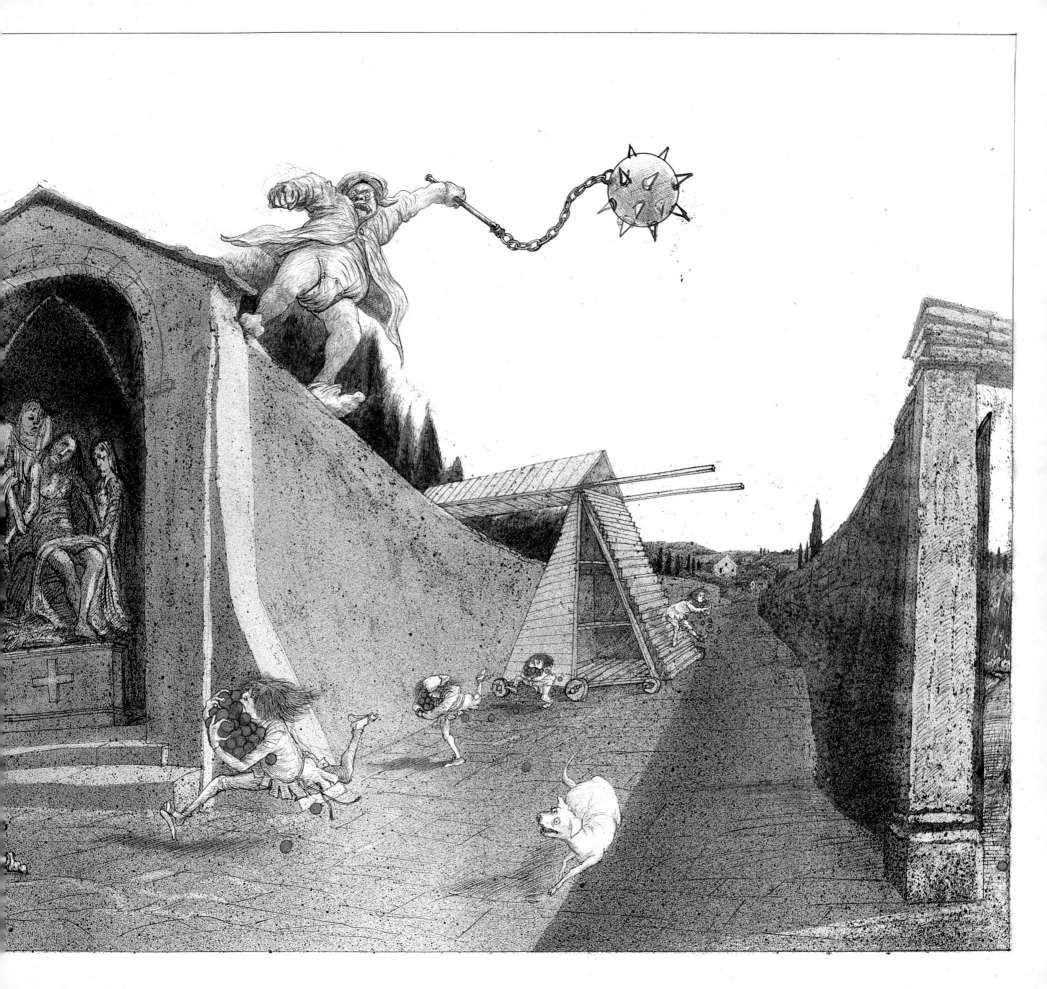

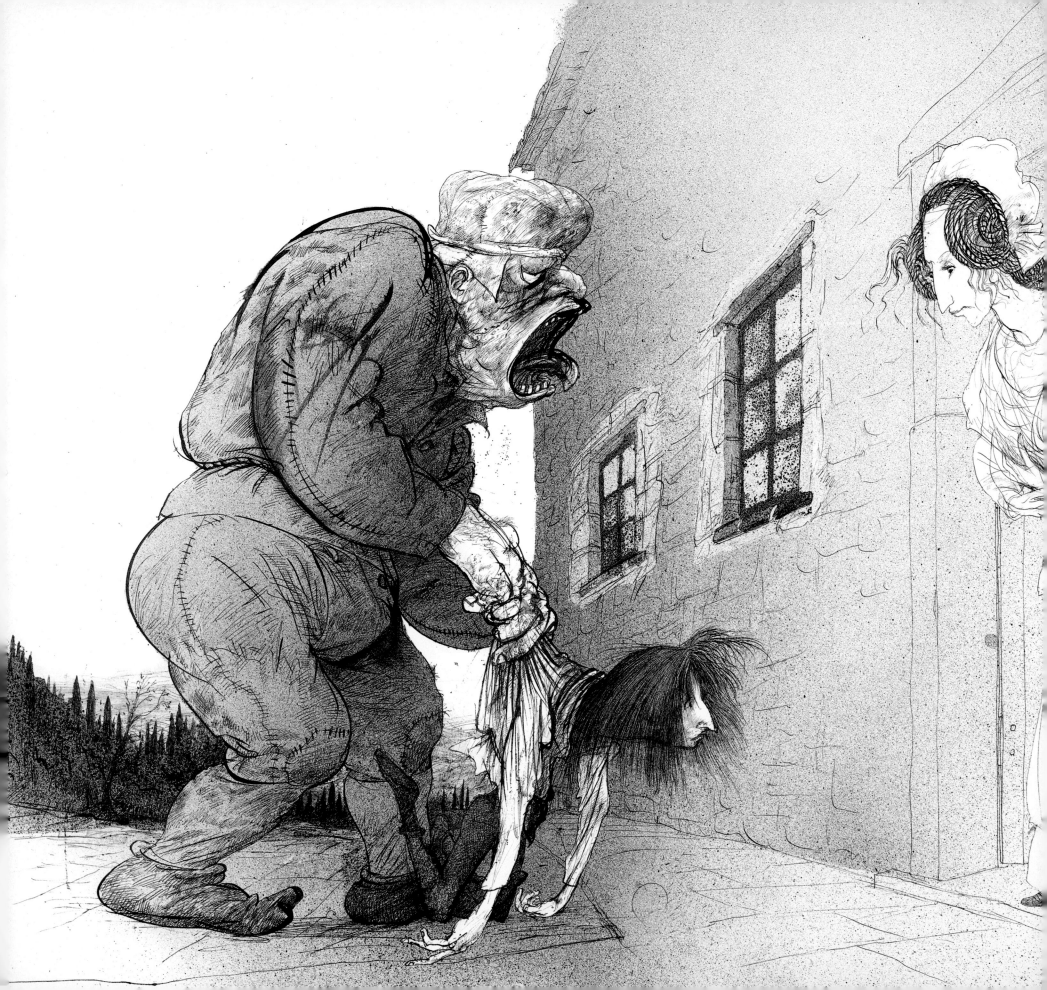

I never knew exactly what moved little boys beyond the trifling task to hand but it appears to me that most desired simply to pit their growing strengths against the odds as they did find them. Only in this way might they develop in an alien world though I am certain that their struggles and boundless energies were inspired more by strong instinct than strong sense. Nevertheless I did my best to be a boy.

The love I felt for my mother in those early years gave rise to many eventful devices as tokens of that love.

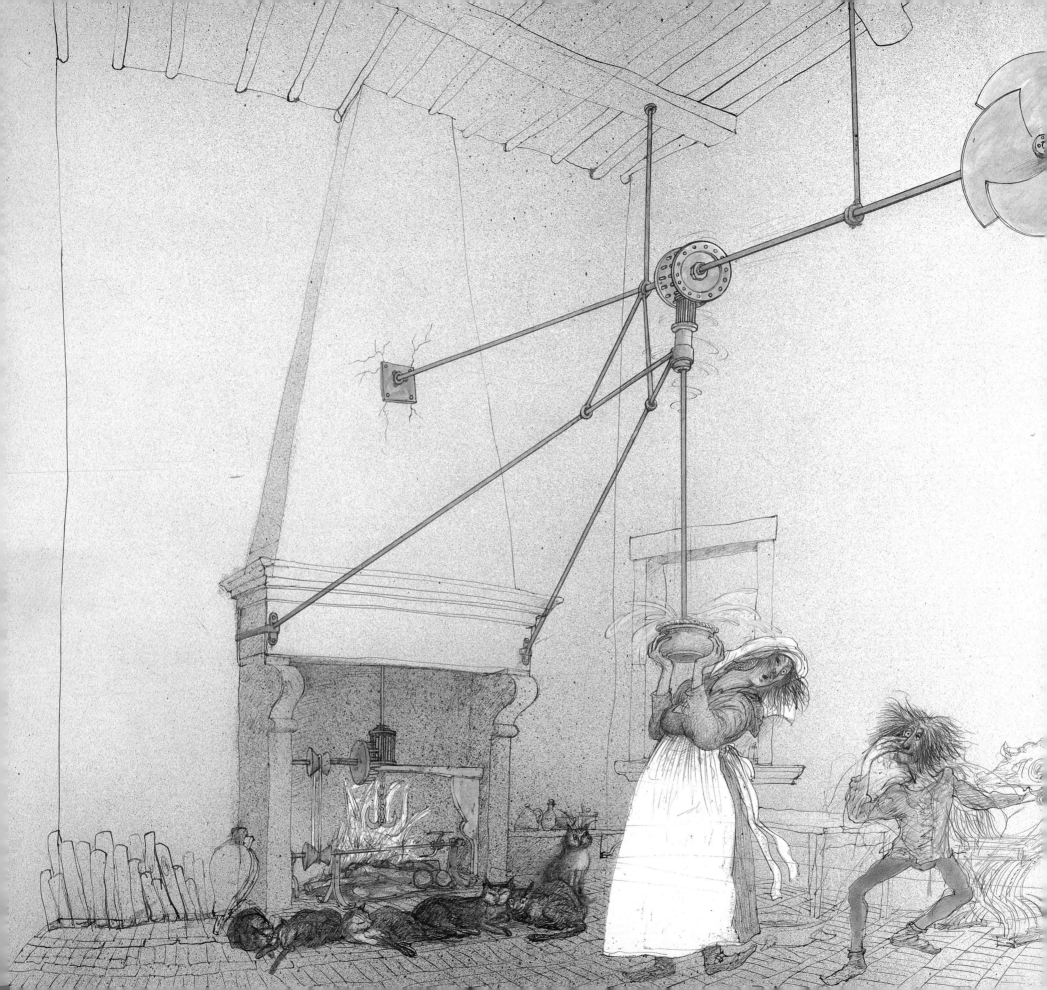

There were bed-warmers, a linen press, snow shoes and bodice clips; a meat-safe to guard against flies, a folding bed and a washboard.

It troubled me that heat from our commodious hearth took the best part of its strength up out of the chimney to disperse itself in the air above and so I gave my mother a practical demonstration of latent power transformed to provide for her a service. A simple fan inside the chimney flue supplied power enough to ease the burden of her household chores. It did not lessen the comforts that fire provides nor diminish its aesthetic presence.

There were chores also that myself must needs attend to. Not least of these was to eject from the house of an evening some of our more domesticated animals for the good of themselves. It was a vexatious task besides, for no sooner had I deposited an animal beyond the door than it would take upon itself to go against my wishes and hasten inside between my legs to regain its place beside the fire. Even beyond the house some several braccia* hence would such a determined animal renew its efforts and get to the threshold yet again.

* 1 braccio (Italian arm) = nearly 2 English feet

 I bestirred myself to devise a simple catapult, a mechanism to encourage these somnolent creatures to exert themselves beyond their usual inclination. I had observed that they would always land upon all four legs and so no harm was done and each of them returned well journeyed though perhaps dismayed.

 Quite suddenly my father called to take me away. My mother seemed to agree, though I sensed an urgent communication transmitted only by the faculties all animals possess. There were no words but things were understood. I accepted the decision as best I could for it seemed foolhardy to go against the wishes of my elders without some reason other than contentment with my present state.

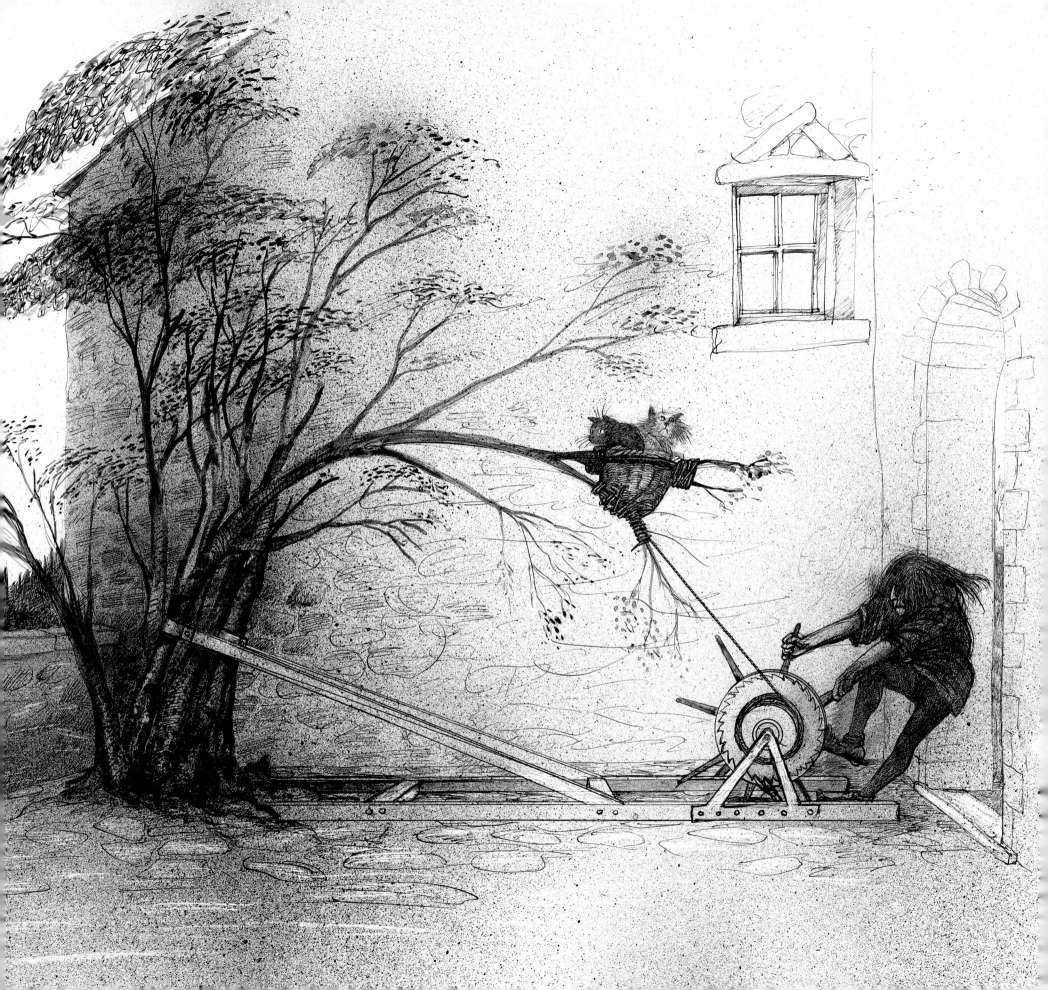

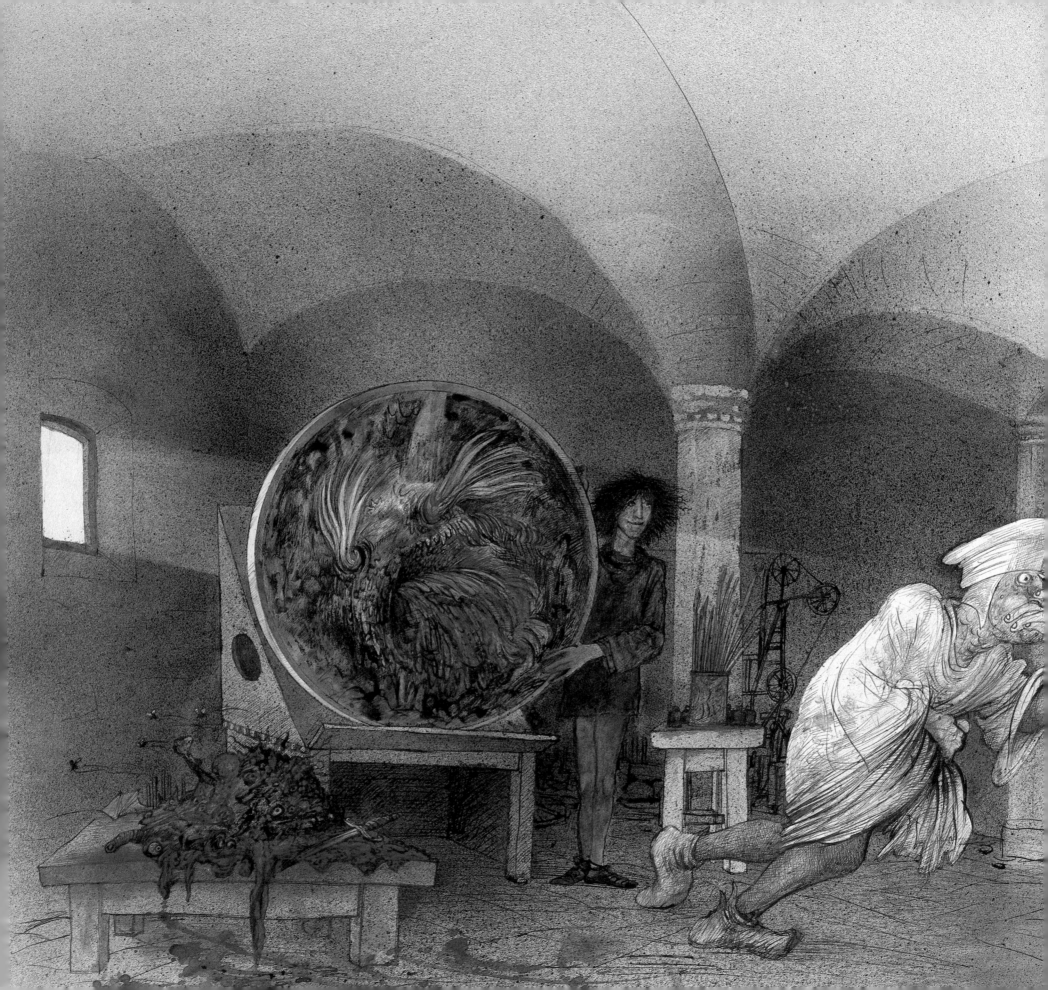

My father had a wife who showed me every care and consideration and even love, though she was not my mother. I rarely saw my mother Caterina after that but I stored my memories of her within myself. I heard later that she was wedded to a fine country man of Vinci and all was well, though I missed the close warmth of those early years.

I settled into my father's household quite readily. I even felt I had more freedom. My uncle Francesco was there which gave me familiar contact in my new surroundings.

Time passed and I grew stronger yet, and my intense desire to learn the nature of what was around me led me always to strive to a point which others would consider unnecessary.

My father came to me one day and carried with difficulty a large crude buckler, a shield hewn from some ancient fig tree but badly weathered. One of the peasants at work on his land had asked a favour – that he should have the shield painted by one of the famed artists of Florence. Knowing of my ability to capture a likeness of known objects and people, my father asked of me whether I could paint upon the surface an image of my own fancy, such as might please the peasant.

I felt it incumbent upon me to give evidence at this point of the intensity with which I would approach such a task.

I straightened and prepared the wood. From the fields around I gathered lizards, slugs, worms, bats, crickets, serpents, hairy butterflies, millepedes, leeches, snakes and other such creatures.

From these I fashioned a monster – with the eye of one, the leg of another and so on, until it was fearsome to behold.

From this my model I painted the image on the buckler, creating something to strike fear into the heart of an enemy no matter who he be.

I summoned my father, who seemed to have forgotten the task. I placed the buckler in such a position as to catch the light with the fullness of dramatic effect necessary for the first impact.

My father knocked, entered and reeled backwards at once holding his nose.

Such was the power of the image I had created and I was well satisfied.

My father asked me from outside the room to bring it to him and this I did. He carried it off showing great pleasure and even respect for what I had wrought. He told me later how grateful the peasant was and I myself was well pleased.*

* The buckler was taken and sold to a merchant in Florence for 100 ducats. Another was bought for a few ducats and the peasant was satisfied.

Because of my many activities I often found myself awake and working into the quiet hours of the night and needful of sleep in the mornings when I should have been stirring. I devised a clock that would alarm me into wakefulness even though I was still heavy with fatigue, for I grudge the wasting of time far more than the loss of sleep.

My invention used the principle called mechanical relay where there is a transfer of power from one part of a machine to another causing a levering or thrusting effect.

Throughout the night a steadily dripping water clock fills a large pan which as the weight of the water within it increases does gently cause the feet of the sleeper to rise by means of a lever. When this lever attains a certain angle the water inside the shallow pan exerts such pressure that finally it is released in a great and sudden gush. The large pan being thus doubled in weight jerks violently upwards the feet of the sleeper, who is thus awakened and goes to his work.

I persevered with this device for long periods, being possessed already of a passion for the mechanics of water.

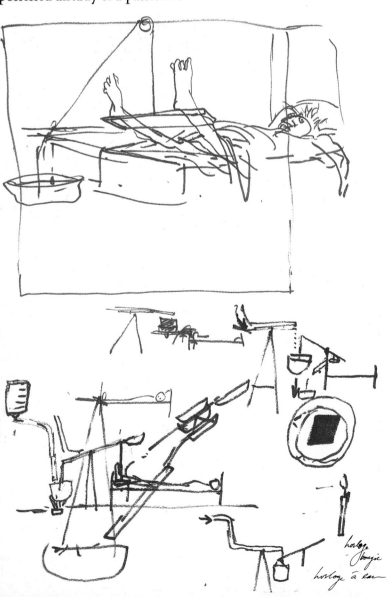

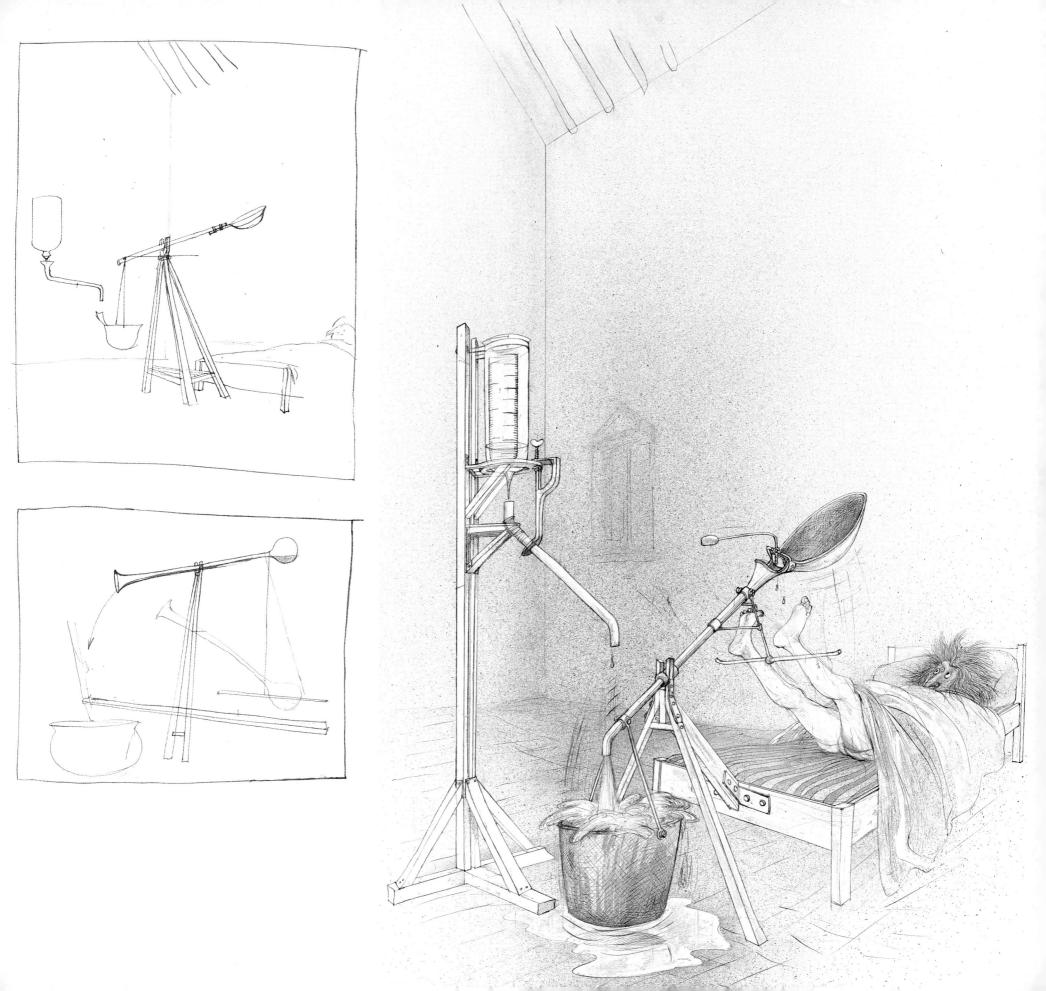

He was such
a good looking boy
—and bright too!

During this time I was growing in many new ways and
the outward signs of manhood had begun to sprout upon
my countenance. These signs develop at an alarming rate
and one is often taken unawares by the strangeness of
bodily sensations that come upon one's sensibilities.

Nevertheless I countered this assault upon my being by
devising a way to eradicate unwanted hair. This was
accomplished by means of a straight serrated drive bar
which engages with a cog and when pressed causes a disc
with tiny cutting teeth around its perimeter to revolve at
great speed.

It became a lesson to me in the futility of vanity. I strove
for many years into manhood to maintain a pride in my
appearance. I finally allowed nature to take its course and
never cut my hair again.

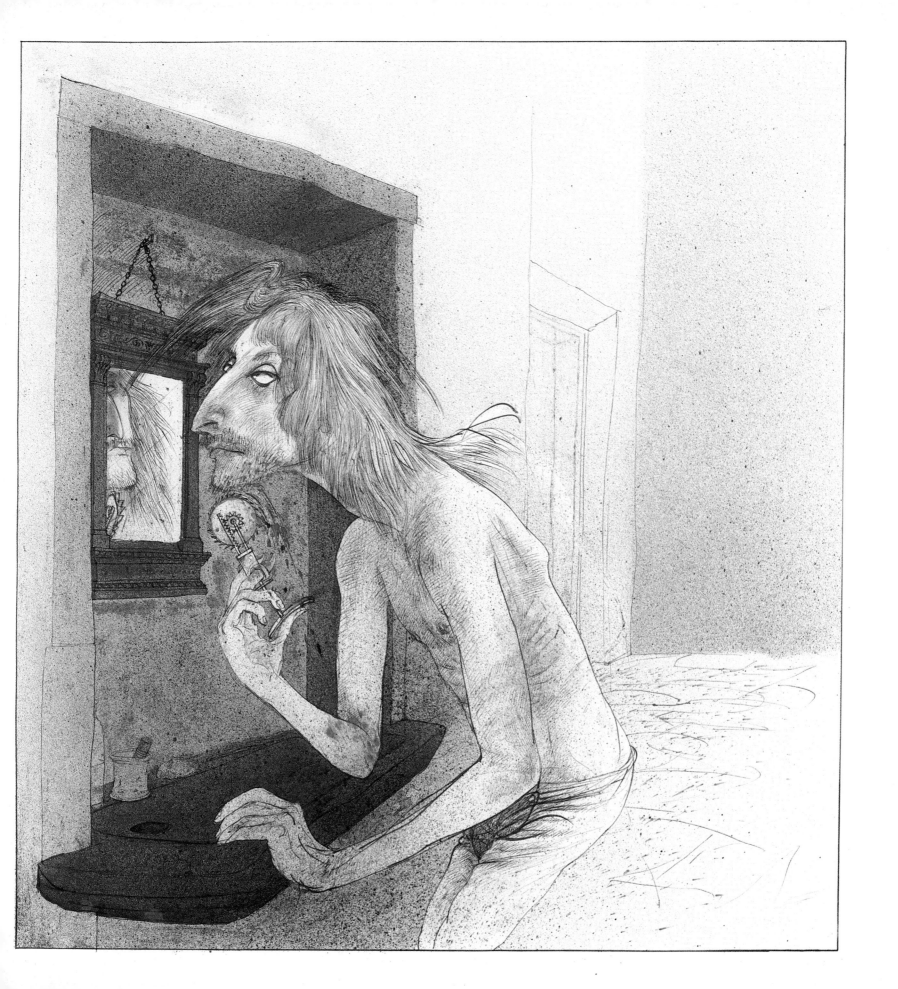

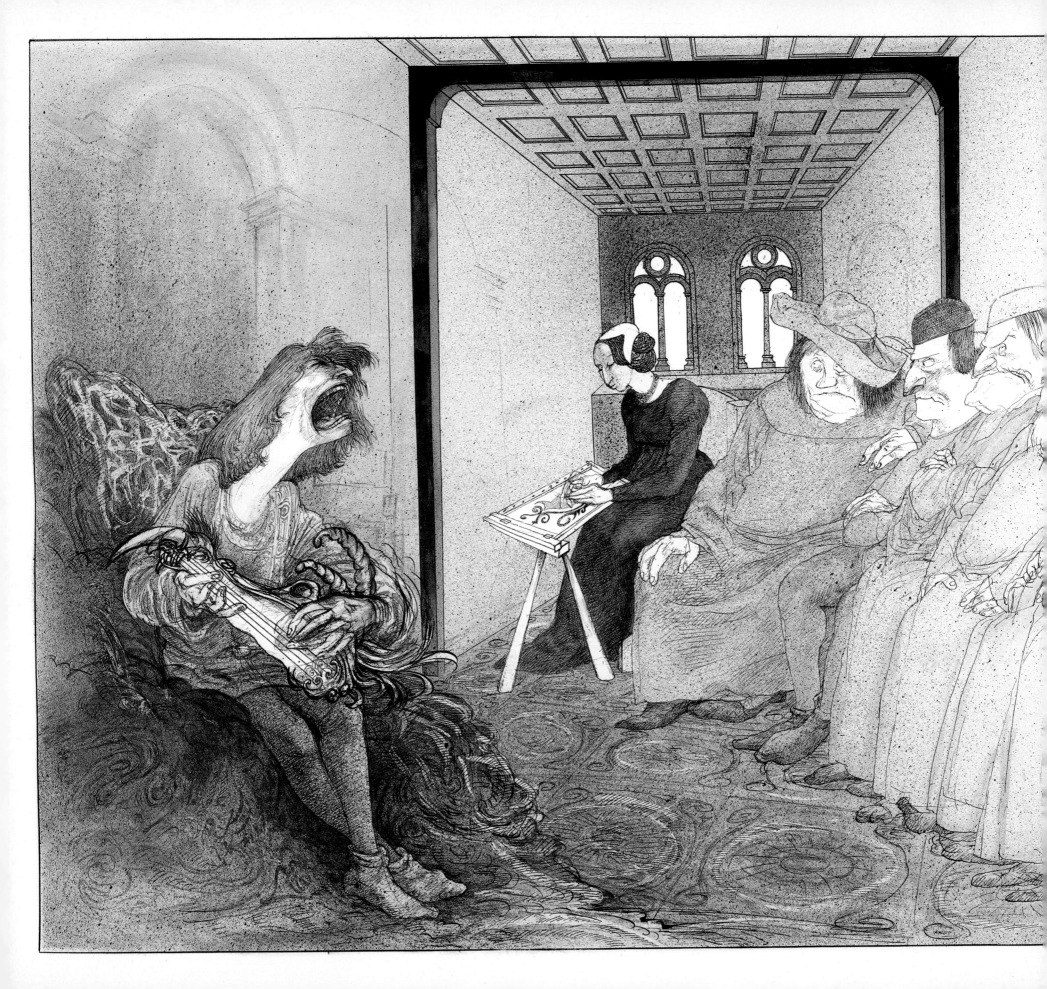

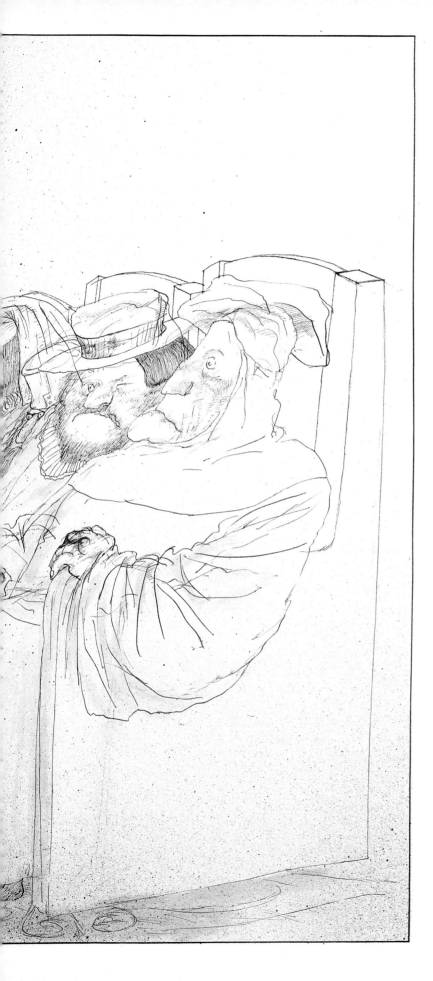

My father began to prosper in his profession as a notary which took him to Florence on many occasions. On his return he would sometimes be accompanied by clients and friends.

I had developed early on a liking for music and especially for the construction of instruments on which to tax my imagination and to improvise the shaping of the invisible. Thus would my father request me to play.

Such was my father's influence that in time his clients came to depend on his sound advice in legal matters and in music too. When he told them to listen – so they would listen. A more respectful and attentive audience I never encountered and thus it was that my musical powers developed under his paternal benevolence. But these things pass away as soon as they are born – they are afflicted with the disease of mortality. Consequently, what manner of music I played I cannot describe as I know no way of committing such improvisations to paper that would justly encompass their complexity.

In and around the fields and hillsides of my native countryside of Tuscany the peasantry are much concerned with the control of nature's abundance in order that they may tend their land unhindered by tall grasses and tangled undergrowth. In the olive groves and vineyards such work is carried out with the simple scythe and the horse-drawn plough.

I thus devised a machine which employed the principle of the scythe but that it should operate more effectively I arranged four such blades to rotate, suitably geared to strike the growing things with great force and cut them down.

It is a method which requires no one to be around while whirling blades perform their task. Perchance a goodly man of Ferrar, one Girolamo Savonarola, was much occupied in some liaison with a young maiden of Vinci and did neglect such simple precautions.

I tremble to speak of the incident for it pains *me* just to think of it.

Suffice to say it set the young man on a course hitherto beyond his inclination. He took Holy Orders and became a most fervent Dominican Friar – a servant of God who denounced the family de' Medici, ruled Florence with an iron hand and suffered no man gladly for his vanities. Of him I will say more later.

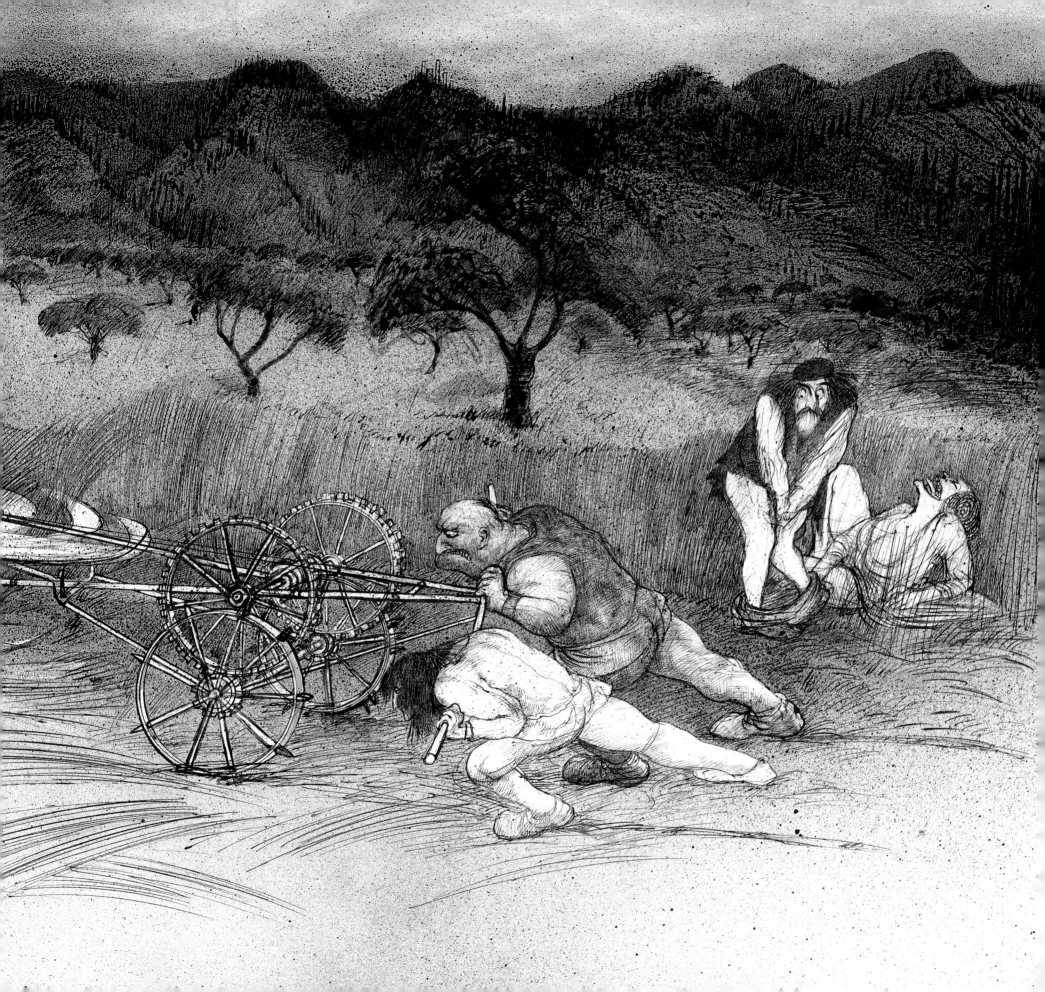

My dream is to be a great bird. I want to feel the exhilaration of floating out beyond the edge of solid ground into a void I know will not consume me. The great bird will take its first flight upon the back of the great swan, filling the whole world with amazement and filling all records with its fame, and it will bring eternal glory to the nest where it was born . . . I must try with all my imagination and all my ingenuity to overcome our earthly prison. It can be done, I know it can.

In the case of every heavy thing descending freely the heaviest part will become the guide of its movement.

The upright position is more useful than face downwards, because the flying machine cannot get overturned. The habit of long custom requires this.

I have made many attempts to fly like a bird. I watch birds constantly and observe their methods of controlling their flight. In the event that I become weightless and fly I will know exactly what to do. I will fly with eagles, and they will fly with me.

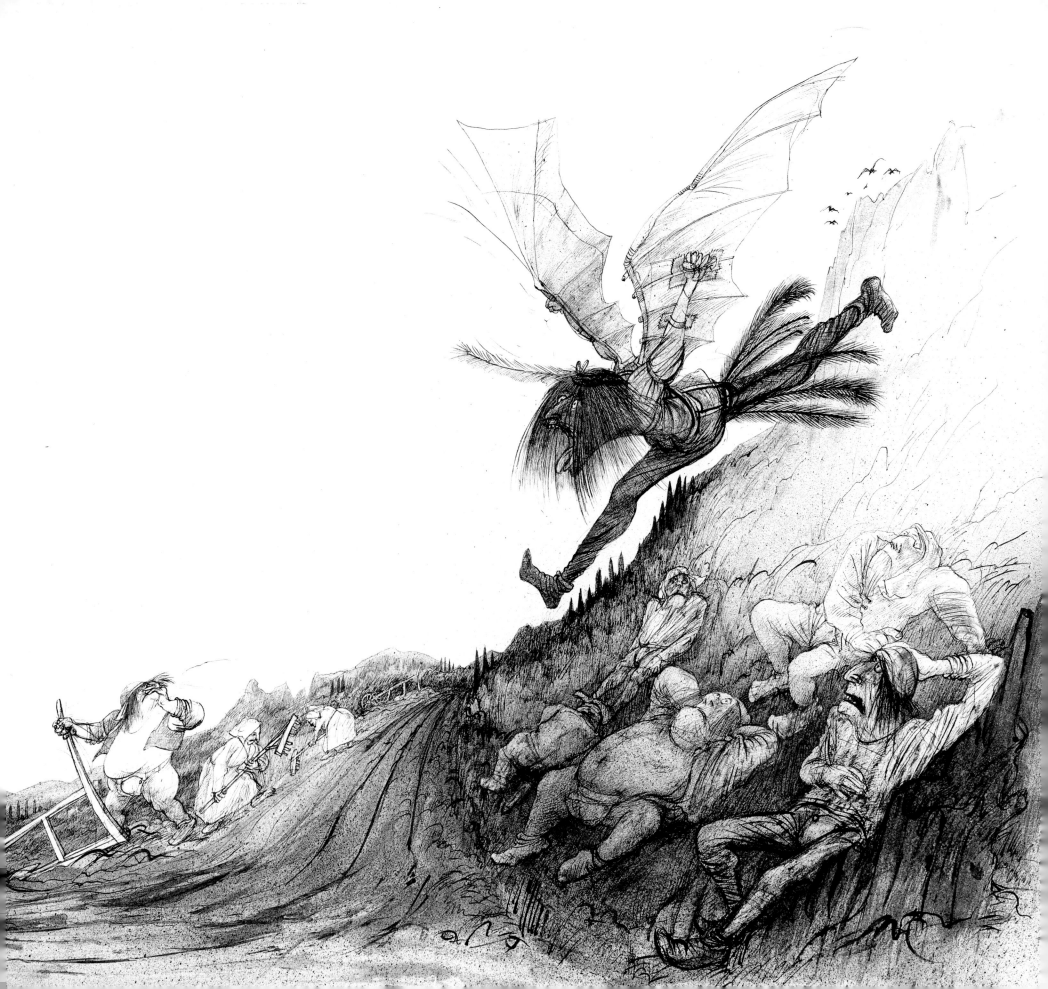

Nothing that can be moved is more powerful in its simple movements than its mover.

I was to accompany my father to Florence in the spring of 1469 to commence an apprenticeship with the master artist and craftsman Andrea Verrocchio. I considered very carefully that our horses would tire quickly with the long journey.

I love horses above all dumb animals. I endeavoured to lighten the burden with which I planned to encumber them. I had many parts of my boyhood days which I felt inclined to take with me to Florence.

A single package would not suffice to contain all that I possessed and love is not the best judge of a problem.

I pondered the situation for many days before departure.

Of weight and its distribution I considered:

The middle of each weight is in a perpendicular line with the centre of its support –

The weight of every heavy thing suspended is all in the whole length of the cord that supports it and all in each part of it –

Thus I considered the lever. A balance of equal arms and weights when removed from a position of equality will have its arms and bows unequal because it changes the mathematical centre, and consequently is constrained to regain the lost equality of arm and weight . . .

Where the potential lever is in existence the force will also be in existence.

The force will be of so much the greater excellence as the potential lever is less in quantity. Every continuous quantity is divisible to infinity. For example let us take ice and divide it towards infinity; it will become changed into water, and from water into air and from air into . . . (Great plagues!)

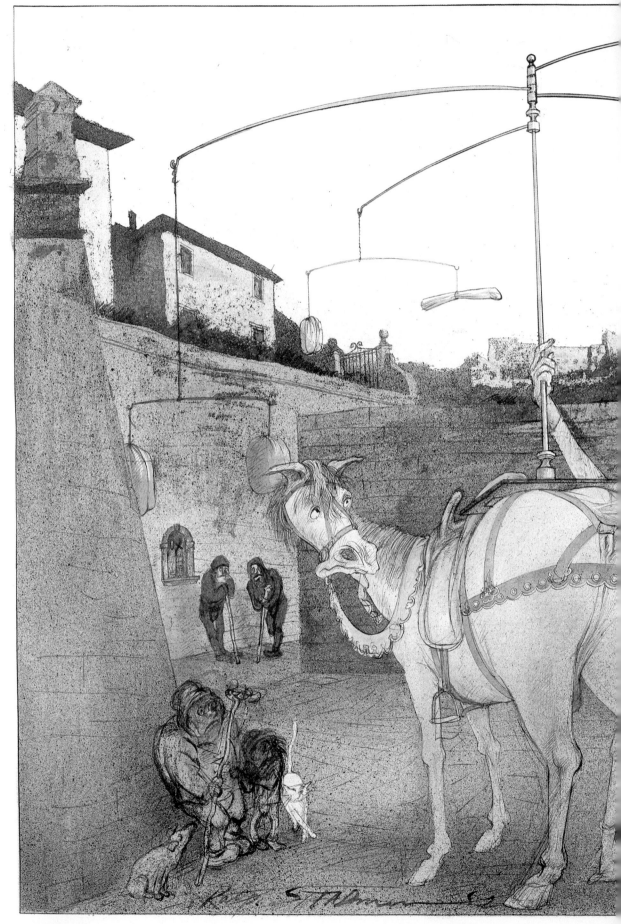

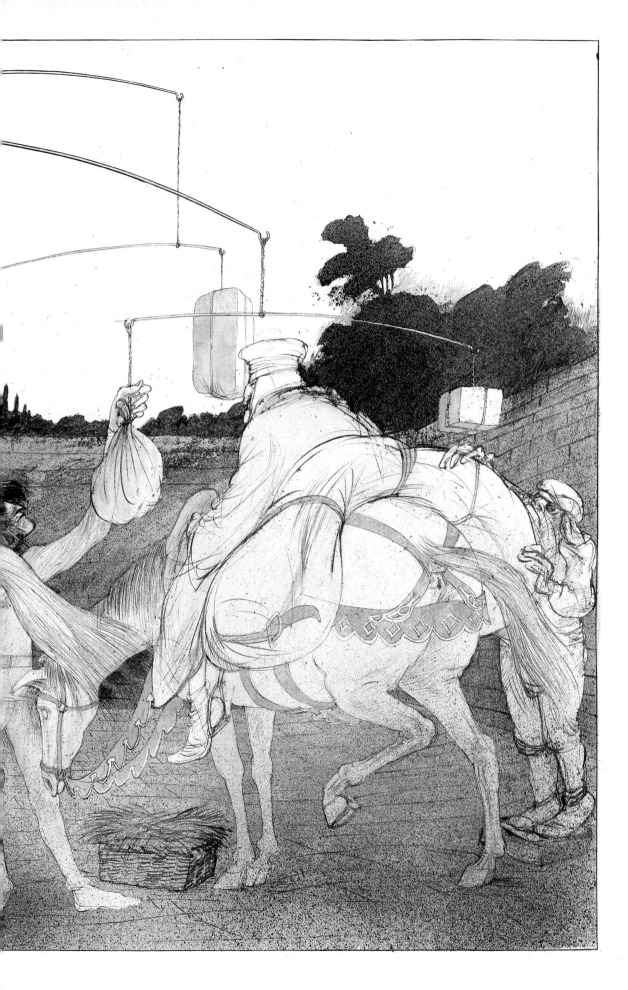

Straightway I set about to prove these things.

I feel bound to say that my scheme hindered our progress within five miles of our commencing the journey. The horse became afflicted with fits of lurching, reeling and even reversing in a manner ill-becoming so noble a creature.

I concluded that that thing which is at a quarter distance from its support will be less sustained by it, and consequently will fulfil its natural desire with greater liberty, causing forces of unequal power and movement.

I abandoned the project though the horse itself did tax my conscience with its look.

We journeyed for two days arriving in Florence on the morning of the third day.

Down many narrow dark streets spanned by arches and overhanging buildings whose tiles met so closely one could scarce see the sky we ventured, making for my father's houses on the Via delle Prestanze where he also practised his profession as a notary.

The walls of these buildings were encrusted with broken stucco and marks surrounded in mossy dampness, the signs of a bygone age speaking and filling my mind with all manner of strange thoughts.

Broken wretches huddled in dark masses. We proceeded fearfully. I looked to the walls to avert my curious gaze. In the dark stains I saw rocks of many colours and the images of infinite landscapes, outlines of mountains, rivers, crags, trees, valleys and broad plains. I saw battles, living gestures, strange figures, a quick play of human faces, apparel and countless other things that live in our imaginations.

This crawling underside of life left a permanent impression on my mind and touched my soul. I was fascinated by the deep ingrain of misery expressed in the human face and equally was repulsed by it. I returned to such scenes again and again and ever in my youthful endeavours would dress as such a person and go among them.

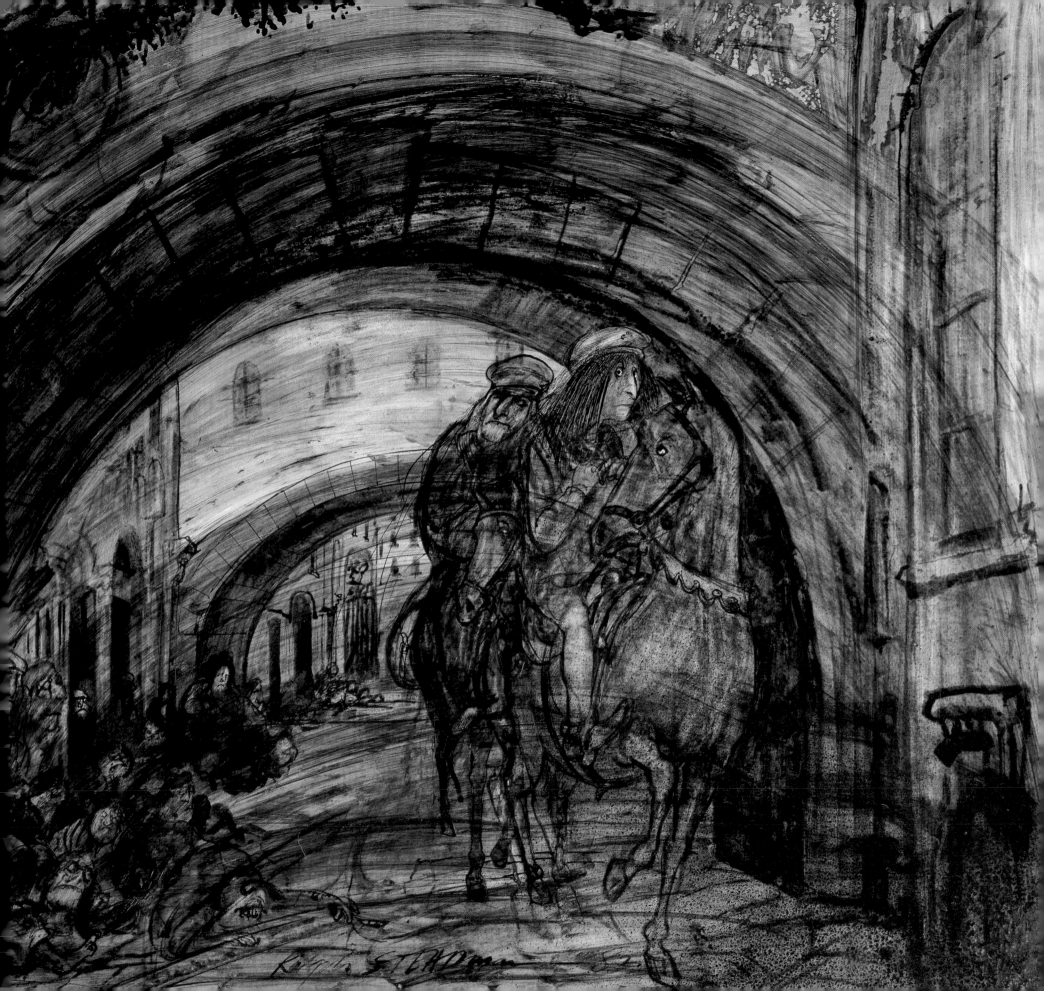

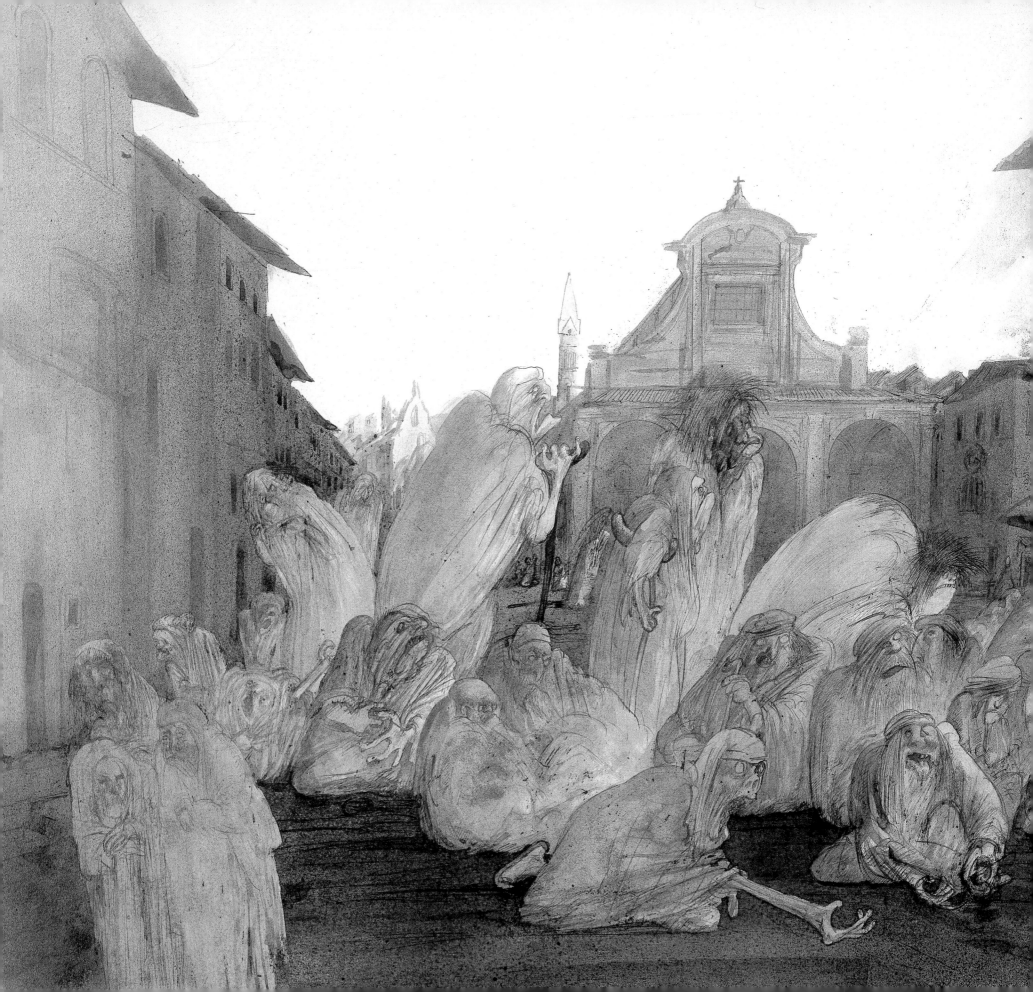

In this way I would observe them closely. They *were* the stains on the walls of the cities. They were the dark landscape of humanity. Such is man. I cannot change it but I sought to preserve its memory, for what reason I do not know, except to feed my growing contempt for mankind.

It makes no difference from which part they emit their voice, from the mouth or below, since both are of the same value and substance.

There are men who deserve to be called nothing else than passages for food, augmenters of filth, and fillers of privies; because nothing else in the world is affected through them and they are without any virtue, since nothing is left of them but filled privies.

The senses are earthly; the reason stands outside them during contemplation . . .

But I digress – for my father and I were entering Florence and I was about to embark upon my course of study.

My father's kindness had secured for me a place in the bottega of the great artist Verrocchio. I was eager to begin and full of anticipation. I was determined to succeed and grasp good fortune by the forelock knowing too well that behind she is bald.

We crossed the Ponte Vecchio, a wondrous bridge lined on both sides with the shops of butchers. The surface of the road was awash with the blood of slaughtered beasts which did not disturb me. Nor did the squealing of pigs in terror distress my mind though I wondered at the mess of sewage created by such a work and where it came finally, for all found itself in the great Arno river which flowed beneath us.

My father took me and left me at the front of Verrocchio's bottega* in the shadow of the cathedral of Santa Maria del Fiore.

I remember how big the cathedral was. It stirred my heart as never before.

My new master found me agreeable and I determined to do his bidding to the best of my ability. I was to learn many crafts and Verrocchio guided me well.

* Verrocchio's bottega, or workshop, was in the Via dell'Agnolo

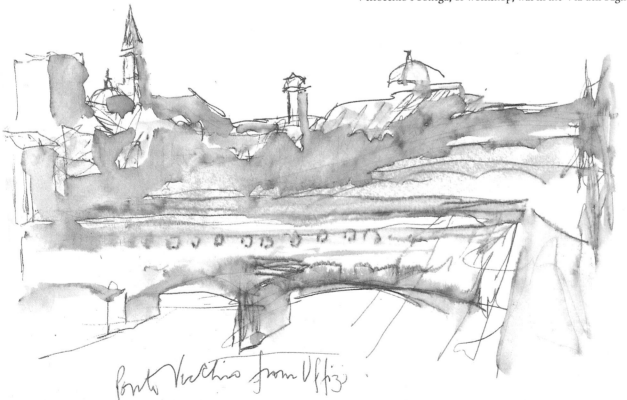

Ponte Vecchio from Uffizi

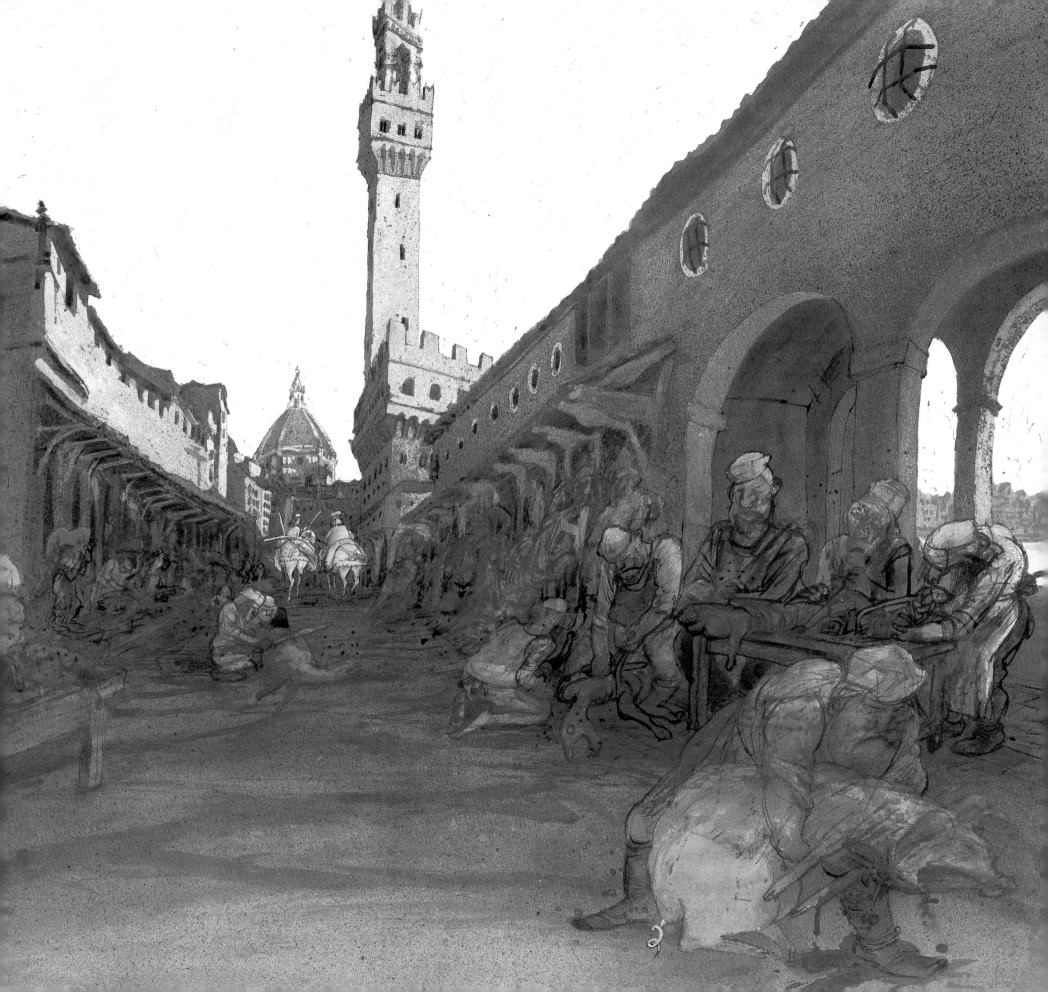

At times I was called upon to busy myself with the strangest requests. I suspect now that it is the habit of working communities to lighten the toils of each day by engaging a young apprentice in an unexpected errand for their amusement.

I was required to journey to an artists' colourman in the Via Tornabuoni to collect paint that was neither one colour or another, but striped.

This task I gladly undertook and welcomed the opportunity to stroll through the streets where people were about their work as I passed by.

On arrival at the colourman's shop I was greatly surprised to learn that no such striped paint could be procured. I was informed amidst some frivolity that I was the victim of a jest.

I protested and demanded various base ingredients for the manufacture of such a paint, for I feared that I might lose my employment if I returned without it.

Separately I mixed colour pigments with oil of linseed, choosing my colours for their diverse primary hues. I took hansa primrose for its brilliance like sunshine, chrome oxide for it reminded me of new grass, rose madder like the fires of hell and indigo and cobalt for the intense blue of the deepest oceans.

Laying them side by side on a palette I gently fused them but refrained from mixing them. I requested a pot containing white of egg and poured the contents over my freshly mixed colours. This acted as a foreign body and a shield so that I was able to mix the colours with confidence into a rainbow of great beauty.

I made as much as I could carry for one needs to make clear one's achievements.

A strange light appeared in my master's eyes when he beheld the mix. He had not seen the like before and neither had my fellow students.

I was not asked to run errands of such a nature again.

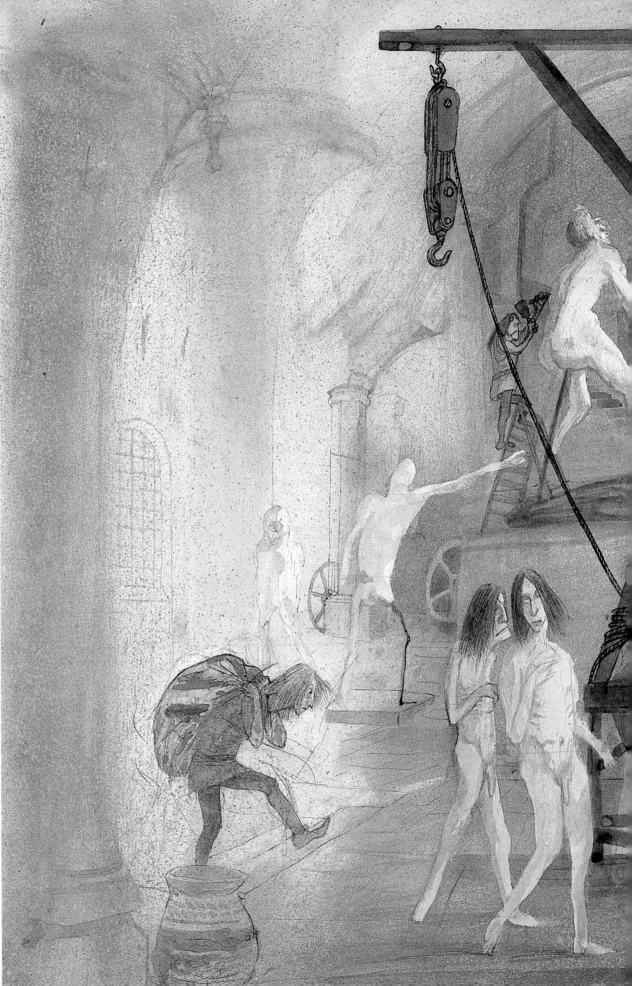

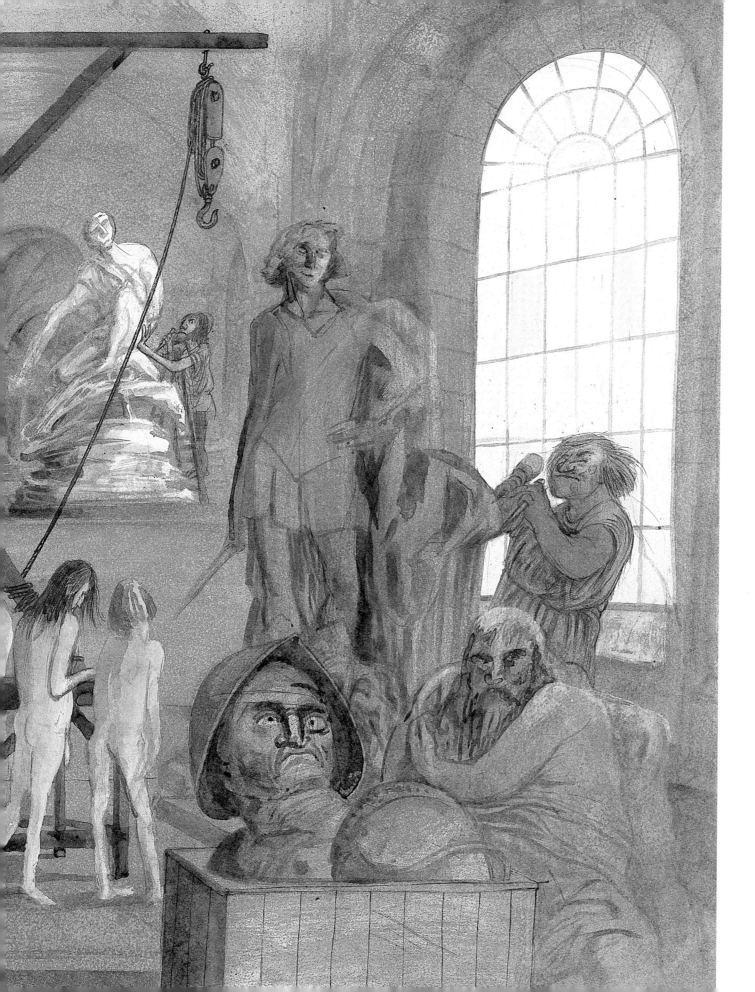

Of the things carried by the course of the waters that which has a larger part of itself in the air responds to the movement of the air more than to that of the water; and so conversely that which has a larger part of itself in the water will follow the course of this water more than that of the air.

Of the four elements water is the second heaviest and the second in respect of mobility. Nothing lighter than itself can penetrate it without violence.

And so it is possible for man to walk on the water and neither shall it be a miracle. Water has no weight except above an element lighter than itself such as air and fire and other liquids such as oil and so it is possible with bags of pig skin full of air to negotiate the crossing of a river and confound the unbeliever. This I proved . . .

The river Arno was indeed a great attraction to me and I proposed a scheme which was ignored.

Let sluices be constructed in the Val di Chiana at Arezzo, so that in summer when there is a shortage of water in the Arno the canal will not become dried up. This will fertilise the country, and Prato, Pistoia and Pisa together with Florence will have a yearly revenue of more than two hundred thousand ducats, and they will supply labour and money for this useful work, and the Lucchesi likewise.

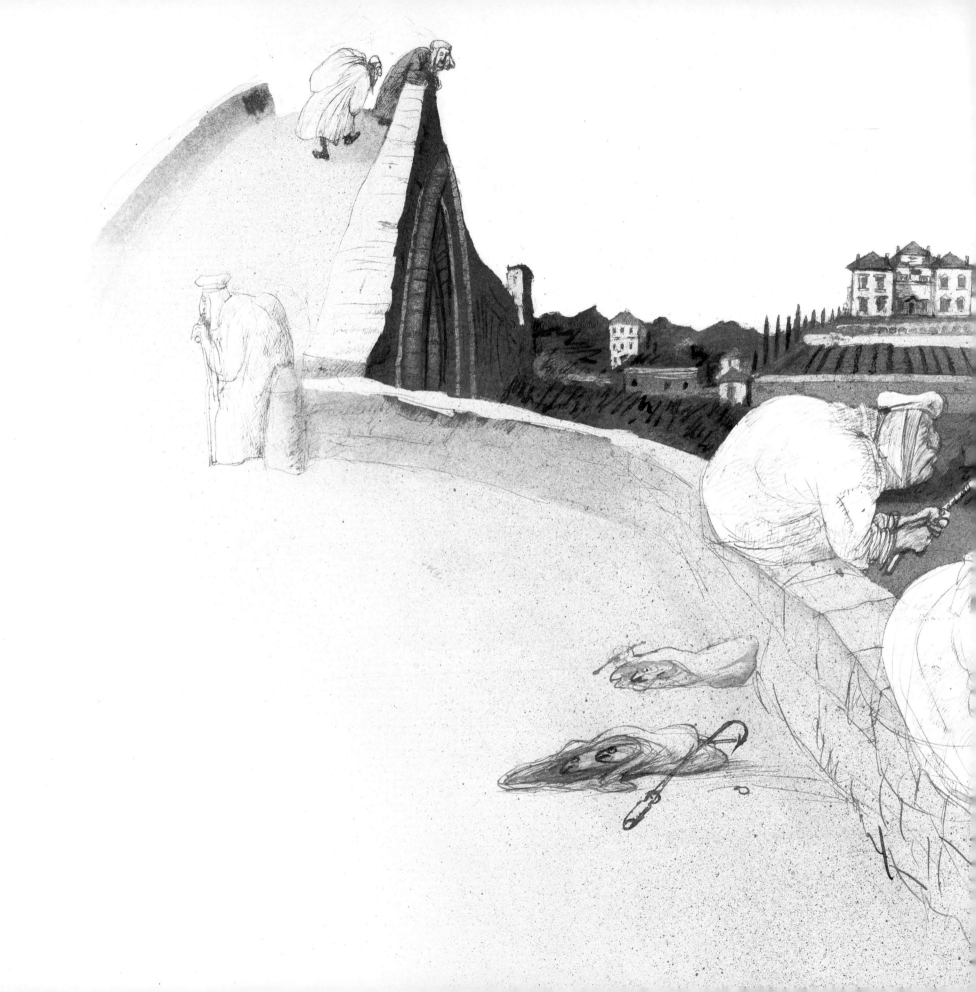

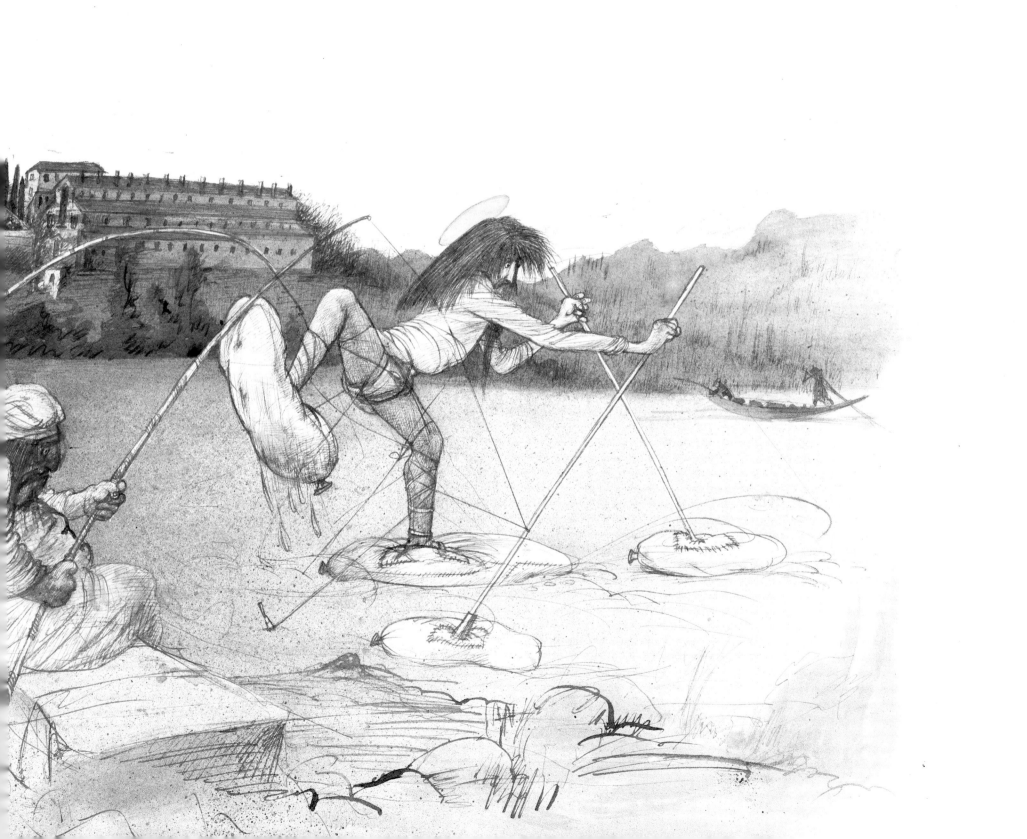

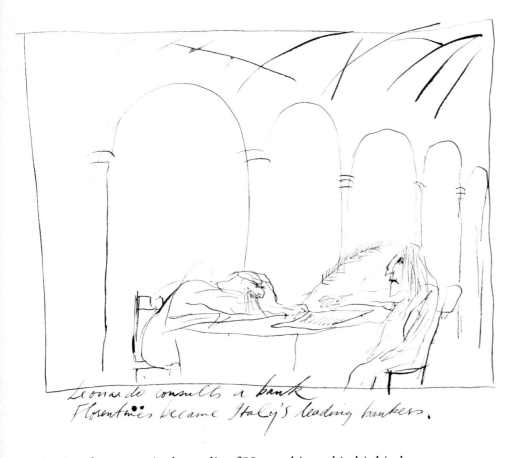

Leonardo consults a bank
Florentines became Italy's leading bankers.

I enjoyed my years in the studio of Verrocchio and in his kindness my master allowed me to lodge in his house where he provided me with good food and warmth even though he himself was much in need at this time. Though many people of wealth and rank honoured Verrocchio with commissions his many dependants kept personal riches beyond his reach.

My own father was prospering exceeding well but showed no great desire to welcome me as a member of the household again, considering instead that I must seek my independence how I would. Occasionally he sent me money, thinking perhaps to lessen the shock of a hostile world by treating me thus, and I urged my master to take most of this money to ease the burden of my presence and the rest I fear I squandered.

I indulged my love of fine clothes and that I should supplement such a vice I played the lyre and devised tricks to entertain.

I could obtain with ease a ready likeness in a drawing and thus I lined my pocket handsomely. My facility in such things grew daily. In time it troubled me thus to dissipate so readily all that I had gathered and I determined to make amends by entrusting my meagre wealth to one of the new banking establishments developing in the city.

I know little of banking.

It seems it was the invention of the Italian people and in my youth everything within its sphere was governed by the great Medici family, whose patronage was shaping a wondrous city about me.

These banks accept deposits, change foreign coins and deal in gold. Bankers' profits come from exchange of coin and loans which give them, so they tell me, 15 per cent increase on the basic amount loaned over each year. They appear to do nothing but lend the money and for this simple service receive in exchange this increased amount. It puzzles me some for nothing worthwhile seems to have been created save the mysterious 15 per cent. I am told that glorious wars are fought with the aid of this money in which I see its purpose. New princes and kings are made by force of arms paid for by the banks' good services. Those who lose battles find their possessions taken over as is the lot of a vanquished foe. But following the transaction agreed upon between the victor and the bank *before* a battle the bank lays hold to at least half the booty plus the return of its loan.

In this I find a certain over-zealous engagement in the affairs of men by the banks but I accept it as the wish of a would-be adventurer to be so treated, for it must also serve his purpose. But he who wishes to become rich in a day is hanged in a year.

Suffice to say I approached an establishment whose members welcomed me and gushed forth in the manner of their calling. I listened to their entreaties and the arguments in favour of leaving my few ducats in their keep but could not reconcile myself to the logic of their mathematics.

Excusing myself, I determined henceforth to mind mine own affairs in a way befitting each changing circumstance – and this I did throughout my life remaining always a patient son of poverty.

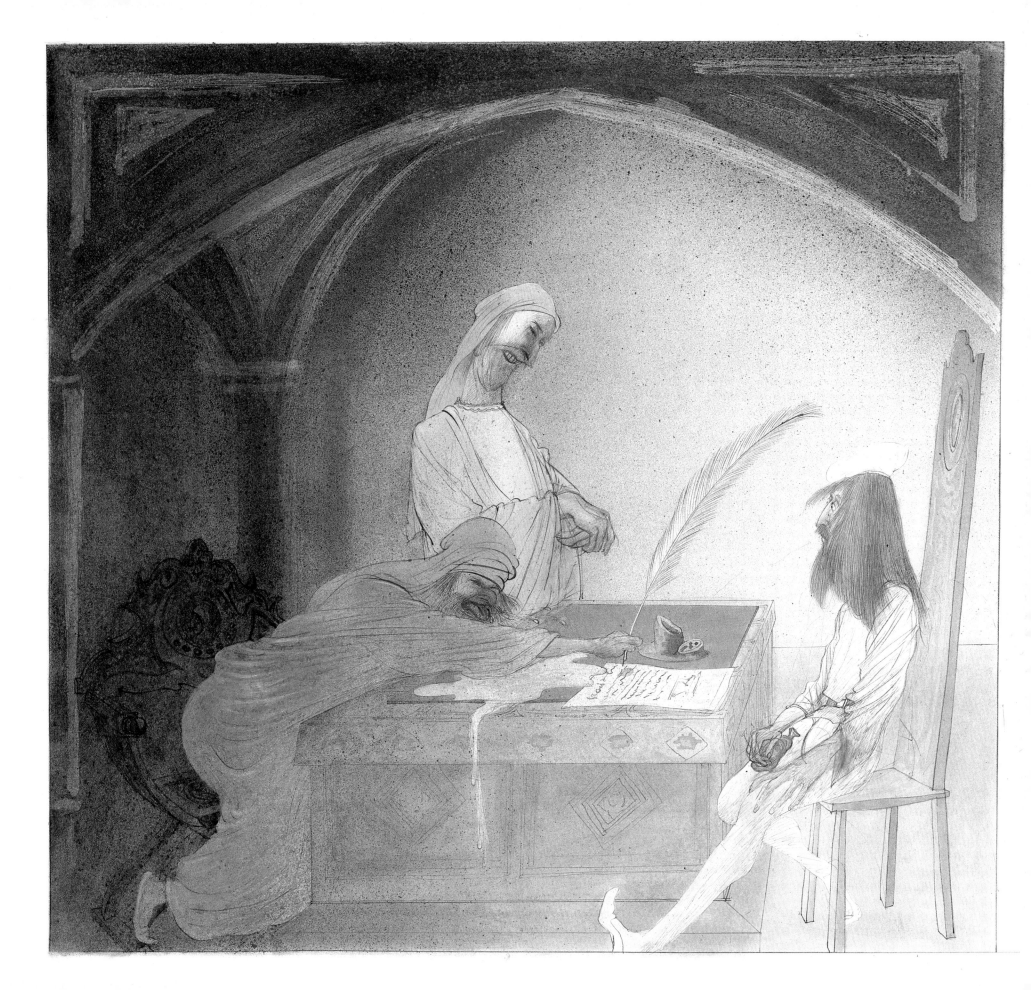

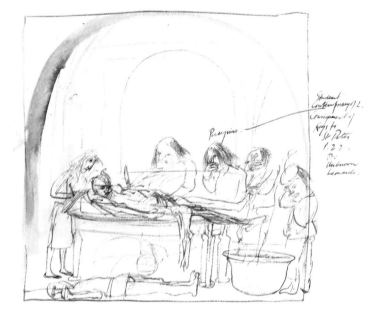

If you cut an onion down the centre you will be able to see and count all the coatings or rinds which form concentric circles round its core.

Similarly if you cut a man's head down the centre you will cut through the hair first, and the skin and the muscular flesh and the pericranium, then the cranium and within the dura mater and the pia mater and the brain, then the pia and dura mater again and the rete mirabile and the bone which is the foundation of these.

In the bottega of Antonio del Pollaiuolo just a few doors from our own, such dissections of the human body became common practice. The desire to learn its mysteries broke down my natural tendency to feel revulsion at such work.

The intense spirit of a new realism was alive and vibrant in our city. It was necessary not only to see the human form but to understand its under-structure that its surface might be expressed more vividly.

I was allowed many an opportunity to observe this work in Pollaiuolo's studio and I endeavoured to convince my master of the benefits of this practice.

Certain qualms inhibited him, however, for the resurrection of the body is an inviolable belief which precludes any dissection.

But curiosity is a strong persuader, and for my own part I entered into the activity keenly – and poor is the pupil who does not surpass his master. I conducted my studies by removing the very minutest particles of the flesh by which the veins are surrounded, without causing them to bleed, excepting the insensible bleeding of the capillary veins; and as one single body would not last so long, it was necessary to proceed step by step with several bodies, until I came to an end and had a complete knowledge; this I repeated twice to learn the differences.

And so I progressed in my apprenticeship. I attended lectures at the Studium Generale on the teaching of Aristotle's natural philosophy and Plato's mathematical universe but I gained most in the wonders of mathematics and philosophy from Paolo del Pozzo Toscanelli who seemed to know much of far-off lands though he himself had not set foot outside of Florence in all his life. His study was his universe and he travelled the world on a globe which stood therein, discovering routes as yet untried to distant places.

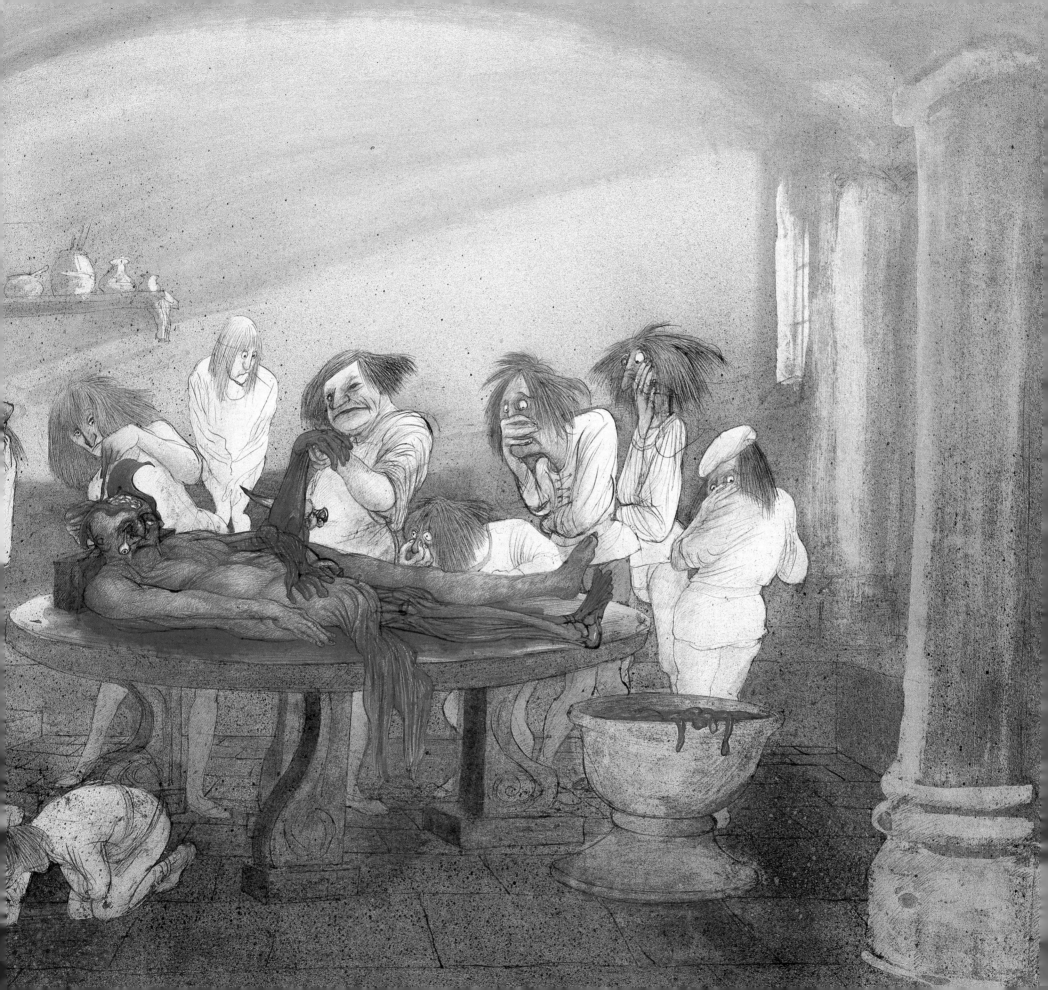

Seeking to relax my mind I was wont to satisfy my interest in the people of the city. My friends were mainly of an odd persuasion but I liked them thus even though they were at times a little crude and excessive in their habits.

My training with the master was fast approaching its conclusion and I was called upon to become a member of the guild of painters.*

It was with great difficulty that I saved the money to pay my membership subscription, for I continued to consort with my circle of friends as one does when young.

Oft-times we cavorted through the streets like peacocks not much caring for the effect of our display.

Perhaps in the wake of such behaviour there was one who took exception to our attitudes and, as chance would have it, placed a scabrous accusation inside the Tamburo on the Piazza della Signoria. This Tamburo is a box set permanently in position in which any person can, if he so wishes, place an accusation against any person or persons whether this accusation be true or false. Worse, the accusation is made anonymously affording no redress against an accuser and thus rendering the victim helpless before such an onslaught.

It was the law that every such accusation would be publicly investigated and whether the victim proved guilty or not, such stigma remained as to scar the person's good name and memory for ever.

Thus it was that I became a victim. Myself and three of my associates.

I felt at once the harshness and brutal indifference of man's inhumanity.

We four were charged collectively with the indecent assault on a boy, one Jacopo Saltarelli. We were acquitted but I must even now protest my innocence. Though many years have passed I feel the soulless stare of my accuser, whoever he may be, looking out through the eyes of those who tried me.

Even my father turned away from me and found comfort in his third wife, who bore him a child. This happy event served him well, for he had had his share of sorrow in the deaths of his first two wives.

I looked for help to many friends and those relations that I knew, but felt their firm indifference to my need. Of my mother I knew nothing at this time and so I shut my trust away and threw myself into my work. It was my only course. I tell you, more are killed by word of mouth than by the sword.

* The Guild of St Luke's

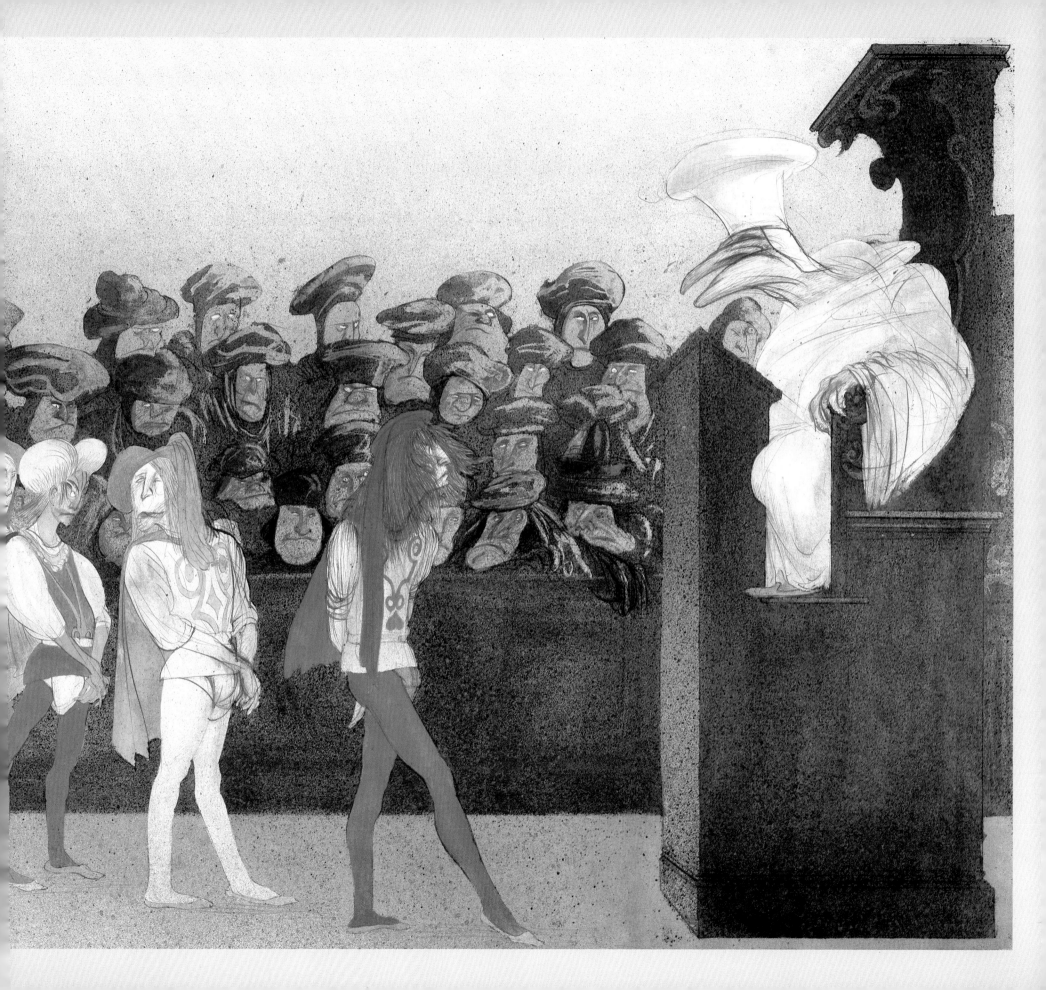

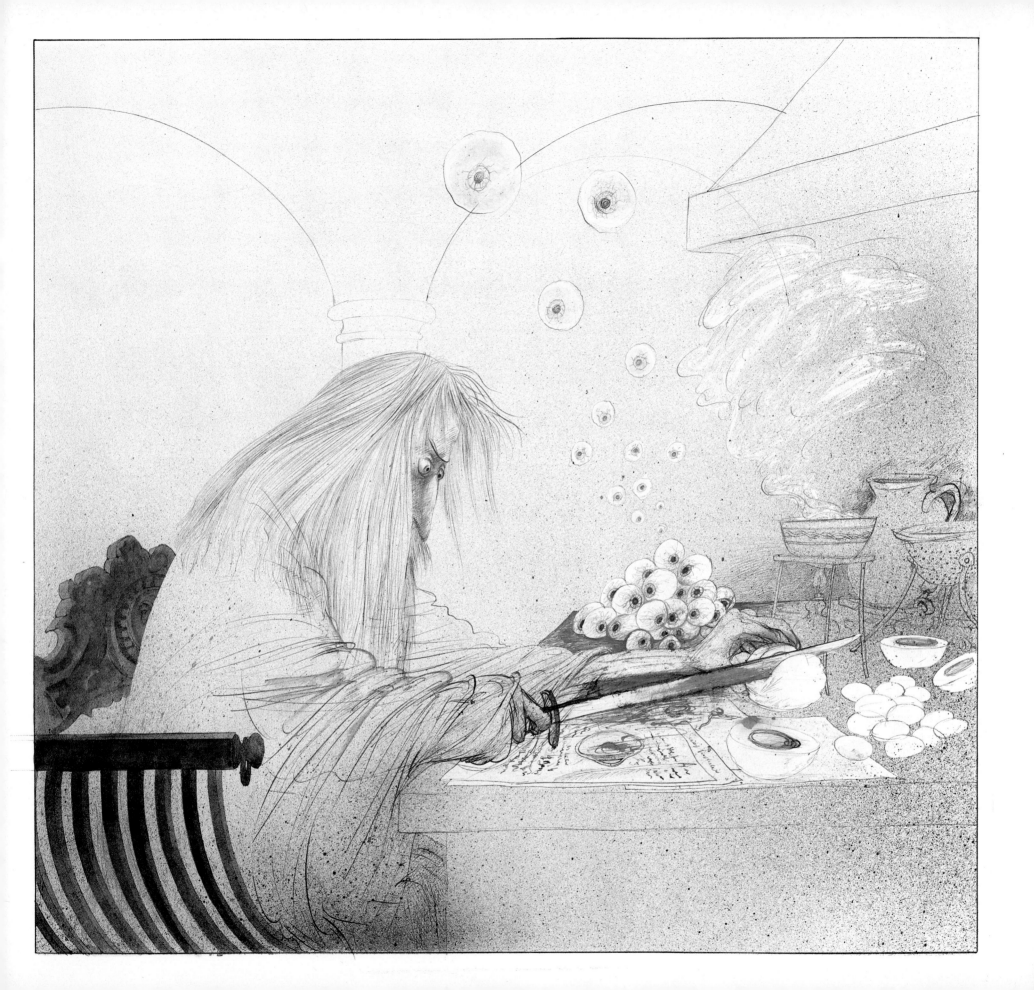

The eyes that never saw my innocence are called the windows of the soul. They are the chief means whereby the understanding may most fully and abundantly appreciate the infinite works of nature.

The eye counsels all the arts of mankind ... it is the prince of mathematics ... it has given birth to architecture and to perspective and to the divine art of painting. Painting encompasses all the ten functions of the eye, that is, darkness, light, body, colour, shape, location, remoteness, nearness, motion and rest.

Because of the eye the soul is content to stay in its bodily prison, for without it such imprisonment is torture. Who would believe that so small a space could confirm the image of all the universe?

The eye keeps within itself the image of luminous bodies for a certain time.

No image, even the smallest object, enters the eye without being turned upside down: but as it penetrates through a crystalline lens it is once more reversed and thus the image is restored to the same position within the eye as that of the object outside the eye ...* But I digress.

In the anatomy of the eye, so that we may see the inside well without spilling its watery humour, it is necessary to place the complete eye in white of egg and make it boil and become solid, cutting the egg and the eye transversely so that no part of the middle portion may be poured out.

At this time I had taken into my household a lady, Maturina, as cook and she kept me well in various titbits of great delicacy garnished and contained in white of egg.

* In fact it is the brain which transposes the image and enables us to see things the correct way up

As I went about my work through the streets of Florence studying figures of wretched disposition that I knew had souls as well, buildings stood in rows and obeyed the law that says that the thing that is nearer to the eye always appears larger than another of the same size which is more remote.

We call this law perspective and perspective is the one law that no artist can ignore, because it is the bridle and the rudder of painting and unites art with science. It rationalizes our view of the world but in this I sometimes doubt its cold precision for it has no feeling. It can construct but it cannot see inside a man's soul. Nevertheless it is important. But it is nothing other than the seeing of an object behind a sheet of glass on the surface of which all things may be marked that are behind this glass.

The wretched subject himself, considered by the artist's brush, would be the last to know. Is the beggar who is but a pinpoint in a picture more diminished in his wretchedness than another beggar who appears some twenty braccia high?

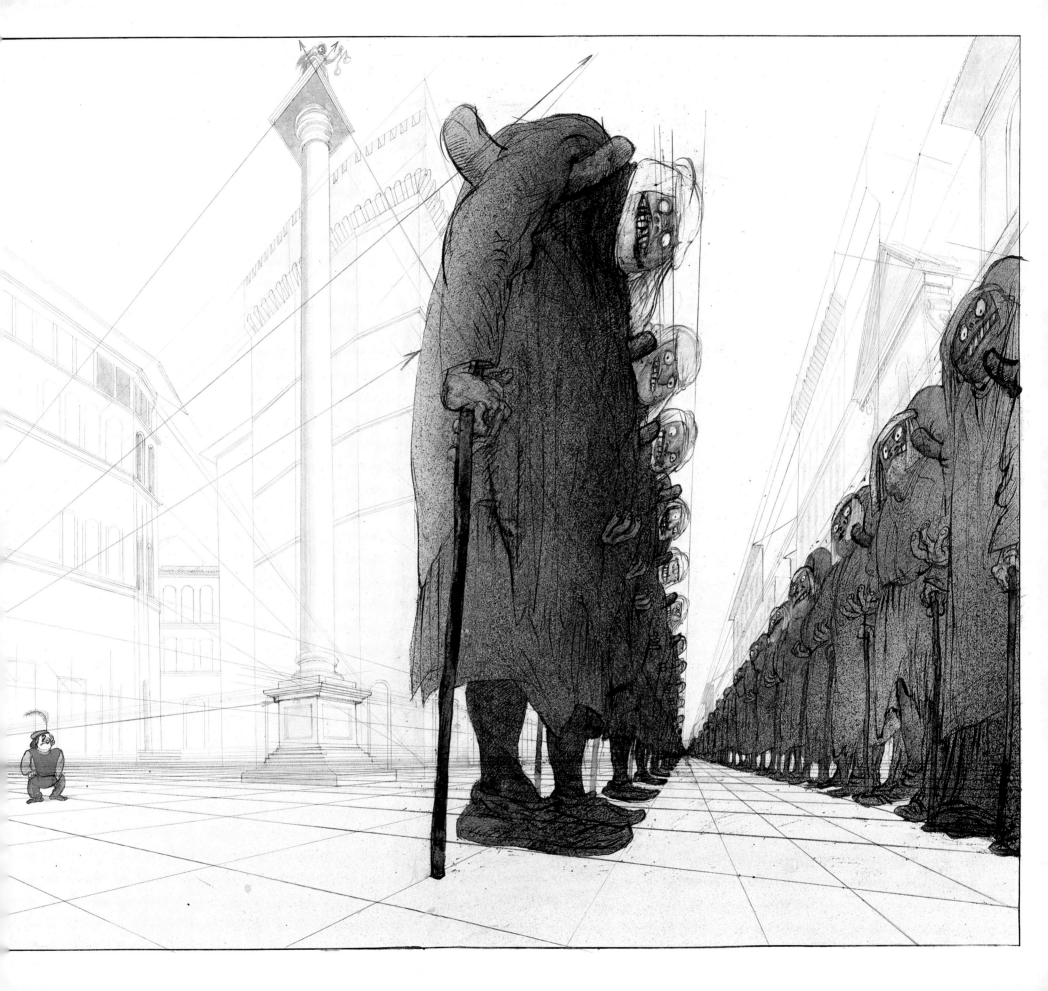

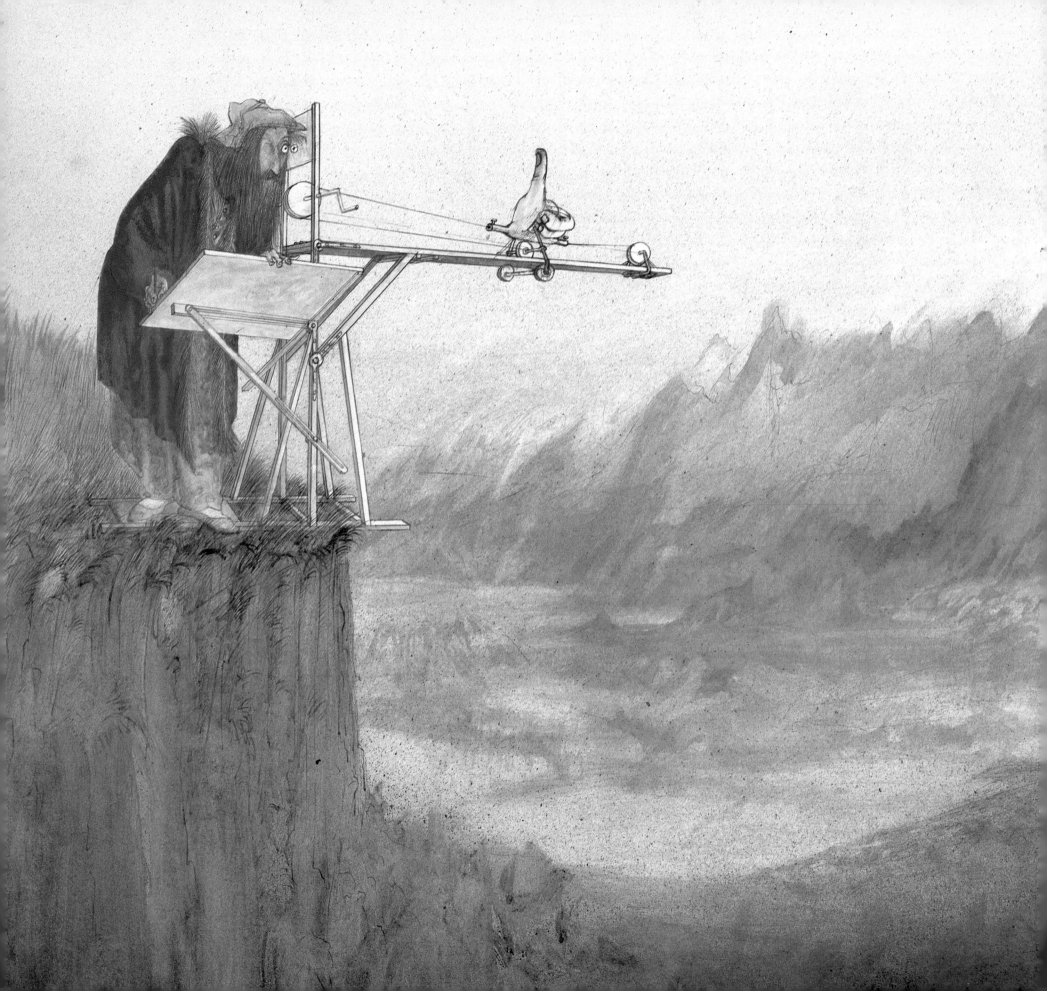

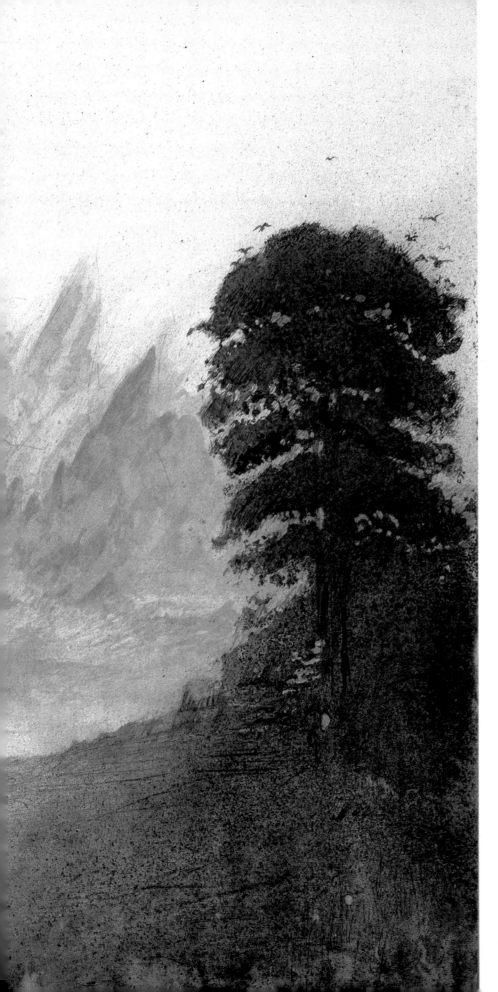

An artist must control his vision and allow these things to be so or not according to his whim and not the law.

Therein lies the danger of perspective's imposition and therein lies its strength in the hands of one greater than the law.

I found much difficulty to my dismay in the gaining of employment in Florence though many sang my praises. I was proficient in all the arts and continued to immerse myself in the study of nature.

As time passed the unpleasantness of the accusation against me eased a little, and my friends, if that is what they were, became more kindly disposed towards me though it was never with the same warmth from either side. Even my father seemed moved to help me and in the year 1478 I secured my first official commission, to paint an altarpiece for the chapel of Saint Bernard in the Palazzo Vecchio.

Alas, the commission was never to reach completion for all of Florence was suddenly thrown into the most fearsome confusion.

There was a desperate conspiracy afoot to usurp the power of the banking family, the Medici. The whole of Florence talked of a murder in the cathedral of the brother of Lorenzo the Magnificent by a rival family. The conspiracy was foiled and eighty people lost their lives that day. Many of the conspirators were brought to justice if that is what it was. The baseness of rivalry will make men use that word if it suits their ends. Such was the hellish recrimination fomenting in the breasts of those who failed that even as the ropes drew tight around their necks and they hung side by side, they struggled to bite and scratch at each other.

One who escaped was caught and hung the same for all to see. I too attended. In my mind I thought perhaps a commission born of the terrible incident might be forthcoming as my father was already engaged in arrangements concerning new commissions for Sandro Botticelli and my own one-time master Andrea Verrocchio.

I noted the poor man's tan-coloured cap, his doublet of black serge, his lined black jerkin and blue-lined coat of fur from foxes' throats. The collar of his jerkin faced with velvet and stippled in black and red. He wore black hose.

Alas, no such commission came my way from the family de' Medici nor did it ever.

War and poverty followed. The papal forces turned against us as one conspirator had been archbishop and one

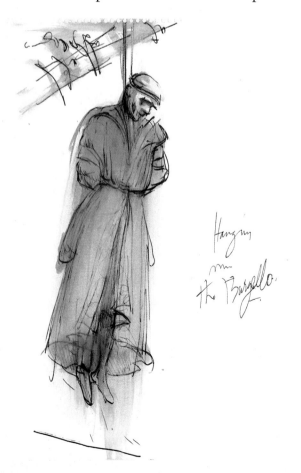

Hanging
The Bargello.

a cardinal upon whom Florentines had shown no mercy. I took it upon me therefore at this time to busy myself with more efficient machines of war since we were under siege and had no choice but no stomach for it either.

This I did with some effect and to my surprise with great enthusiasm although I am a man of peace – I found within myself a paradox of sorts. What I devised I felt was spurred more by a desire to solve a problem of mechanics than a lusting after blood.

As fate would have it once again my work was set at nought for I could not secure enough attention for my ideas. Florence meantime achieved a truce not having will or weight to sustain such conflict.

It was with great relief that through my father I received a worthy commission from the monks of San Donato at Scopeto. I chose to paint the Adoration of the Magi and set about my task with huge resolve.

The work was joy indeed and I pursued a way to show that birth of such a one as Son of God was more than mere spectacle. That within us all lies hope that such a miracle shall come to pass though we may not believe. I threw all sense of order to the winds to leave my thoughts unbridled.

It taxed my powers and I was grateful for this time but something made me falter in my way. The point I reached was full with wondrous possibilities and there it stayed much to the great dismay of my providers.

I left the city in a flux. I felt my time there had run its course and of those who sought to work as I did, most were gone to Rome in great array to work for no less a patron than Pope Sixtus IV.

Instead I travelled north to Milan and hastened to a brooding castle, court of Lodovico Sforza, self-named Duke of that gracious city.

I took with me my lyre of silver as token of the musical strengths that I possessed.

I felt obliged to write of myself an introduction that would turn the head of any man of state no matter what caused his preoccupation.

I would indulge my need to quote it to you near in full but modesty in retrospect prohibits me. Though I would tell you that my proposals spoke of military constructions as yet unknown, of bridges, ladders, and besiegers' implements to overcome a citadel. I spoke of bombards that not only worked with greater speed to wreak the utmost devastation but threw fire and smoke in all directions such as would terrify an enemy. I spoke of these things more to capture the good Duke's imagination for I hoped that he would favour me in times of peace with works to grace a noble city when such wars were won. It was with greater fervour that I pressed upon his Lordship my desire to be the one to create a bronze horse to bring immortal glory and eternal honour to the happy memory of his father and to the illustrious house of Sforza.

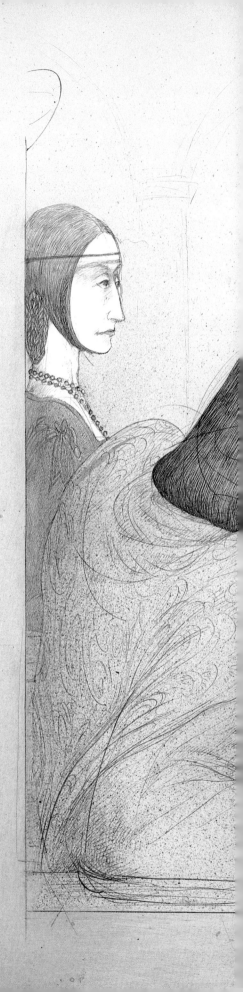

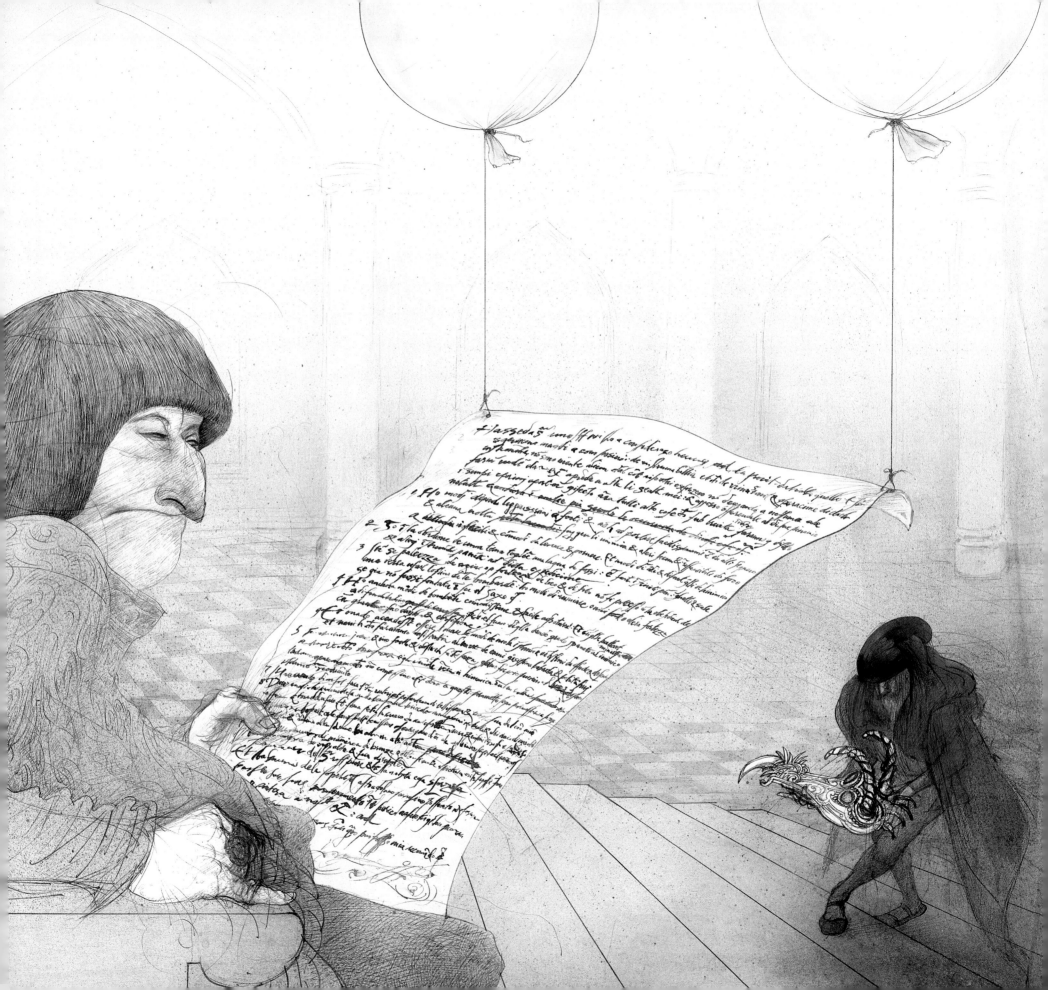

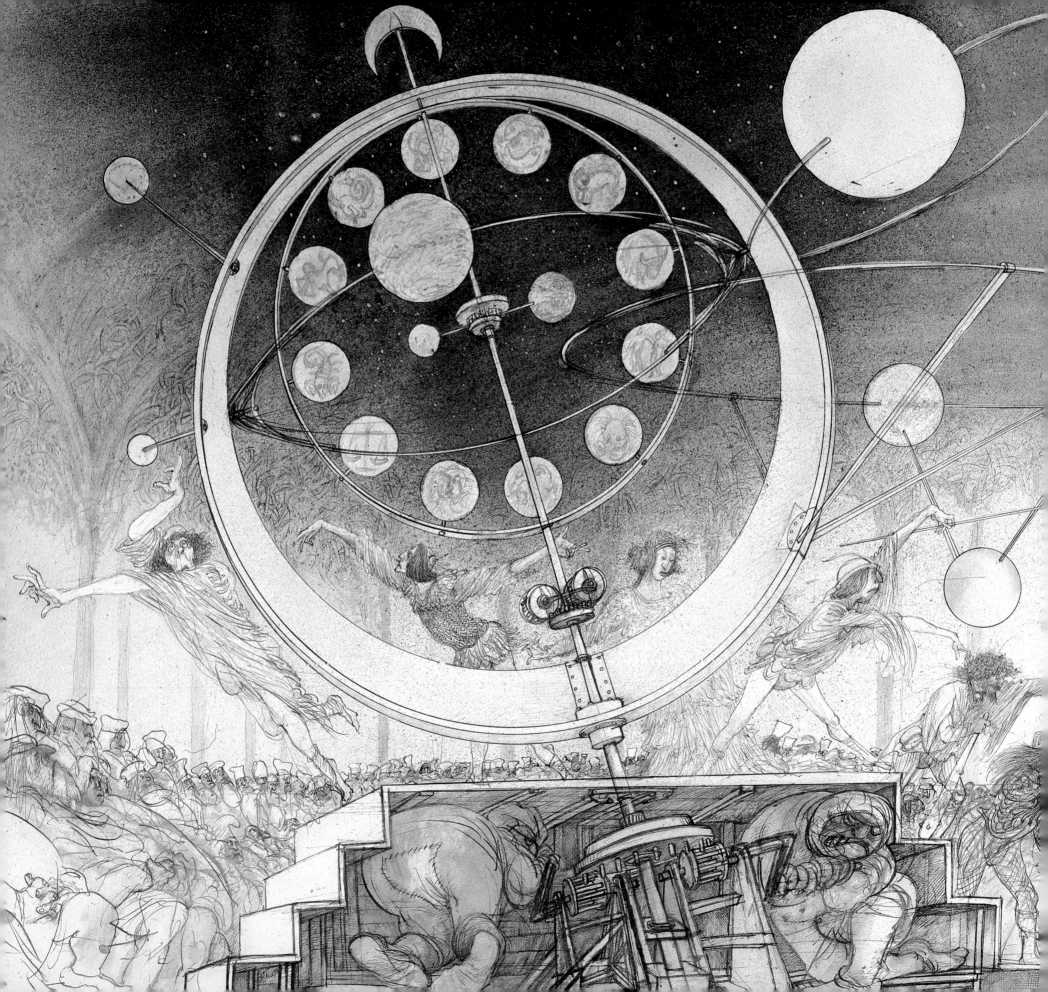

And so it was I came into the presence of this Lodovico Sforza called 'Il Moro' – a man of uncertain temperament and worldly whims.

Not discouraged by a certain coolness in his demeanour I felt in time that he would honour me with more taxing commissions than designing ingenious privies for ladies of his acquaintance, as was the nature of his first request.

My meagre savings soon ran out for I found that in matters of payment for services to the Duke, honour was more than money and should suffice until such time as would please him to bestow his favour.

I took lodgings with one Ambrogio da Preda and his family.* He too was an artist and together we secured small commissions to help the household pay its way. For myself I longed for independence. There was no joy for me in this creative bridle. We did at last sign a wretched contract to produce an altarpiece for the fraternity of the Immaculate Conception.

Nothing was left to creative chance by these misguided patrons who demanded angels and cherubs flying everywhere in disarray around God the Father floating on a cloud who was to fill most of the picture in his magnificence. The list of their demands was long and futile and written too in Latin – a language I did not quite come to master. I determined to ignore their earnest requests and set about my own way. I gave instead of my best and produced a scene which pleased me much but which I could not finish in the appointed time;† neither would the fraternity pay me as they ought and so a dispute arose which neither party found a way to settle for nigh on twenty-three years.

These waffling pedants contrive to put us into bondage for a stipend!

I waited long to find some worthy challenge from the patron I most desired to serve and long it was in coming. My friend da Preda went about his work with banker's zeal and made himself a prince of portraitists to suit the fashions of the day and we parted as was meant to be.

I was engaged to paint at last the mistress of Lodovico, Cecilia Gallerani, whom I found to be a lady of fine upbringing with a learned mind proficient in the arts of music and poetry. To paint her was a pleasure and if the Duke had chosen not to pay me for my work it was the one time when his careless habit would have been forgiven but as though to prove the contrary ways of man he paid me handsomely to boot.

I think I fell in love with her for she became my

* Near the entrance to the city known as the Ticino Gate
† 'The Virgin of the Rocks'

Madonna Cecilia – secretly my most beloved goddess.

I worshipped from afar as one who needs to keep himself for art alone. I think too that I desired to keep my head a little longer in this life! The Duke was an extremely jealous man and my ambitions lay elsewhere besides. I needed something now to prove my worth above the rest.

The challenge came in ways that taxed the oddness of my inclinations and the measure of my certain talents.

I was charged to create a fantasy of paradise to delight the whims of a foreign brood of noble whores and men of wealth to celebrate belatedly the wedding of my patron's nephew which had it seemed as yet to be consummated and lay beneath a darkest cloud of one year's standing.‡

There was a reason in me beyond the need to stir this young boy's manhood into action. It was my fervent hope the Duke would favour me to sculpt the great equestrian monument to Francesco, his father. And so I brought to bear upon this frivolous occasion an intensity unmatched before or since and far beyond its true importance and gave to this rare gathering a spectacle to stir another world of kings.

The nephew too it must have spurred to greater effort for within the year his wife was with child and he meanwhile suffering from stomach disorders through 'working the field too hard', as those at court would have it in the crudeness of their manner. My patron the Duke also was reconciled by my performance and knew now that my capacities were boundless. I was charged to commence the massive work.

‡ Gian Galeazzo, the rightful Duke of Milan, was impotent and King Ferdinand of Naples refused to pay the 20,000 ducat dowry of his daughter, Isabella of Aragon, to Lodovico Sforza until the marriage was consummated.

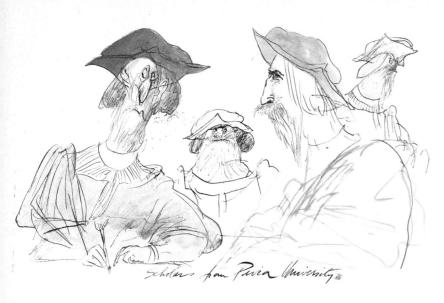

Scholars from Pavia University

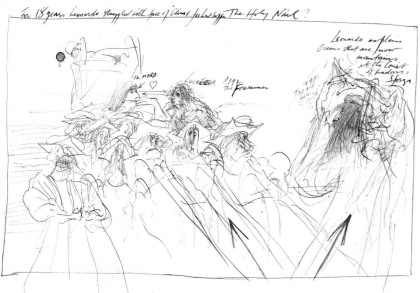

For 18 years Leonardo struggled with face of Christ for last supper The Holy Nail?

IL MORO LUCREZIA ???? The Freemaker

Leonardo explains Oceans that are now mountains at the Court of Ludovico Sforza

I found within the court to my dismay I was at every turn confronted with the views of official scholars – men who spent their lives in study of things known or merely claimed as truth.

Their days at court gave rise to futile speculation and great heated babbling concerning matters steeped in cant and helpless superstition and I was in no way esteemed for my ability to speak of knowledge learned of observation, so I kept my peace.

There were odd times when forced by confrontation or command to express my own opinion I thrust myself upon them in no uncertain manner, and much to their dismay, though I feared such times with all my heart and soul.

For often the discoveries I had made about our world would not find words enough to describe them and I would hang in open sentence while all about men would take me for an idiot.

The more I spoke the more I sensed my isolation.

The minds of men shut down on simple truth or they talk instead of 'higher science' as though it were untouchable to common mortals and governed by the stars.

If I soiled my hands in experimentation I was treated with contempt as one who dabbled in a lower science. Had I to accept their view as a beggar who holds out his hand to receive a piece of stale bread? Was it not honourable to find for oneself by sweat of brow and observation that there is only *one* science which Nature herself practises inside dark caves and in the breasts of nightingales alike?

She abhors the vacuum which she would have found inside their books if not inside their heads. But I digress.

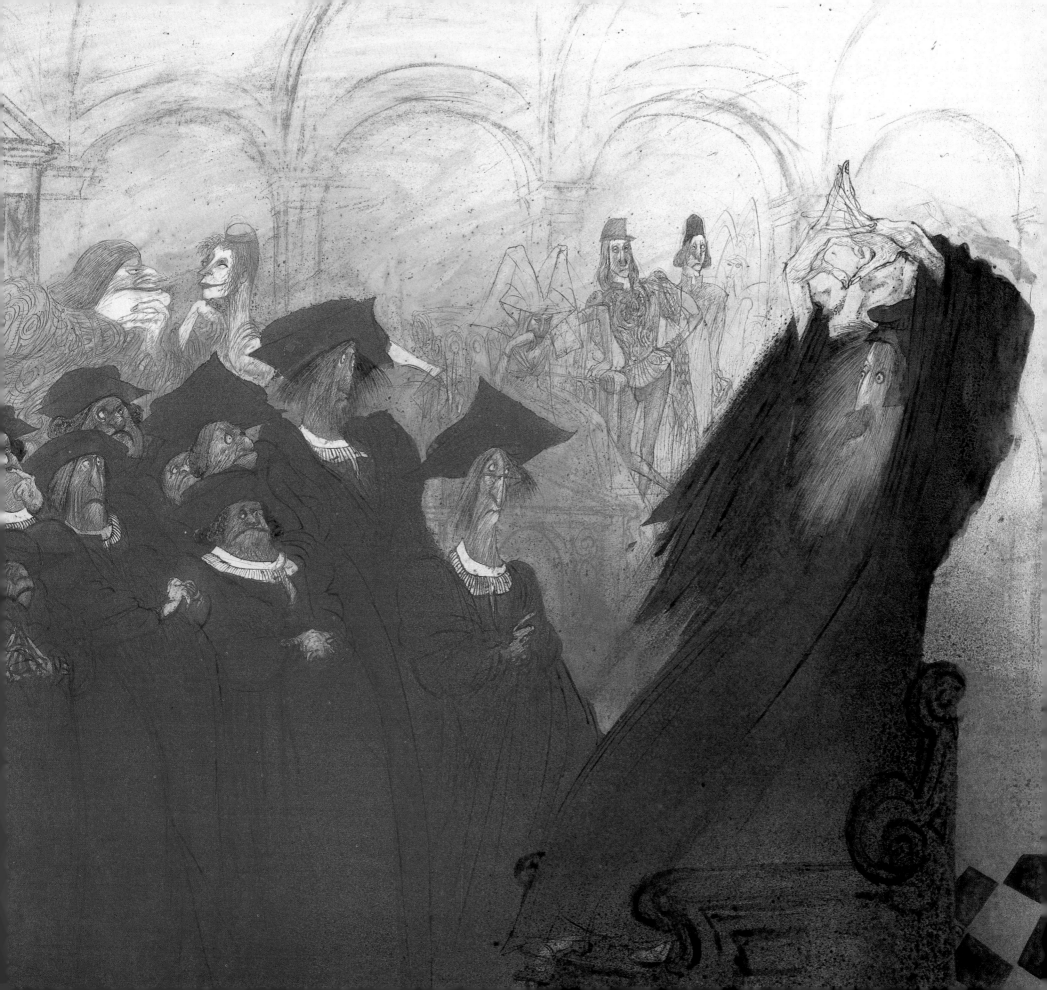

Eight years had passed and still the Virgin of the Rocks had not finished with me nor the patrons for whom I first began it.

I had disciples but they would not learn as I would. But still I needed their help as they spurned mine for now my Cavallo to Francesco was begun.

I seemed to find the worst of human kind to take as my assistants for they could be as evil behind their youthful beauty as beggars can be kind behind their hideous façade.

One such Giacomo I took in off the streets. He came to live with me on Magdalens Day 1490. His age was ten. He was, I have to say, a thievish, lying, obstinate glutton.

The second day I had two shirts cut out for him, a pair of hose and a doublet, and when I put money aside to pay for these things he stole the money from my purse and it was never possible to make him confess although I was absolutely convinced. This cost 4 lire.

On the following day I went to supper with Giacomo, and he had supper for two and did mischief for four, for he broke three flagons and spilt the wine.

Item, on the seventh day of September he stole a style* worth twenty-two soldi from Marco who was with me in the studio. It was of silver. After the said Marco had searched for it a long time he found it hidden in the box of the said Giacomo. This cost 2 lire 1 soldo.

Item, on the twenty-sixth day of the following January when I was in the house of Messer Galeazzo da Sanseverino in order to arrange the pageant at his tournament, and certain of the pages had taken off their clothes in order to try on some of the costumes of the savages who were to appear in this pageant, Giacomo went to the purse of one of them as it lay on the bed with the other effects, and took some money that he found there. This cost 2 lire 4 soldi.

Item, a Turkish hide had been given me in the same house by Messer Agostino of Pavia in order to make a pair of boots, and this Giacomo stole from me within a month and sold it to a cobbler for twenty soldi, and with the money as he has himself confessed to me he bought aniseed comfits. This cost 2 lire.

In the first year he cost me thus: a cloak 2 lire, 6 shirts 4 lire, 3 doublets 6 lire, 4 pairs of hose 7 lire 8 soldi, a suit of clothes lined 5 lire, 24 pairs of shoes 6 lire 5 soldi, a cap 1 lira, laces for belt 1 lira – and the rest.

But I knew he tried well on occasions even though there was an impish end in his benevolence.

Somehow he would contrive to entice right off the street those souls one would prefer to stay outside.

I covered my embarrassment with tricks to entertain for to be fair they had been promised food and drink in exchange for posing in my bottega. I was bound to tell

them coarsest anecdotes to please their fractured minds.

And this I did also: if I poured wine into a bowl of heated oil the alcohol flared up and burned before their eyes.

It was enough to turn me from a man into a wizard and sometimes I had drawings at the end before they parted and in this I begrudgingly felt gratitude to Giacomo but Salai was his name hereon and Salai it shall stay. It means 'little devil' and so he was.

* Used in the art of silverpoint drawing

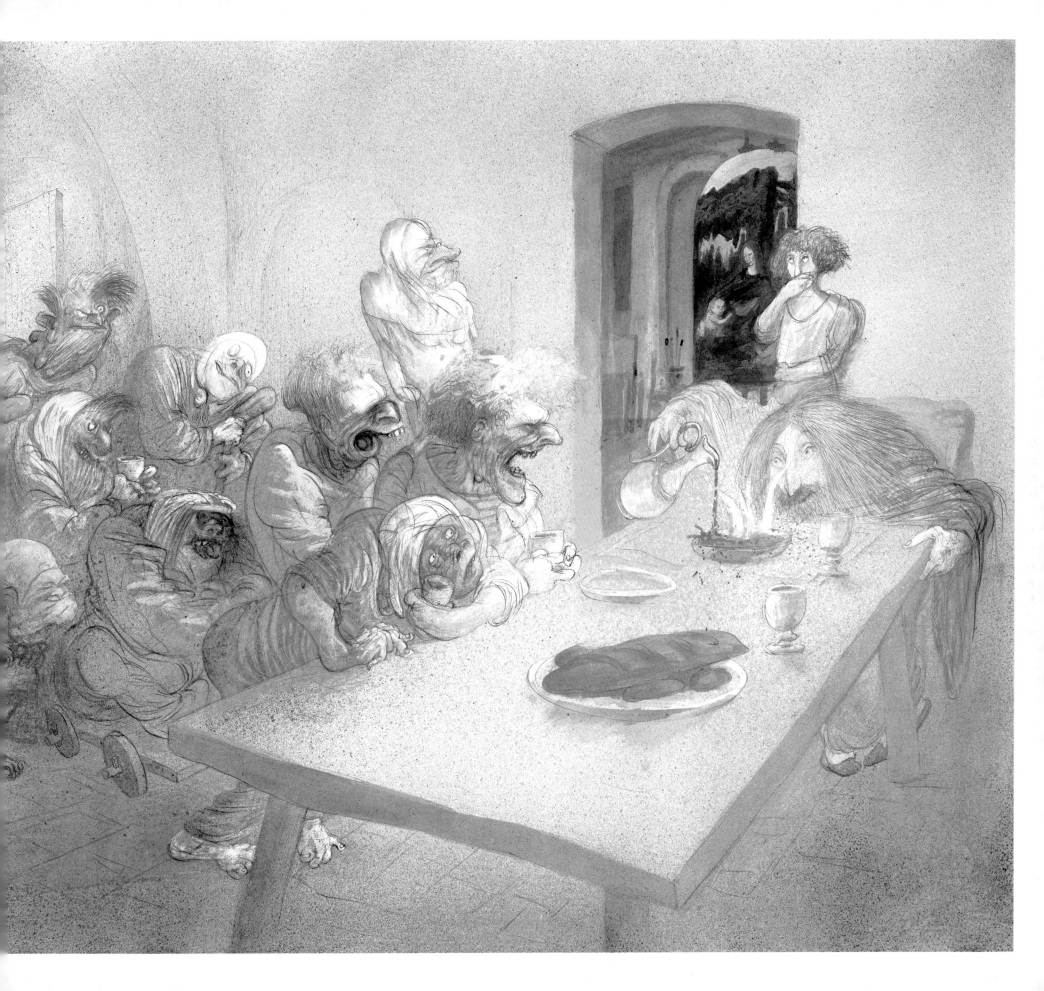

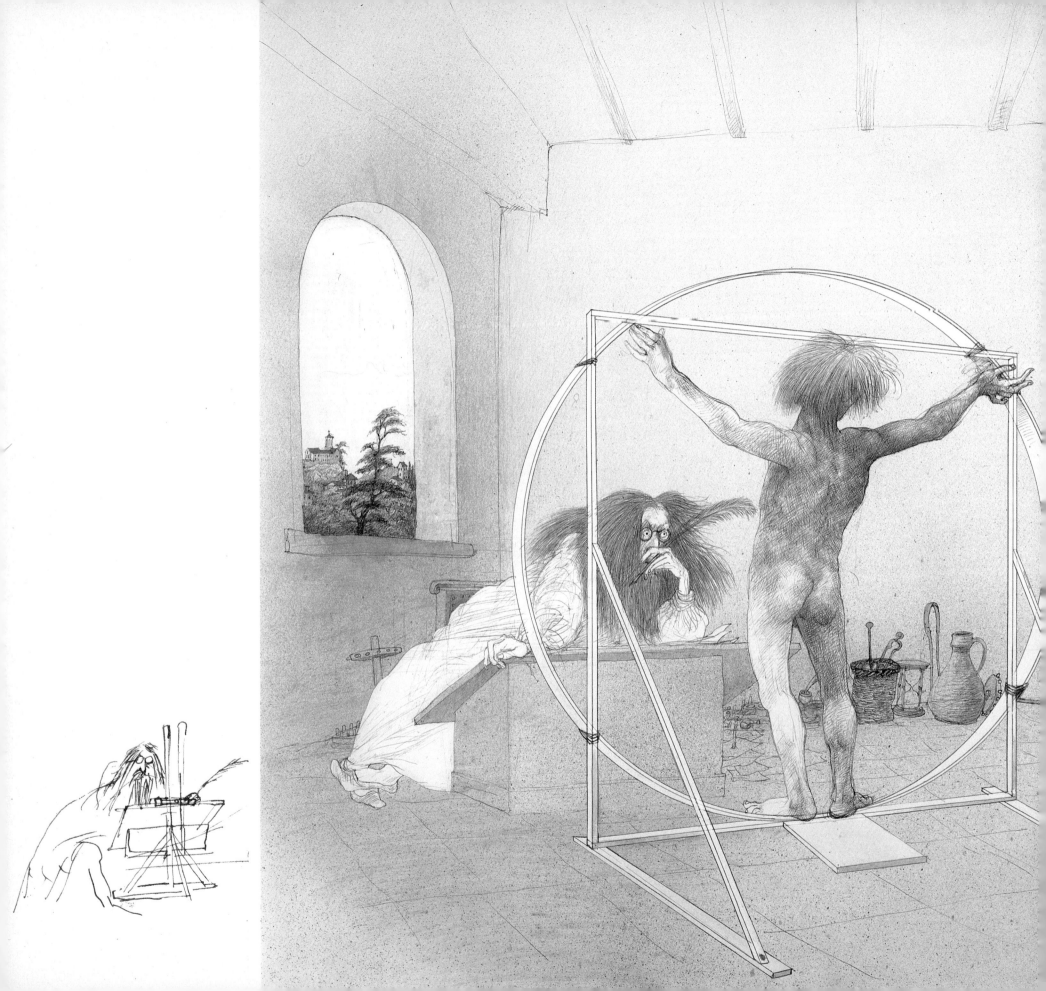

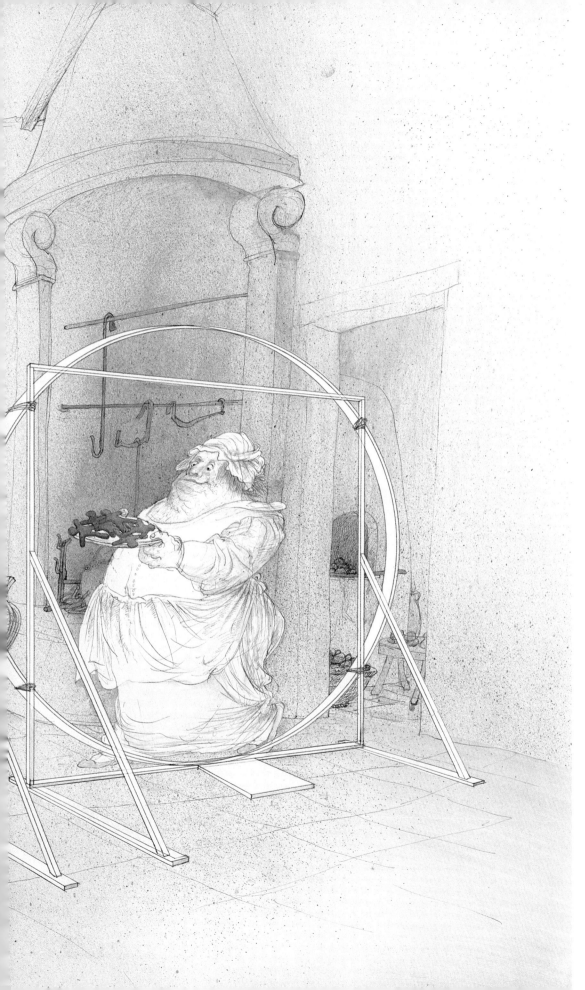

As happens to the most of us, particularly those who use their eyes to do fine work, we need an aid to help us see more clearly what we do.

I made my own two lenses and struggled for a time with their correctness. My studies also led me to construct a framework not unlike the lens frames I had made.

With this I observed those proportions God has wrought in man, that the span of a man's outstretched arms is equal to his height.

It is not so in all men for some are cast a little less than perfect.

To pay his way, since he could do nought else I bade Salai (my Giacomo!) pose according to the manner I desired. He did it well, I give him credit, though on occasions he did adopt an attitude to give offence through provocation.

Cook Maturina, bless her heart, took all of this and more besides in good spirit as many who are worth their weight in gold, and in response found inspiration in her culinary arts to make a simple replica in pastry bread of Salai, arms spread wide. He was not chastened but did eat them all before he posed again. I bade Maturina make some more and they became great favourites and we did sell a few upon the streets to help pay for our comforts. We called them 'Salainos'.*

I am beset continually with thoughts of flight. It is the greatest thought beyond all else that I may do. It is a fantasy that I would have made real before someone does before me. There was one trying that I knew called Danti.

* Gingerbread men, baked after an old Tuscan recipe for *berlingozzi*

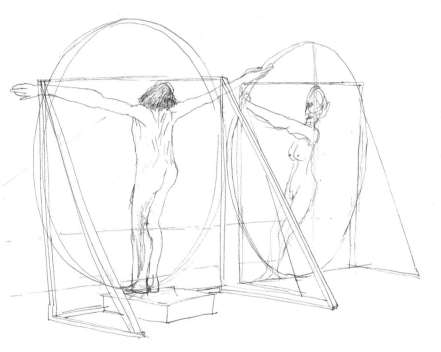

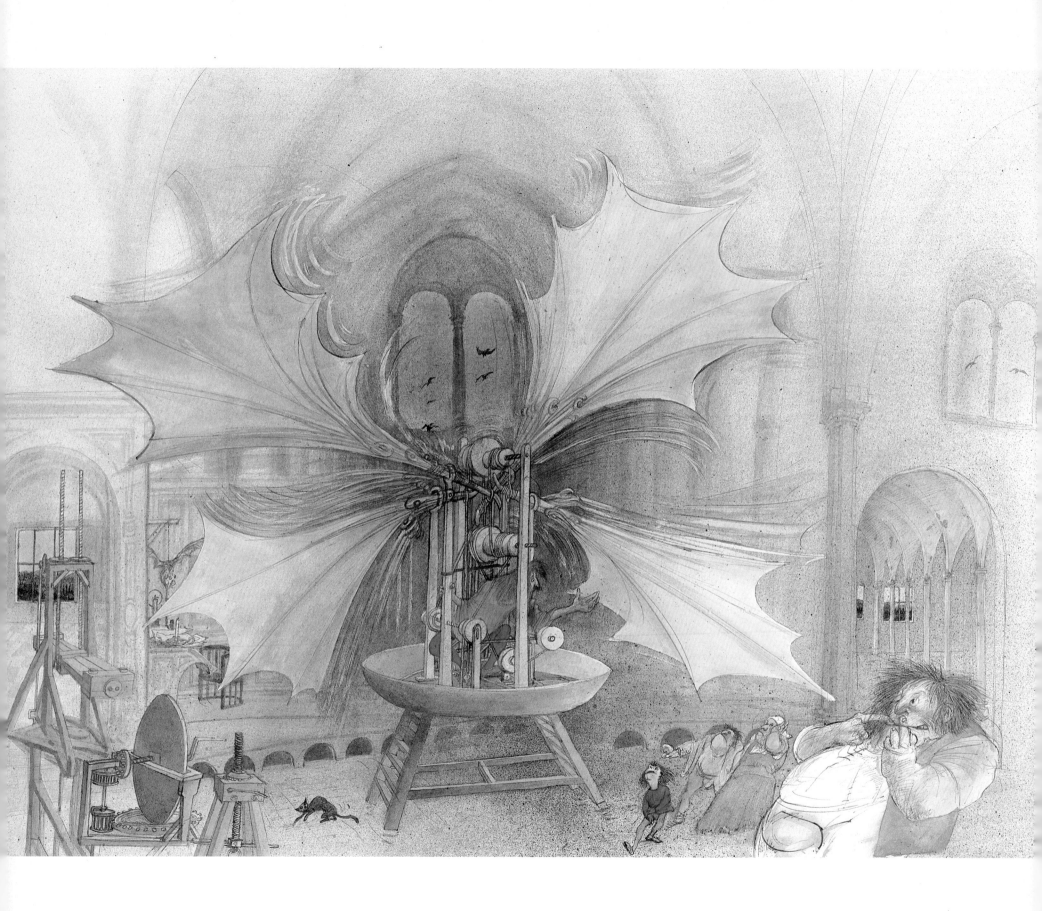

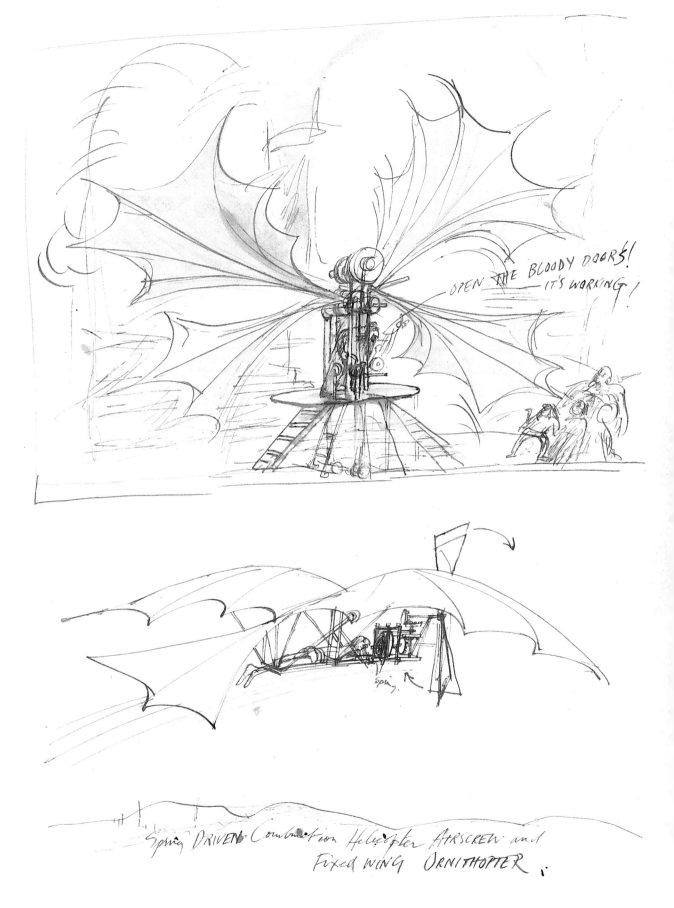

OPEN THE BLOODY DOORS!
- IT'S WORKING!

Spring DRIVEN Combustion Helicopter Airscrew and
Fixed WING ORNITHOPTER.

To construct a machine whose components measure the work-load on the operator by means of leverage yet increase the weight by their very presence would seem to me to be in contradiction.

And yet to be airborne for but a few seconds would surely be more desirable than to be for ever earthbound. A second in the company of Gods would be an eternity in the minds of men.

I constructed a machine and bade all stand aside for I was certain that within a moment I would fly. It mattered not how far or even whether such a thing could be controlled. Why seek control when freedom holds the reins and angels bid you join them?

In this I was mistaken as I was soon to learn. I gathered all my strength to give my angel life to move.

Zoroastro, my sturdy helper, Maturina, Salai and the rest, all were there and staggered backwards as the thing attempted to take flight. The urge to fly comes strongest at a time when you feel most restrained.

And those few moments of exhilaration will remain for ever in my head before confusion struck terror inside all who watched and I recall no more until the tender bathing of my brow awoke me from the strangest dream.

I dreamt that all the people around were flying through the air and even crippled beggars soared high and free and down below the world was full of beauty.

Mountains were like hillocks and the towns were subtle frameworks full of colour. The clouds were places on which people sat whilst pausing in their flight.

I led a multitude of flyers towards the sun; then I began to fall . . .

I troubled myself to devise a plan to eradicate disease from among us and place Lodovico in a treasured mould as benefactor to mankind and he would be as well a collector of revenues from starting such a course.

I proposed a city built on two levels. The one above would be a place of beauty for the mighty and the one below would be a place whereby the poor would carry on their honest labours and their heavy traffic necessary for the well-being and convenience of those above.

The cities would be built along rivers and seashores with adequate discharge pipes using running water and the flow of tide to carry such filth and distemper away from the city as each day brings forth.

And still I laboured hard to build my horse of clay and make the greatest sight that all men will remember. But all these projects came to nought and up to this time I had not fulfilled a single work.

Beatrice d'Este came into my patron's life – she such a child and he still so besotted with Cecilia Gallerani it makes me wonder at the selfless disposition of these men of state that they would enter into marriage for the greater glory of these families who rule our lives. And he so troubled at this time with wars. I understood why no bronze was forthcoming for my mighty horse.

I made instead festivals of gaiety and fantasy for his court and found a new delight in writing fables and jests for the pleasure of his new queen Beatrice.

The court was wont to travel and to visit in great pomp and ceremony. A more polite way to chide at lesser nobles and their entourage has never been invented.

The French were always masters of such an art and made grandiose gestures and alliances to prove their strength with neighbours. But Lodovico Il Moro, my patron, also made great play of diplomatic tournaments and would not be outdone. Even my horse was wheeled out in its nudity for all to see and marvel at, though I myself would rather it were bronze to show the world.

I found to my dismay that all these kings and princes he did court loved women above all else and most rode out to fight with them in mind.

But chivalry is one thing and lust another. Many battles have been fought and lost inside the feverish ravings of a pox-ridden mind.

The king's nephew Gian Galeazzo, the impotent prince and rightful duke of Milan, fell sick and some would say it was because of me. I had been dabbling with effects of poison on fruit trees. I injected arsenic into a peach tree and was very wary of the fruit. But Zoroastro, my good helper, ate without a thought and nothing untoward became of him.

My patron's nephew died knowing full well that it was not I who caused his death and for that I was much relieved.

Now Lodovico was Duke indeed of all Milan. My patron was well pleased and my time was full now with strengthening the castle, plotting canals and painting arbours planned in woven branches. The Duke gave thought to summer palaces befitting his new stature and did employ a wondrous architect called Donato Bramante.

I had much time for study and research and found the mathematics of proportion and geometry of greater joy than I had hitherto imagined.

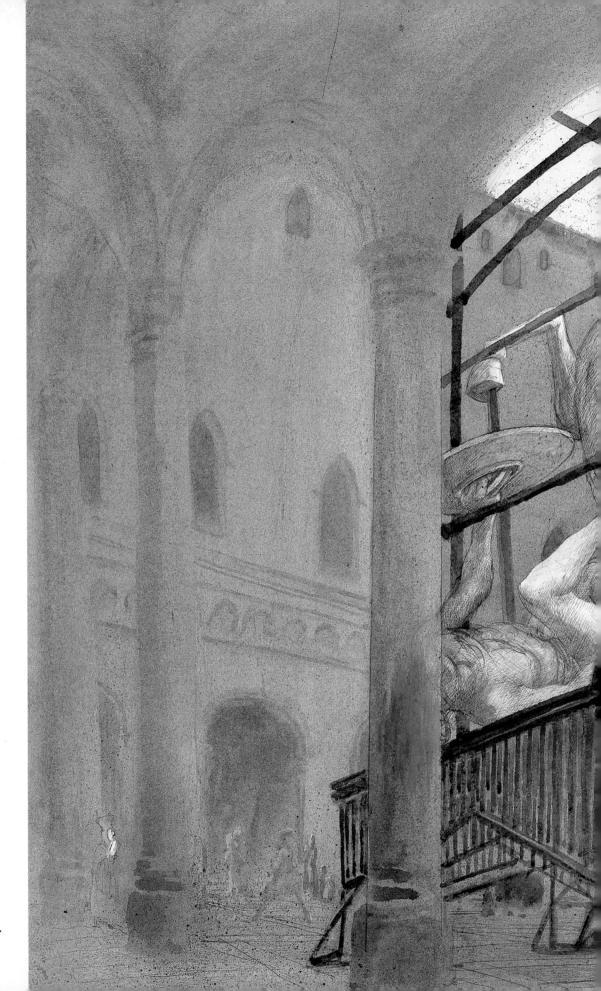

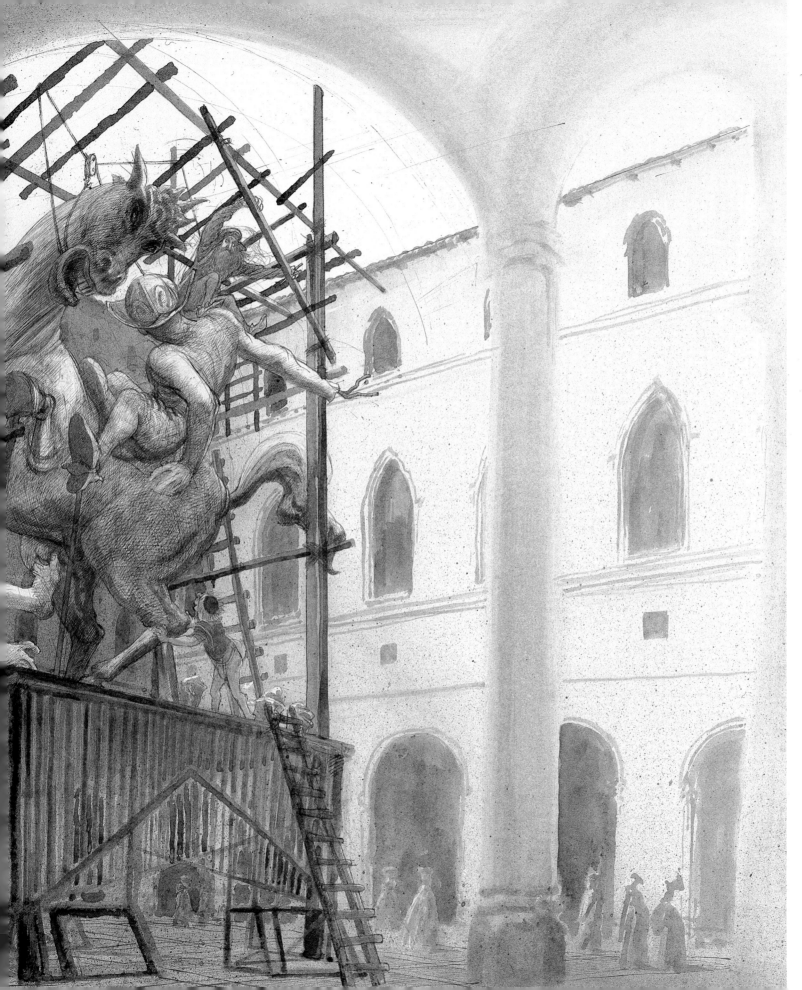

But in matters of money I remained at a loss and greater as the power of Lodovico grew, so smaller grew my hope of ever wresting remuneration for my labours from his treasurer Gualtieri, who thought perhaps that I was wealthy on my growing fame alone.

For thirty-six months I fed six mouths and all I got for it was 50 ducats. I implored the Duke to help me but he took no heed.

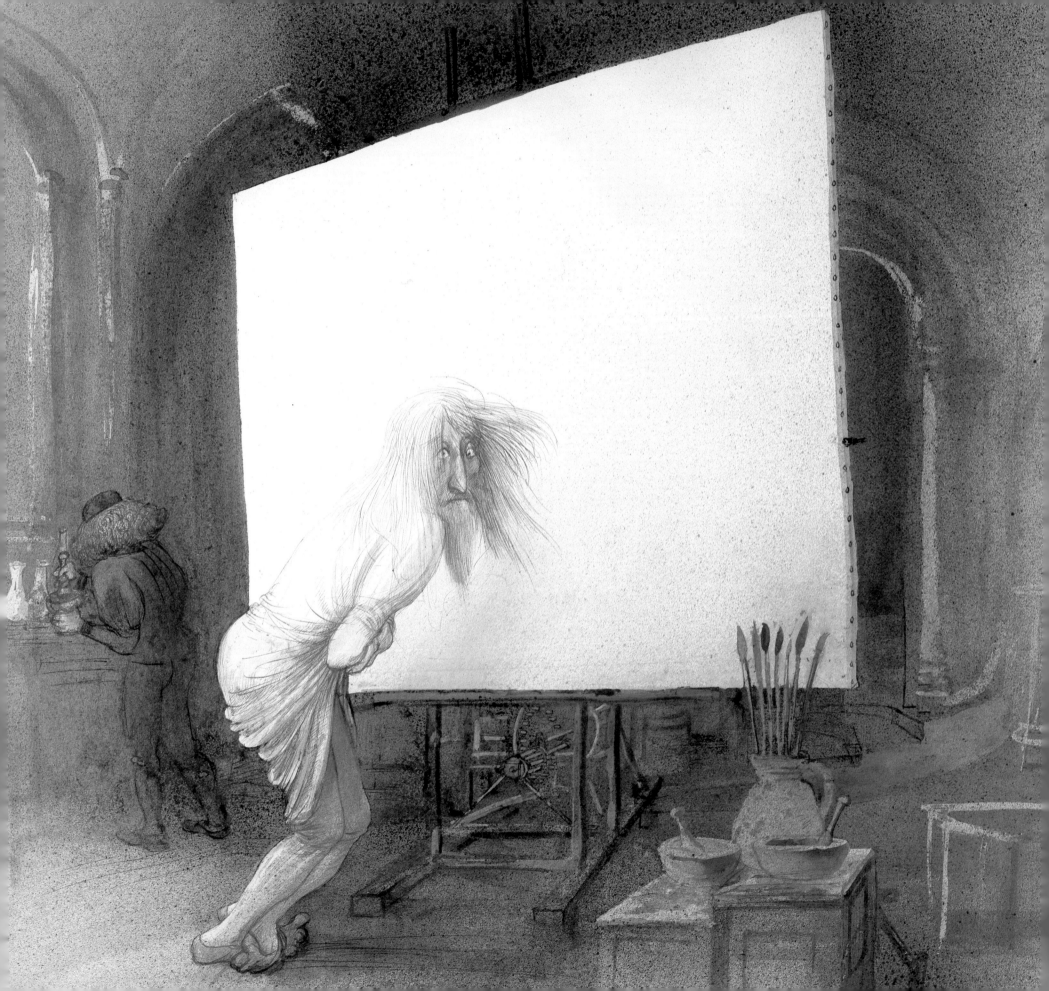

My patron was much given to praying and I saw his piety grow in equal measure to his swelling power and its attendant problems. Each day he would walk as if in a trance to the little monastery not very far from the castle known as Santa Maria delle Grazie. There he would spend many hours in meditation and perhaps find respite from the mental anguish such a man must feel.

It was his intention to enlarge and decorate this place in a fashion suited to the grandness of his state.

The architect Bramante was called upon to design a new choir, in the form of a resplendent cube crowned by a dome. He extended the perimeter of the building to incorporate a refectory for the benefit of the Dominican monks who lived there. This was a gesture of benevolence the Duke made clear.

It was given to me to decorate the back wall of this refectory which faces all who enter. Because of the very nature of this place as a room where the monks spent time each evening eating, it seemed a most natural choice of subject to paint the Last Supper.

I was greatly excited by the prospect. Here was an opportunity to demonstrate the powers of perspective which draw a spectator into the world created by the painter. Here was a subject wherein I could portray the range of emotions of thirteen men good and true save one. How shall he be? And how shall I portray the divinity given to one only? How shall He be? How shall I incorporate in the one man all the evil that we

share and in the other all the suffering and the forgiveness that He alone displays?

For that was my intention. My painting would be so real as to be a part of the room itself. An extension so convincing as to make the monks experience each evening that most extraordinary sensation of eating in the very presence of their Lord.

Each evening they would be reminded of their own frailty, the reality of their world and the other world to which they aspire as disciples of the Son of God. But who *shall* He be? Who would possess such a face to display such a goodness from within?

Where must I search for a Judas whose evil is the very baseness of an earthbound soul?

For the others I must only look around for they are all of us and we see ourselves in them. Our frailty is forgivable. We mean no harm though we are not innocent.

The task I set myself was filled with such challenge that I feared the very touching of the wall. At times I was overcome with desperate fear and dared not mar the whiteness there before me.

I spent much time in searching for those who would be my unwitting models. Perhaps too it was because of the fear engendered by the white wall that its power rendered me impotent before it. The image in my mind, the desperate hope of achieving something close to the vision I would wish to see there, made it impossible to begin for fear that I should fail.

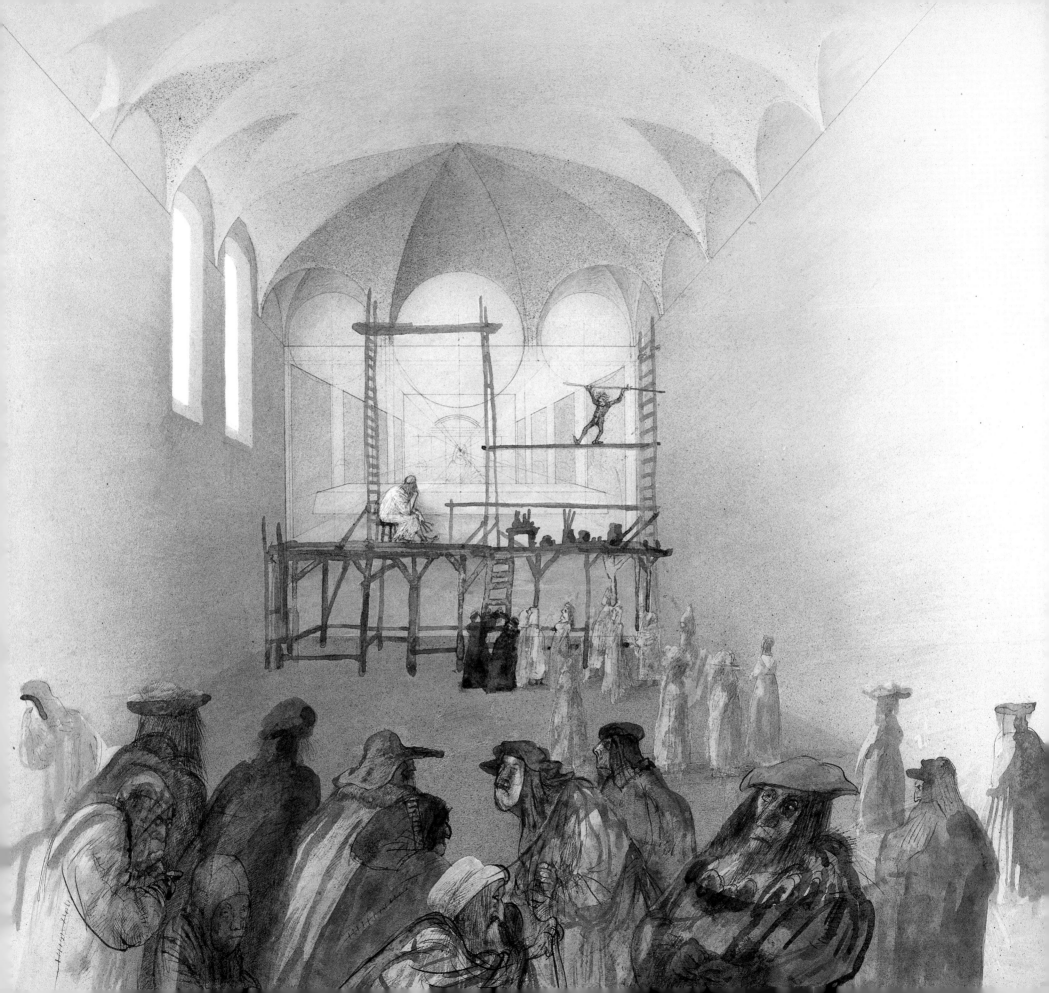

The first mark, the decision, why it should be in one particular place, will determine everything that comes after. And if it should be wrong? Can it be wrong or is it all preordained? My reason told me not but my insecurity suggested that some power greater than me willed its course, if only to reassure myself that the very subject would inspire me. I made perspective the anchor of my feelings. I felt certain that with a framework that described a space to contain my picture, I would know that within it my figures must exist. In there I must find them.

The first mark did not need to be a figure. My first mark was to be structural. The continuation of the room as though in perspective proceeding into the wall towards a vanishing point.

As the Lord himself was to be central to my theme he must also look out from my picture through his eyes, into this room, the refectory. This would complete the illusion of his presence. He can see us as we can see him.

I decided that Christ's right eye would be the point at which all things in the room converged. If I was to begin anywhere it would be at that point.

All lines radiating outwards and into the room would start at that point and so the spectator outside the painting would look upon Christ first. For Christ will have spoken at the very moment that the spectator observes the scene.

'One of you that eateth with me shall betray me.'

His words will be like a tremor passing through those assembled. The spectator will register his reaction at the very same moment and look towards the rest of the scene. He too will feel that tremor and his gaze will absorb the feelings of dismay of all those present.

All except Judas. Judas will be bathed in shadow. His response will be least in evidence but he will still sit among the others, because he will wish to hide and he will wish not to show his guilt and thus he will clutch his bag of money close to his breast. And the index finger of Christ's right hand will point to his own palm and the other three fingers, the trinity, will point towards Judas.

And all except Judas will show in their faces and the actions of their bodies that what Christ says cannot be and in so doing I will represent the motions of the mind by gestures and movements.

Thus I reasoned. The essence of my picture was to be as true to real life as it was possible for me to attain, for between us and the actual event there are mists created by the re-telling until all those present are mere shadows or mythical creatures particularly Christ and Judas, for they represent good and evil in their most extreme forms and for that reason must suffer the distortions of legend. I must depict this scene as though I were present in the room and the retina of my eye held for a brief moment all that was before it as though frozen in time.

... One who was drinking has set down his glass and turned his head toward the speaker. Another, twisting the fingers of his two hands and with brows knitted, turns to his neighbour; this neighbour spreads his hands and shows their palms, raises his shoulders to his ears, and opens his mouth in amazement. Another whispers into his neighbour's ear; the listener turns towards him to lend an ear, holding a knife in one hand and in the other the bread half cut through; another, who has turned, holding a knife in his hand, upsets with his hand a glass on the table. Another rests his hands on the table and watches; another blows out his cheeks, another bends forward to see the speaker, shading his eyes with his hand; another draws back behind the one who leans forward and sees the speaker between the wall and the man who is leaning ...

Between these notes and the final result comes the process of painting. Consequently the two are rarely the same.

It seemed that my fame had spread far and wide and the painting of the Last Supper became a spectacle for all to witness when they would.

Those who came stood for long periods behind me and observed what I was doing as though I was a juggler about to drop a club.

We are, with minstrels and tumblers, objects of admiration or derision depending on our performances; although I think I fared better than most because of what was emerging from the flatness of the wall.

I too impressed myself and found that what I strived for returned my efforts with surprise.

An unexpected effect, a hidden expression once revealed filled me with joy and helped me to continue.

I listened to all comments from those who passed before my wall and pondered, how the painter ought to be desirous of hearing every man's opinion as to the progress of his work.

Surely when a man is painting a picture he ought not to refuse to listen for we know very well that though a man may not be a painter he may have a true conception of the form of another man, and can judge aright whether he is hump-backed or has one shoulder high or low, or whether he has a large mouth or nose or other defects.

Since then we recognise that men are able to form a true judgment as to the works of nature, how much the more does it behove us to admit that they are able to judge our faults.

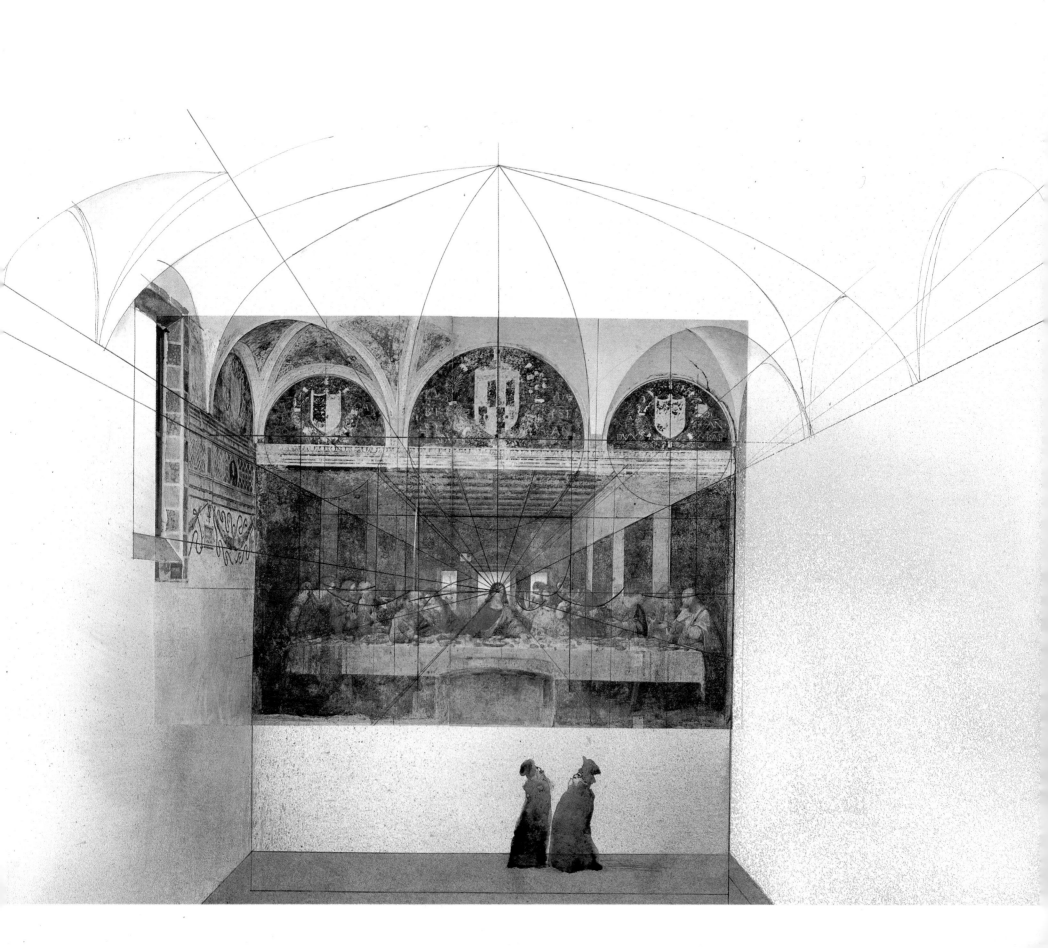

I engaged the help of my students and instructed them in the mixing of colours for the work. I did not feel at ease with the process of fresco painting which is the application of colour pigment mixed with yolk of egg directly on to wet plaster.

There is no time for reflection and I knew with this technique that it would not suit what I had in mind. I needed time to help a face to emerge with all its subtle strains and uncertain movement or I would lose my way and settle for a mask.

I devised a method peculiar to myself. To counteract the dampness which seems to lie for ever present in the walls I applied to the roughened surface a mixture of pitch and mastic which I believed would resist the scourge which damp provokes. I coated then the surface of the wall in gesso grosso – a mixture of chalk and size to form a crude foundation for the work. A second coat of gesso sottile – a finer mixture of slaked plaster of Paris and size.

The surface then was a pleasure just to feel. I smoothed my hands across it in the tenderest fashion imagining that I was touching flesh itself.

My pigments were all earth colours, oxides and the like and so that I might lighten all without destroying brilliance with a creamy bloom, my white was made from lead and gave me such a silver hue it was a wonder just to mix.

My students watched intently and I knew that this they all would learn – except perhaps Salai. It is a craftsman's skill born of knowledge passed from one to another and nothing else, but the painter who draws by practice and judgment of the eye without the use of reason is like a mirror that reproduces within itself all the objects which are set opposite to it without knowledge of the same.

The painting was another matter and I could only proceed and hope that what they saw would help them to aspire beyond the usual, for many things lie dormant within the minds of men and only await the signal from outside. But I digress.

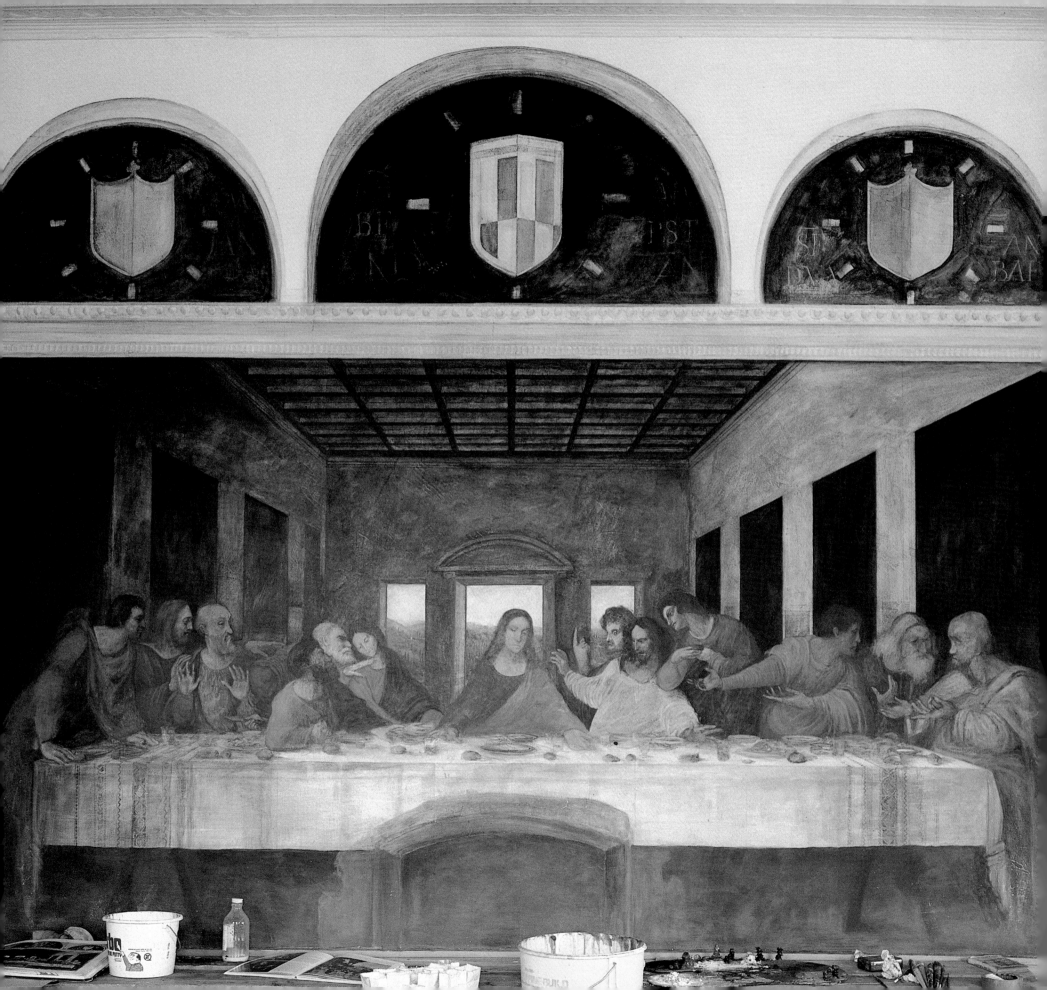

Behind all my intentions to paint, as I have said, an actuality –
a true scene of human emotion and response – I came to depend
on a geometric construction that would keep my work on course.

The austere beauty of my friend Bramante's architecture allowed
my mind to accept a composition of such simple lines that all the
power of expression would reside within the figures alone and let
the surrounds describe the space that they enclosed.

The walls inside the painting became as fundamental as the very
ones which were the place itself.

I talked at length to Luca Pacioli, a mathematical professor in
the employ of my patron. He was a monk and a man who
watched me work and he became my friend. He too was full of
interest in the wonders of geometry and I found answers to the
problems I was posed within the Last Supper.

I did help him in return and found great satisfaction in the
expression of his ideas. He was at pains to write a book describing
things that I too held in high regard – that proportion is divine
and part of everything we see in nature.

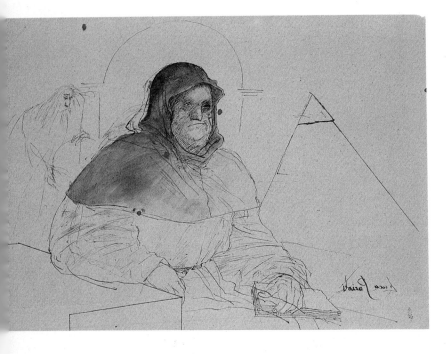

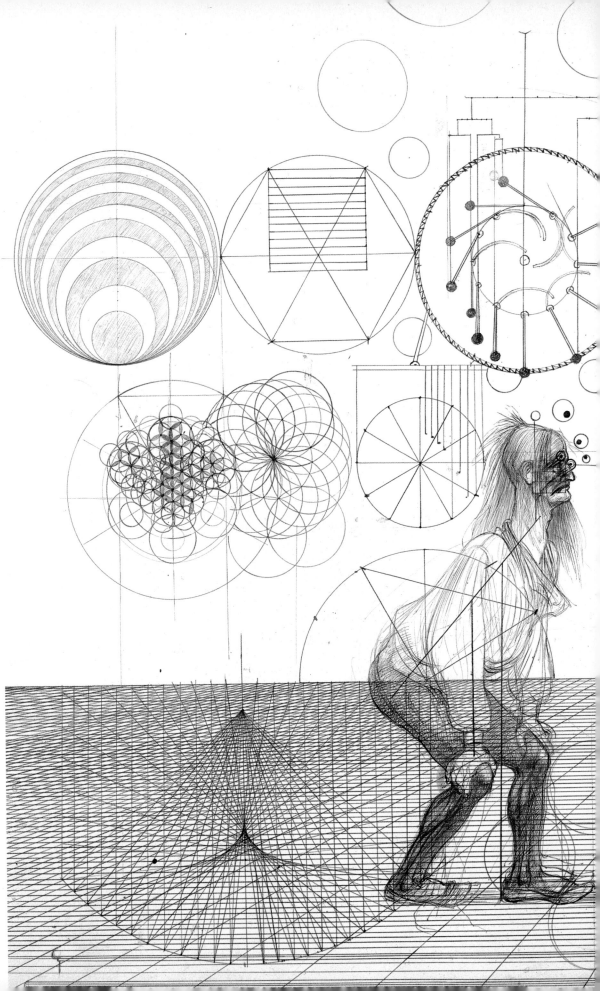

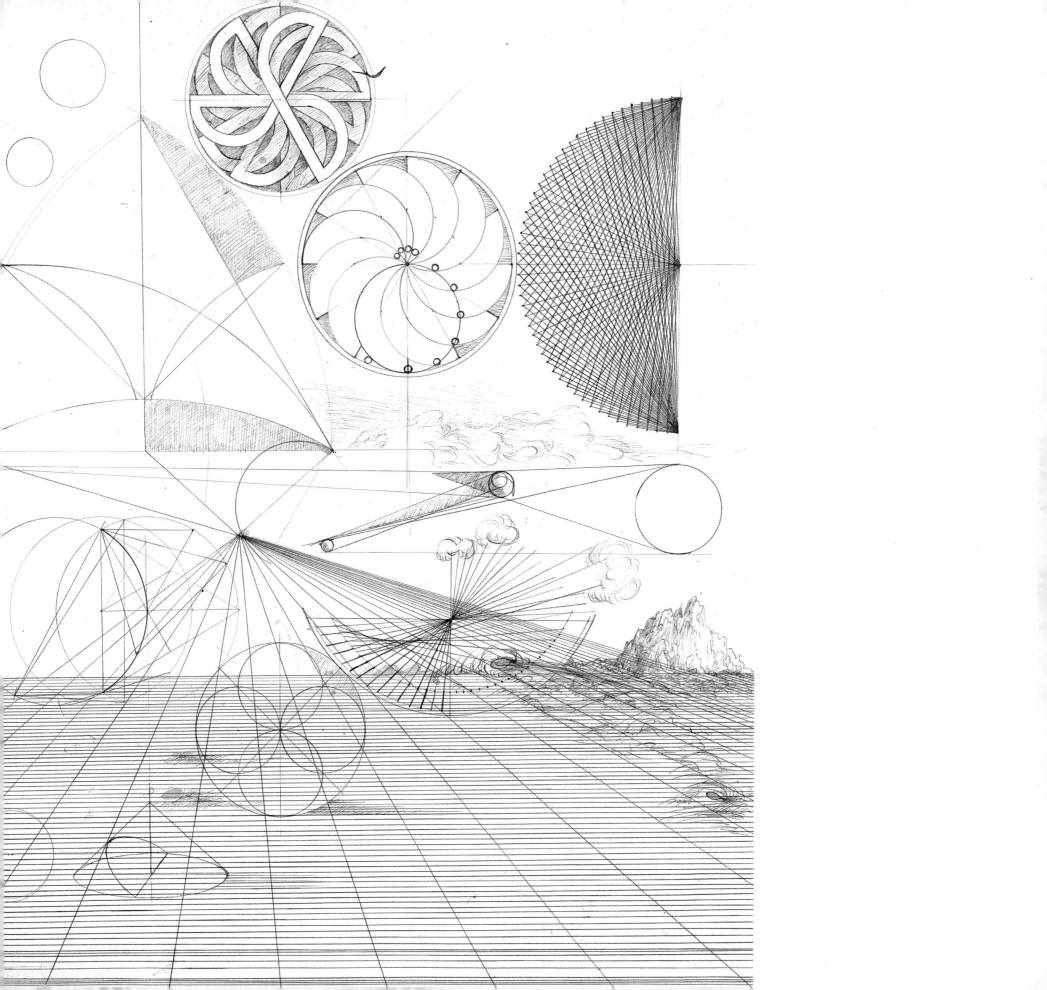

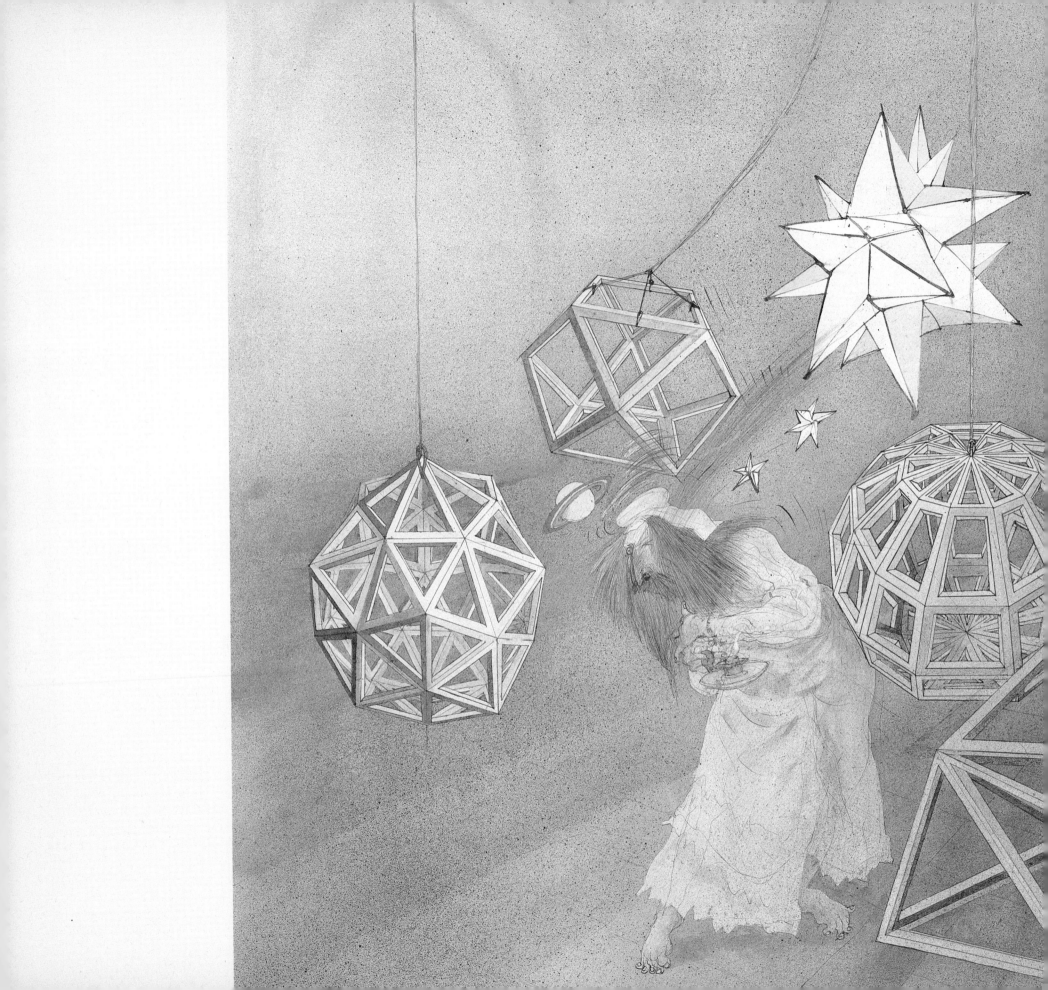

He gave me much and I in turn drew for him such wondrous shapes as geometry can describe. They thrilled my mind till I became intoxicated.

We talked of things too as fools would talk of making gold. To devise a wheel that moved upon its own once started and would move for ever. I doubted it was possible but as with all in curious minds one cannot help but try.

Moreover you might set yourself to prove that by equipping such a wheel with many balances, every part however small which turned over as the result of percussion would suddenly cause another balance to fall, and by this the wheel would turn in perpetual movement. But by this too you would be deceiving yourself; for as there are these twelve pieces and only one moves to the percussion, and by this percussion the wheel may make such a movement as may be one twentieth part of its circle, if then you give it twenty-four balances, the weight would be doubled and the proportion of the percussion of the descending weight diminished by half, and by this the half of the movement would be lessened; consequently if the first was one twentieth of the circle this second would be one fortieth, and it would always go in proportion, continuing to infinity. But I digress . . .

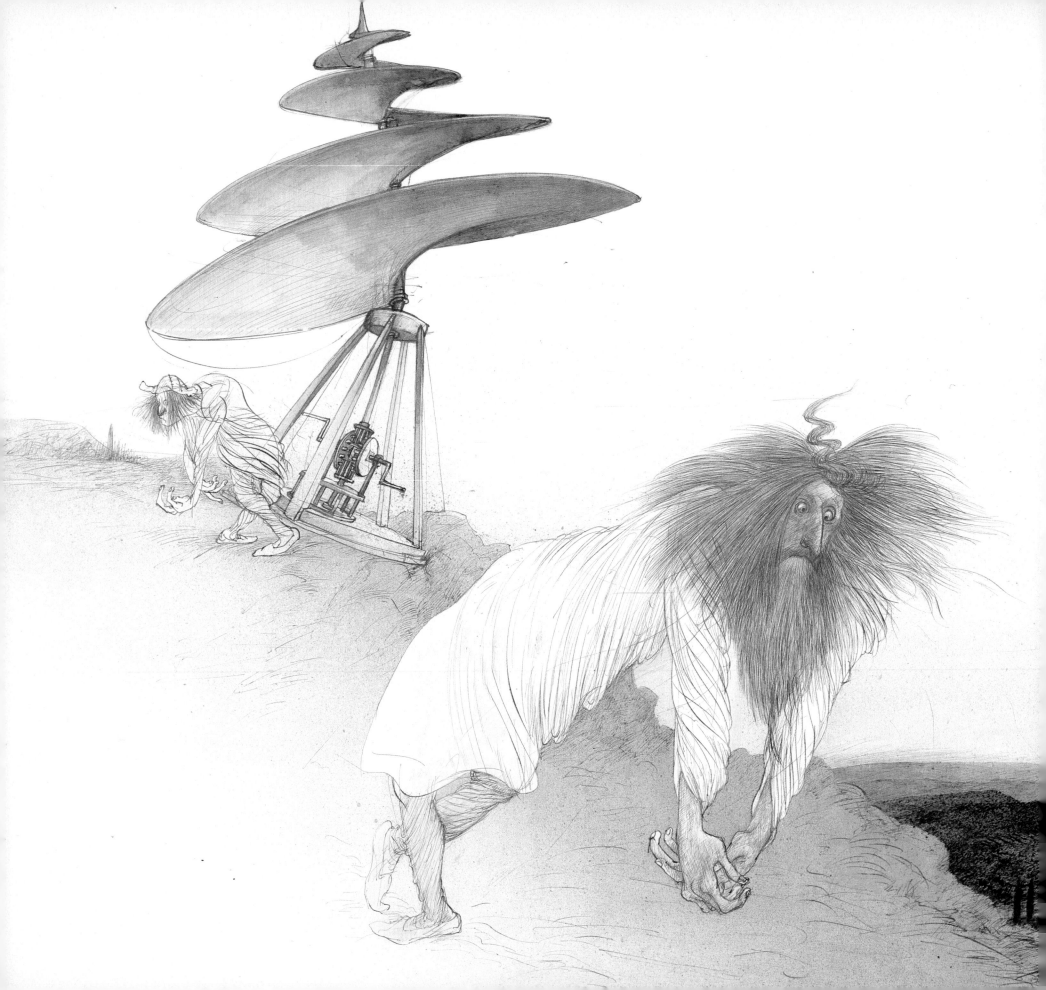

I did not doubt however that as a fish can swim and a bird can fly, so might man and this I repeat must one day come to pass. I found that when I spun around and held a ruler at arm's length the air which struck the ruler would lift its leading edge upward in the direction which my arm was moving on its axis, my body.

In this way I thought that it was also possible to construct a screw which would lift itself up into the air as it revolved.

Its puzzle was not that such a thing would work for yes it would – but how to hold the framework for the flyer and the mechanism underneath.

I could not determine a solution, for it always seemed to have a strong desire to revolve the other way against my wishes.

My work on the Last Supper inside the refectory took all of four years and much had happened in Milan before it was done.

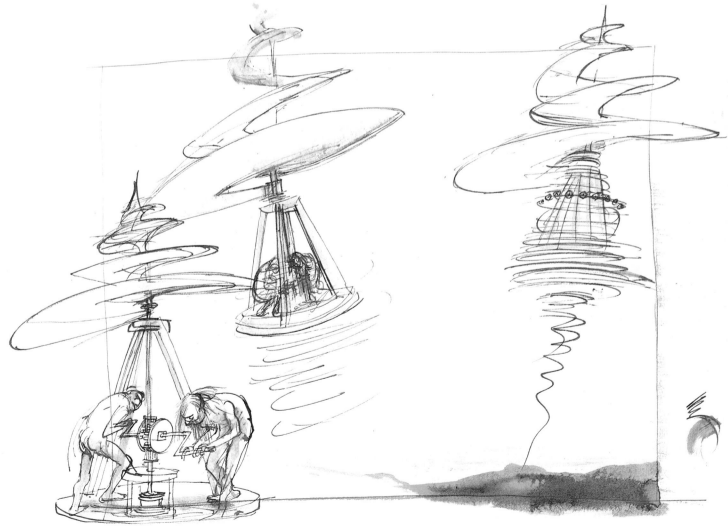

Giovanni Boltraffio who showed a promise beyond his years in the catching of a likeness, and in the understanding of the things that I had taught him.

Besides, I still dreamed to cast my great horse which stood inside the Corte Vecchio these past four years and nothing but decay became of it.

And Lodovico was as unpredictable as he was grief-stricken and went through alternating bouts of desperation and high spirits and then at such a moment paid me handsomely and gave me vineyards which I gratefully received, but there was nothing for the horse.

We went on expeditions throughout his lands to ensure that all was as it should be.

I perceived that many who would wield a torch of power can never rest unless they see it all before them, each tiny particle of earth within their kingdom must be inspected so that they shall know exactly what is theirs.

I took to wandering while on these trips and found myself a stranger in a town near Pavia.

As you may know you think that you are not lost until it comes about that you desire to leave.

I was pursued by women of the street who knew nothing of my dislike of their aims and so persistence on their part led me to their evil nest.

I was appalled by what I saw. It seemed to me that passion was the last thing welcomed here.

Embarrassment was no respecting friend as those of high rank met the dregs of common man upon the stair.

It was no way to conduct a business even of the mildest form, besides one such as this, and so I devised a worthy plan of corridors and separate doors whereby no one whether wretch or king should suffer unexpected stress upon his indiscretions.

My patron had been plunged into misery by the death of his beloved daughter Bianca and as though that were not enough, fate had in store a further blow when Beatrice who was heavy with child and into her eighth month expired and I believe this drove him near to insanity.

I had myself been touched by grief, for someone whom I knew in early life as Caterina my mother came to visit me in Milan on July 16th, 1493. I knew her only as a stranger and it shocked me thus to realise who she was. I bade her welcome and I treated her as an honoured guest.

I sensed that life had not been kind but she had borne it with good heart.

We have no means of judging those who wrong us with no wilfulness on their part. She fell ill within our house and died. I gave her all that I could offer now — as big a funeral as I might manage — and I sent her on her way to be in peace.

Now Lodovico urged me to complete my Last Supper for I think he had in mind new works on all the other walls. A Crucifixion by Donato Montorfano had been painted opposite my work at the other end of the refectory but it seems that this was not approved by all.

My patron required that I should paint his portrait and portraits of Beatrice and their two sons within this Crucifixion. I had no heart for more just yet.

To begin anew on other things while waiting for my due for previous work was more than I could countenance. And to work it into another's painting was in no way to my taste. I made feeble intimations as though to start and entrusted the beginnings of such a task to my student

Bordello design.

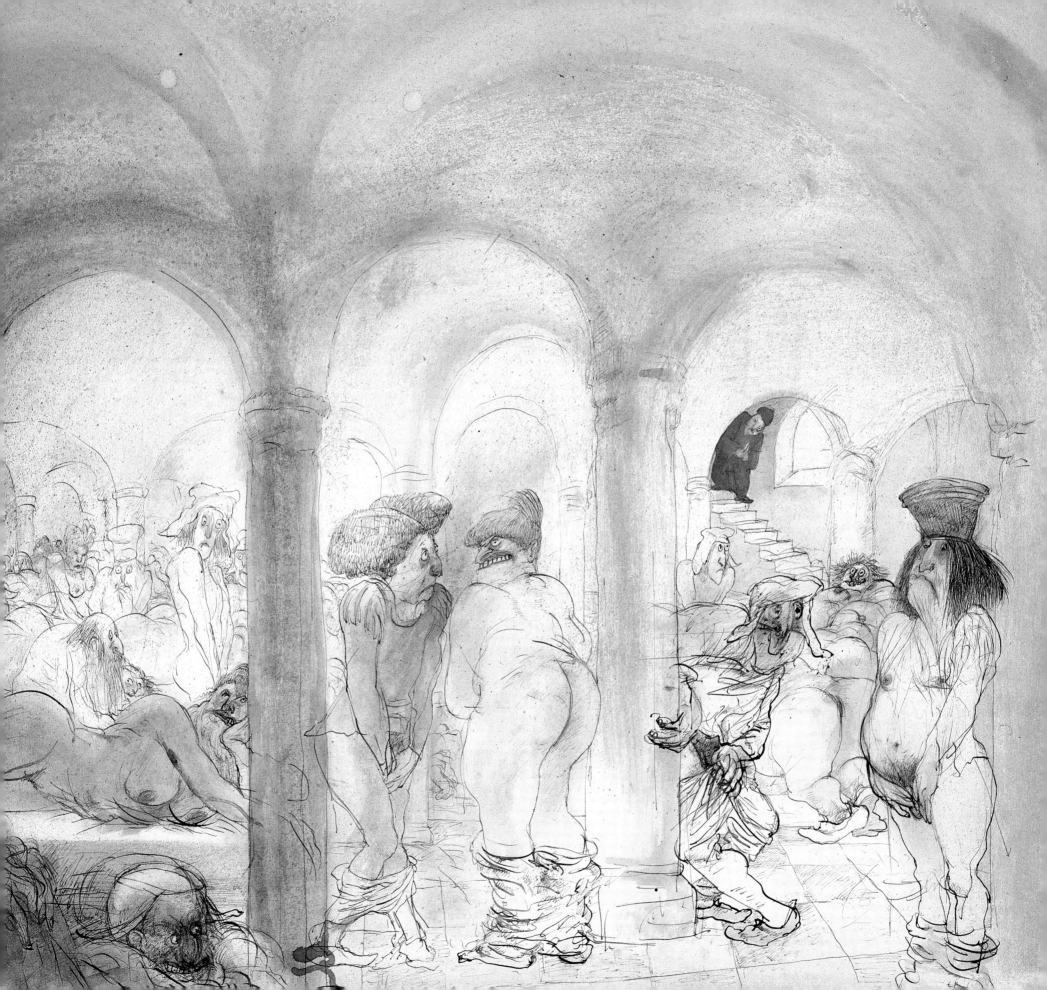

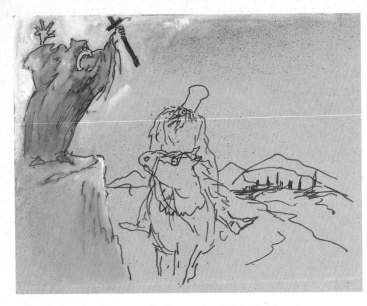

While I had been wholly occupied in Milan Lorenzo de' Medici passed on and my native town of Florence in turmoil fell into the grip of Fra Girolamo Savonarola, a monk of fearful ideas and such moral indignation as struck terror into all who listened to his words.

He would engage the help of children and bend their tender minds to his will in order that they might press upon their guardians and elders to cast off and burn all their worldly vanities, their ornaments and paintings, scents and mirrors, veils and false hair; their lutes and harps, chessboards, books and playing cards. All, in fact, which forms the fabric of our worldly endeavours.

I knew of him from an earlier time and know for sure that he was not a saint – and nor indeed is any man.

The vanity I think is with the man himself and he with necromancers, charlatans and the rest.

But of all human discourses that must be considered as most foolish which affirms a belief in necromancy, which is the sister of alchemy, the producer of simple and natural things, but is so much the more worthy of blame than alchemy, because it never gives birth to anything whatever except to things like itself, that is to say lies. This necromancy, an ensign or flying banner, blown by the wind, is the guide of the foolish multitude, which is a continual witness by its clamour to the limitless effects of such an art. And they have filled whole books in affirming that enchantments and spirits can work and speak without tongues, and can carry the heaviest weights, and bring tempests and rain, and that men can be changed into cats and wolves and other beasts, although those first become beasts who affirm such things.

And undoubtedly if this necromancy did exist, as is believed by shallow minds, there is nothing on earth that would have so much power either to harm or to benefit man; if it were true, that is, that by such an art one had the power to disturb the tranquil clearness of the air, and transform it into the hue of night, to create coruscations and tempests with dreadful thunder-claps and lightning-flashes rushing through the darkness, and with impetuous storms to overthrow high buildings and uproot forests, and with these to encounter armies and break and overthrow them, and – more important even than this – to make the devastating tempests, and thereby rob the husbandmen of the reward of their labours. For what method of warfare can there be which can inflict such damage upon the enemy as the exercise of the power to deprive him of his crops? What naval combat could there be which should compare with that which he would wage who has command of the winds and can create ruinous tempests that could submerge every fleet whatsoever? In truth, whoever has control of such irresistible forces will be lord over all nations, and no human skill will be able to resist his destructive power.

We have therefore ascertained in part the mischief and the usefulness that belong to such an art if it is real; and if it is real why has it not remained among men who desire so much, not having regard to any deity, merely because there are an infinite number of persons who in order to gratify one of their appetites would destroy God and the whole universe? But I digress.

The fire Fra Girolamo made to take all the possessions of the Florentines and purify the souls of all his followers took several things of mine, I do believe, and also, so Boltraffio tells me, my Leda and the Swan – a painting. But then the fire took him, finally, though I do not rejoice in that. I would not exchange the life of any man for something made by man.

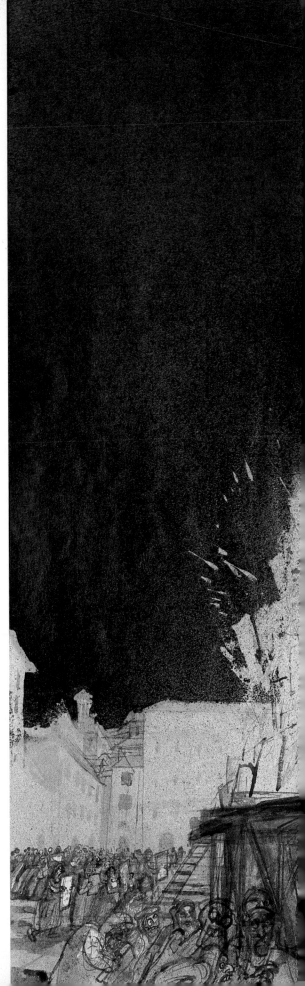

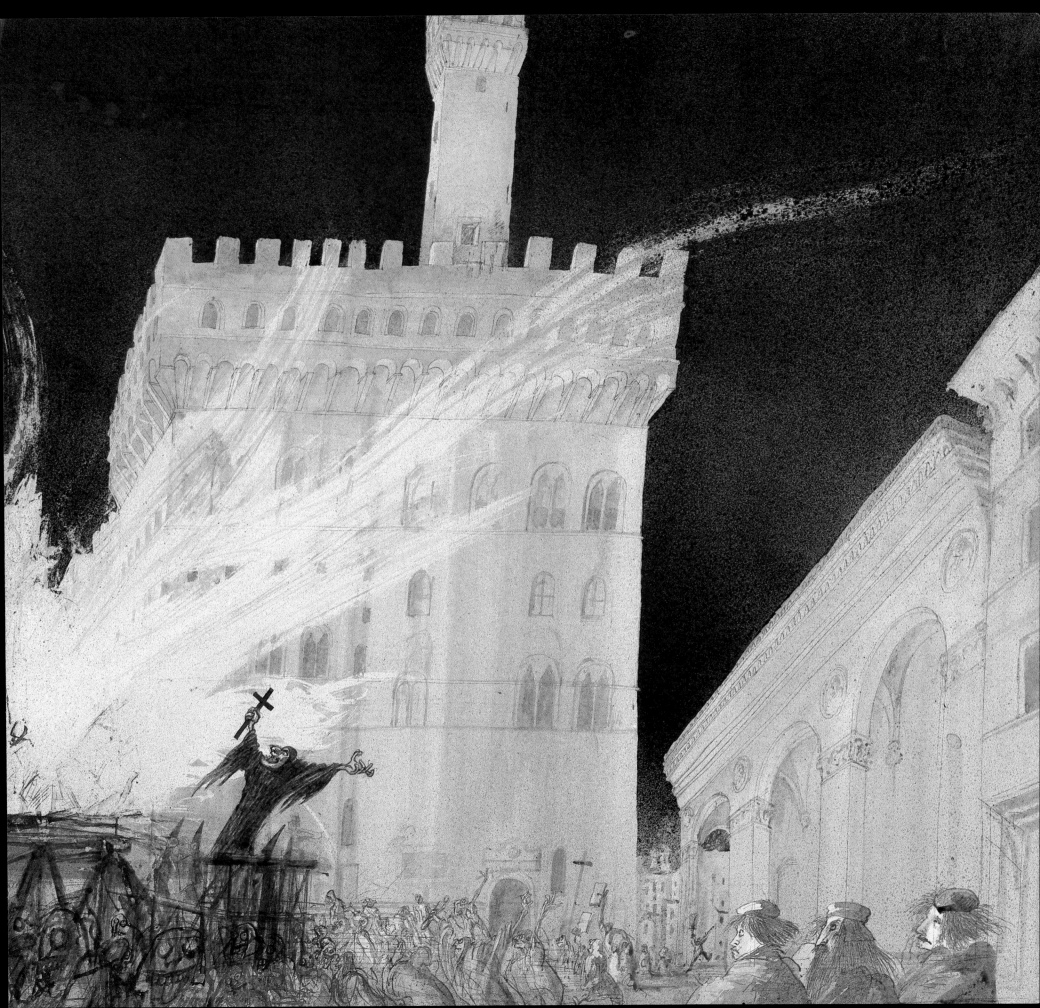

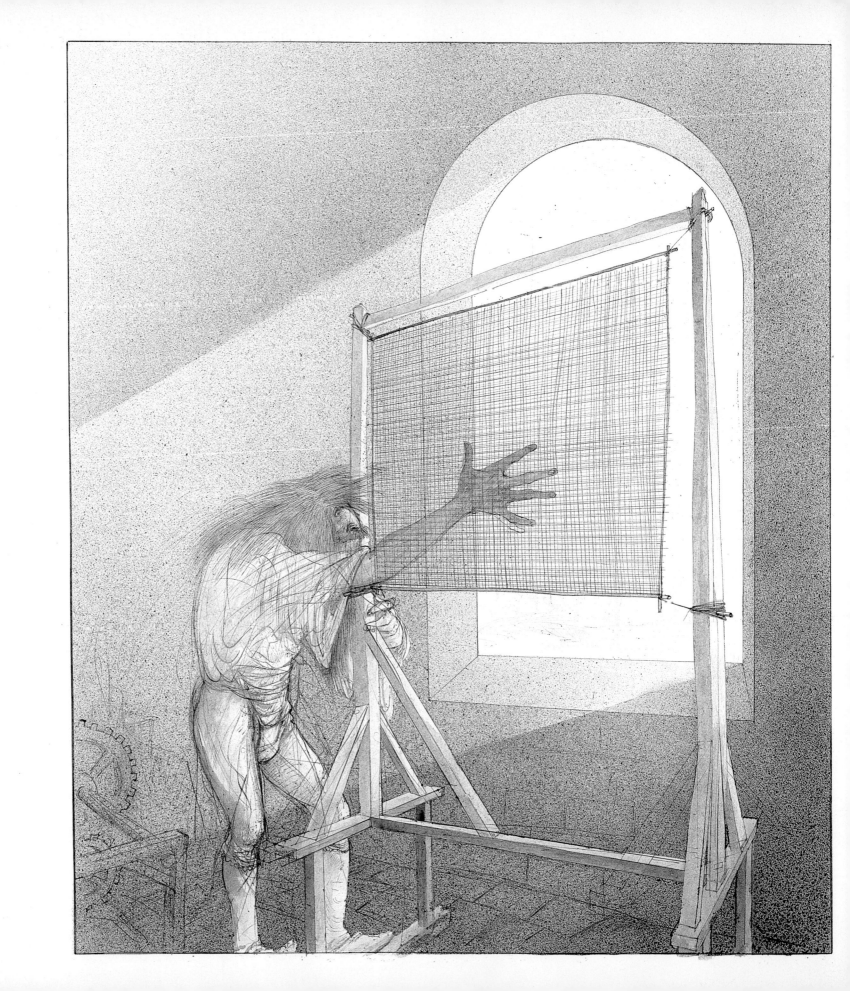

Milan itself was not without its political eruptions and my patron Lodovico Il Moro, of the House of Sforza, Duke of Milan, was swept away by French invasion, a fact I could have borne more philosophically had Gascon archers not used the modelled horse, my own Colossus, as a target for their bows.

It was time to go and with my friend Luca Pacioli and Salai and Zoroastro and Maturina, I sought refuge with a noble lady Isabella d'Este of Mantua on our way to Florence. She had been a patron to many artists and was well respected though her persistent pleading to have me paint her portrait had at times irked my spirit and now I tried in vain to please her for she had set a place aside where I could work.

But I did nothing to please this lady save a portrait drawing to serve for working from, which found no favour with her husband,* but I promised to pursue the problem further. I spent much time engrossed in experiment. There was such light in Mantua, a pure softened luminous glow, and I became aware of something strange upon the feathers of a bird. For if I held one up towards the sun it seemed as though I saw instead of whiteness, colours of a rainbow and yet upon another look they seemed to disappear and reappear between the fineness of the feathers' tracery.

I made a screen of finest wires to form a mesh to hold up to the light and there I saw before my eyes upon the edges of the wires the colours of a rainbow with the white light of the sun piercing through each middle.

The colours of the rainbow are not created by the sun, because in many ways these colours are produced without the sun, as happens when you hold up a glass of water close to the eye, for in the glass there are the tiny bubbles which are usually seen in glass that is imperfectly refined. And these bubbles although they are not in sunlight will produce on one side all the colours of the rainbow; and this you will see if you place the glass between the atmosphere and your eye in such a way that it shall be in contact with the eye, the glass having one side exposed to the light of the atmosphere, and on the other the shadow of the wall on the right or left side of the window, which side does not matter. So by turning this glass round you will see the colours round about these bubbles in the glass.

Moreover on the surface of ancient glass found buried, and in the roots of radishes which have been kept a long time at the bottom of wells or other stagnant water, we see that each of these roots is surrounded by a sequence of colours like those of the rainbow. It is seen when some oily substance has spread on the top of water . . . That oil and water do not mix is accepted by us all but do they not produce a wondrous rainbow just the same? Were it so with people.

We journeyed back to Florence through Venice. It seemed my fame as engineer had gone before me – I suspected that Luca Pacioli, my mathematician friend, had spoken of me and I was belaboured with requests for help from the Venetian government in the design and construction of fortresses and bombards for defence against the Turks and possible ways of damming the Isonzo river at Friuli by making sluice gates to open and close at will to flood the plains along its banks and thus frustrate their foes. I devised a system whereby a man could breathe under water and advance upon an enemy unseen. I suggested too a submersible machine. Both would enable a man to hole ships of any size and thus prevent them forming an attack. Such an idea was received with no small measure of surprise and disbelief. In some ways I was relieved for many would have drowned from such an action by reason of the evil nature of man.

We took our leave and by the spring of 1500 we were back in the city of my youth where much had happened in my absence and the name of Michelangelo was upon the lips of everyone. All the friends I knew had left or died. My old beloved teacher Verrocchio was dead but left behind him works of greatness cherishing his memory. So too was Pollaiuolo dead and so was Ghirlandaio.

I sought my father's house in the Via Ghibellina and found to my dismay that he had lost a third wife and had taken a fourth who had blessed him with five new children in as many years and was yet again heavy with child. He seemed careless both in the losing of wives and in the gaining of children.

I was amazed and knew there was no room for bed in that place.

And Salai too tugging at me in his insolence confirmed my plan to go. Although I had savings I sought work for our immediate needs and chanced to meet the monks of the Servite Order through an artist Filippino Lippi who was engaged for an altarpiece.

He pleaded with the monks that I instead should do the work and retired elsewhere.

I was given rooms inside this wondrous haven – a peaceful place where I might immerse myself in studies and have lodgings for my entourage besides.

I suggested a subject for the altarpiece based on a cartoon I had begun in Milan devised upon a triangulated form.† It pleased the monks well and thus they left me alone again to follow my own way, though I did finish the design which all of Florence seemed to come and see.

I was without a mind for painting and its like at all. All I had done before had come to nought and even the Last Supper had suffered damage from some flood upon the marshland where the monastery stood for which my painting method had no sound resistance. I was humiliated. It seemed it was my fate to work as though my efforts were but sand upon a shore. And Louis XII as conqueror of Milan on seeing it demanded, as only kings can do, if it were possible to take it from the wall and move it all to France!

* Francesco Gonzaga

† 'The Virgin and Child with St Anne and St John the Baptist'

I recommenced my studies in anatomy and spent strange nights among the dead. Discretion was imperative as many would seek redress against those who violated the human body in any way after death. They would not know of my higher motives in my quest to reveal to men the origin of their being. It mattered not how men were treated during their lifetime and some were cruelly treated but when they are gone there is no more man can do to fellow man and only then they show respect.*

It puzzled me that sometimes such a man who looked quite healthy died with unexpected suddenness and he was only thirty. And so I came to look again at someone else wizened and as bent and broken as a willow who continued to survive in spite of all reason.

I took to visiting the wards which were administered by good monks. And so it was I chanced upon an old man, a very old man, a man who claimed he was one hundred years of age. I observed the structure of his bones which were nigh upon the surface of his skin.

Upon the strike of ten hours of that day I sat by his bedside. He sat up in bed as though he saw something ahead, and as if with some delight, he reached forward with his whole body, opened his mouth to speak and then fell backwards on his pillow, and without making another movement or any sign that aught was amiss, passed away

* Excommunication was the fear which prevented many from attempting dissection. Boniface VIII had issued an order in 1300 to stop the practice of boiling the bones of Crusaders so that they might be transported more conveniently for burial at home. As with all religious matters this order was interpreted too literally. Anatomists accepted it as absolute authority against dissection and some took it as a warning as to what effect ignoring it would have upon resurrection.

from this life. I was strangely puzzled by so gentle a death.

I took my cutting tools and when they had taken his body down to the mortuary I did follow and upon request I was allowed to dissect. I realised that I had come to know this man as a person, but it did seem that he would give me blessing to pursue my work and so I set about to cut him up and draw each piece as I did find it.

As I laboured, so I did bethink me of others who declined this form of study. For if a person should have a love for such work, he might yet be deterred by loathing, or if this did not sufficiently deter him, he might be restrained by the fear of living through the night hours in the company of these corpses, quartered and flayed and horrible to behold. And if this does not deter him, he then may lack the ability to make good drawings essential for such presentation, and even if he possesses the ability to draw, it might not be combined with a knowledge of perspective, and if it were so, he might not understand the methods of geometrical demonstration or the method of estimating the forces and strength of muscles; patience also may be wanting, so that he will lack perseverance.

I found the old man's death to have proceeded from weakness through failure of blood and of the artery that feeds the heart and the other lower members, which I discovered to be very parched and shrunk and withered; and the result of this examination I wrote down with great ease, for the body was devoid of either fat or moisture, and these form the chief hindrance to the knowledge of its parts.

The old who enjoy good health die through lack of sustenance. And this is brought about by the passage to the mesaraic veins; and the process continues until it affects the capillary veins, which are the first to close up altogether; and from this it comes to pass that the old dread the cold more than the young, and that those who are very old have their skin the colour of wood or of dried chestnut, because this skin is almost completely deprived of sustenance.

And this network of veins acts in man as in oranges, in which the peel becomes denser and the pulp diminishes the more they become old.

I returned each night to work but then had to stop finally with the onset of putrefaction. I could not sustain such interest upon my own bodily discomforts and gave his remains to be interred. I did a drawing that would suit as memory of this man, to honour him in this life and wish him well in what life he might have to come thereafter.

My return to Florence did find me consulted on such matters as sliding foundations of stricken churches and drawings of villas for private vanity. The people here were changed. I thought that even Savonarola was more desirable in his way than this, as though the very tidal wave of aspiration had sunk back into the sea of dark from which it came, without a trace.

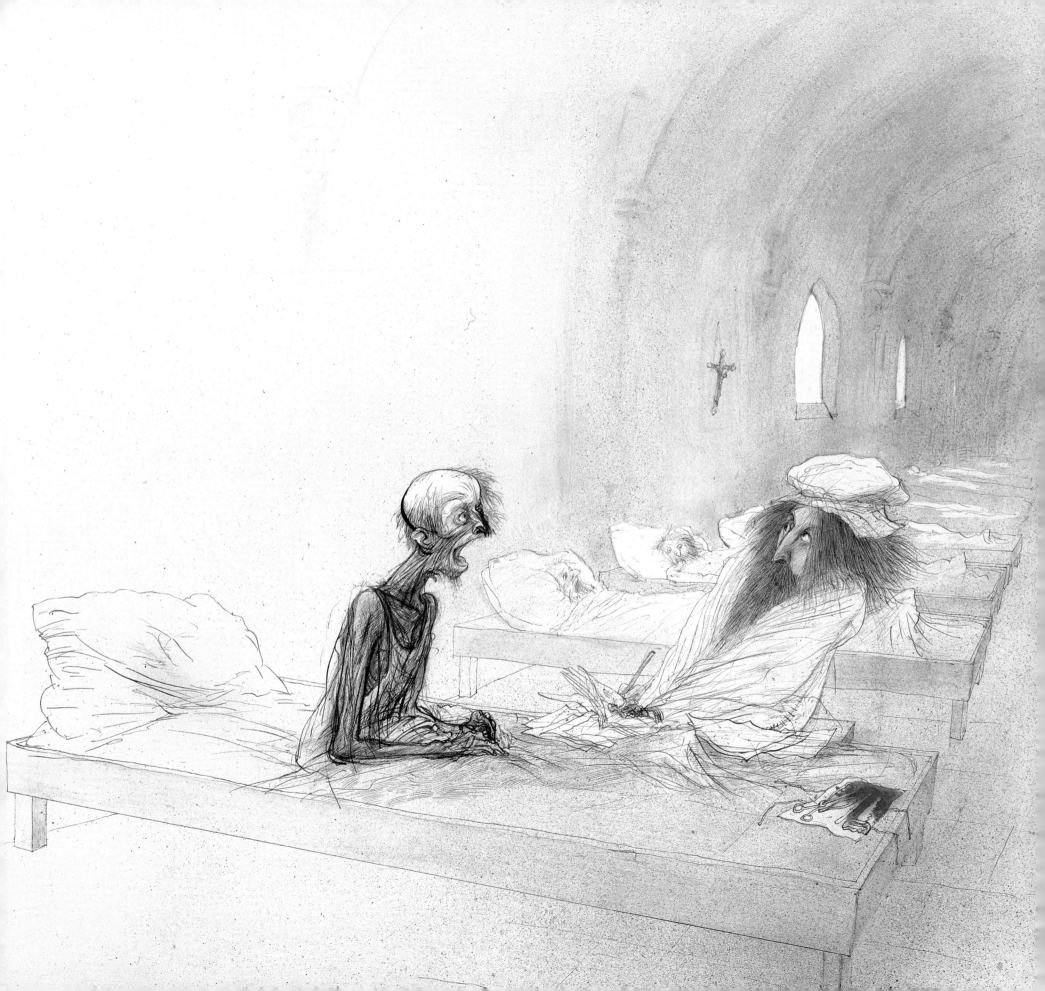

The city was now ruled by a Gonfaloniere called Piero Soderini.* He ruled without inspiration, but steadily if that is anything. I felt no urge to work on those things that most men expected of me. I was restless.

I heard the name of Michelangelo again. I think perhaps he baulked at things that I have said concerning painting and its comparison with sculpture. That sculpture is less intellectual than painting and lacks many of its natural parts.

In the first place, sculpture is dependent on certain lights, namely those from above, while a picture carries everywhere within it its own light and shade; light and shade therefore are essential to sculpture.

The effects of aerial perspective are outside the scope of sculptors' work. This perspective is the difference in the atmosphere one is able to distinguish by the various distances of different buildings when their bases appear to end on a single line. If in painting you wish to make one seem farther away than another you must make the atmosphere somewhat heavy. In an atmosphere of uniform density the most distant things seen through it, such as the mountains, in consequence of the great quantity of atmosphere which is between your eye and them, will appear blue. Therefore you should make the building which is nearest of its natural colour, and that which is more distant make less defined and bluer. But there is none of this in sculpture.

The one advantage which sculpture has is that of offering greater resistance to time.

Sculpture reveals what it is with little effort; painting seems a thing miraculous, making things intangible appear tangible, presenting in relief things which are flat, in distance things near at hand.

Painting is adorned with infinite possibilities of which sculpture can make no use ... But I digress.

And so perhaps Michelangelo had cause for bitterness, though he had yet to prove himself as painter and I had neither need for proof of excellence in either pursuit, only disappointment, for I never achieved what I set out to do as fully as it filled my mind.

I had been going daily to the market place observing all the bustle that a gathering inspires.

It became a habit to buy a bird inside a cage and let it free so that I might observe its flight away from me with joy. I noted the smiles on the faces of those who watched. I wondered if they thought I did not know the bird that I released had only been recaptured after I had let it loose before. But such is ever the way with those who take me for a fool.

All birds which fly in spurts rise to a height by beating their wings; and during their descent they rest themselves, for while descending they do not beat their wings. Therefore an object exerts the same force against the air as the air against the object. As it propels a well-laden ship forwards so it will lift the wings attached to the arms of a man and if they be so constructed as to give him control enough to manoeuvre himself he will fly freely. We can at least attempt to fall gently as a leaf falls from a tree.

I devised a simple flying harness whereby myself or someone who might fit the harness willingly would soar out from some eminence.

I chose a day to journey out of Florence to a high place near Fiesole called Mount Ceceri.† Zoroastro accompanied me, for his desire to fly was sometimes stronger than my own. The climb was a day's journey and harder as it got higher. The higher the mountain, the rockier the surface and we struggled with our burden. By nightfall we were near the top and were constrained to rest until the morrow.

I thought with irony of the weight that we had carried that could maybe have carried one of us with ease to soar out over the wide horizon that was bathed in evening's golden mist as summer's day gave way to cooler air.

We ate some fruit and simple bread made for us by dear Maturina and prepared ourselves for sleep inside the mouth of a small cave within the rocks. I was reminded of the cave I knew as a youth in Anchiano where in fear I found the bones of a huge animal – petrified and silent testimony to an older life long gone into the darkness of eternity.

I fell asleep and when I awoke the air was chill and mist hung low beneath us hiding Florence in a smooth white cushion.

I looked about for Zoroastro and found that he was gone as was the machine that we had brought to fly.

I called him but I got no answer save the echo of my call and looked above as though I thought that I would see him flying like an eagle.

My eyes searched all around and then fixed surely on a sight that made me think that I might still be dreaming.

A sturdy figure stood erect upon a cliff and looked about him with his arms outstretched and on his arms he bore the wings that caught the light of early day and displayed the framework that looked light as willow wands.

I called and as I called this bird took flight and it called back my name – 'Leonardo! I can fly!' I held my breath as it soared away into the void and man took flight before my eyes and disappeared behind the dark edge of the mountain.

I watched and waited for the sight to reappear when suddenly my gaze was diverted by the voice of Boltraffio who was climbing up the slope towards me.

* The Gonfaloniere was the spokesman of the ruling body or Signoria

† Ceceri means 'Swan'

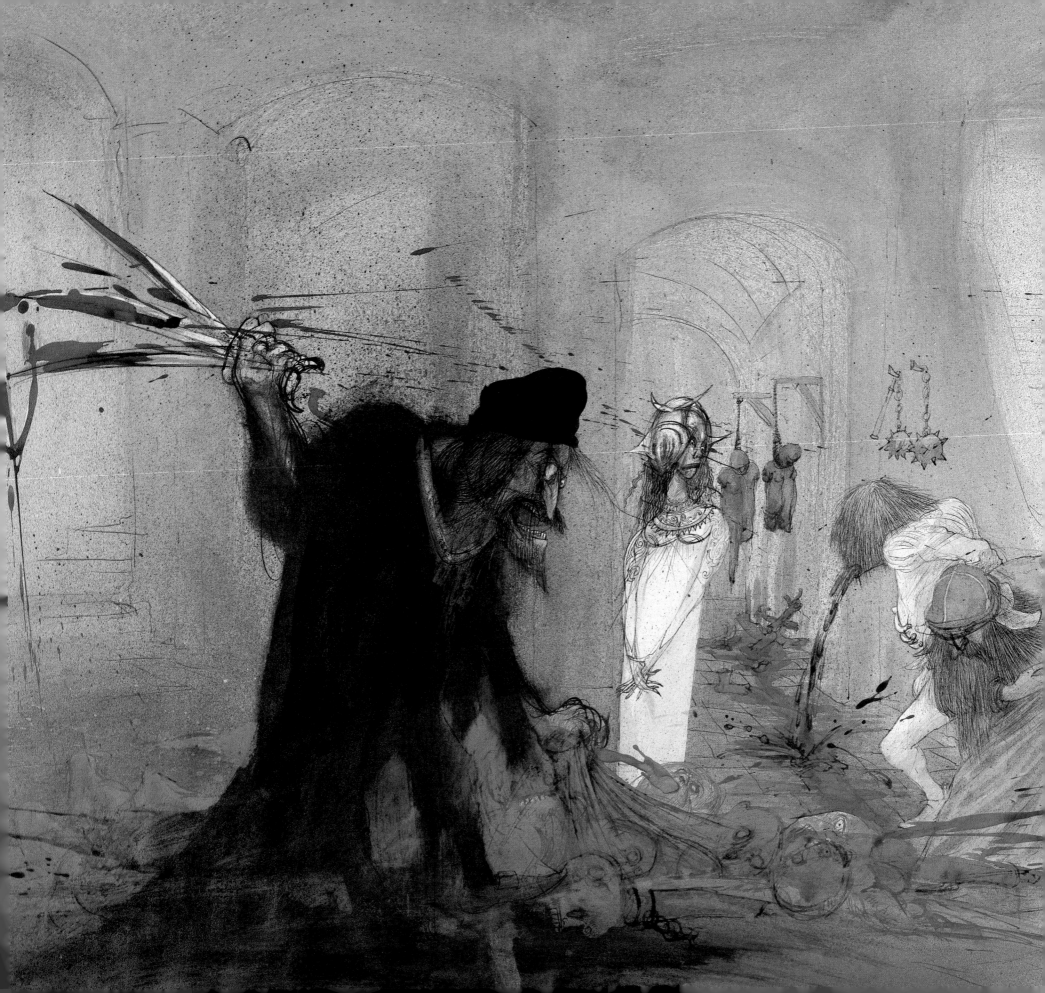

He had news that I was called to serve Cesare Borgia, the son of the Pope, whom I had met awhile at court before leaving Milan.

I was filled with exhilaration for what I had just seen and Boltraffio found me in wild spirits.

'Lead on, Giovanni, Zoroastro will follow on angel's wings and meet us back in Florence.'

Our new patron's ambitions could never rise above our own for all his desperate intent.*

What I love most cannot be desecrated by the likes of him or by bow or cannon and Tuscany would be there still when he was dust.

I was commissioned right away to travel with him as an engineer and draw him maps to chart his path around the growth of his domains, to offer him advice upon the road, to help his army to advance by water and by land and gather information that would aid in fortifying places won in battle.

In such a way I travelled well to Imola, Cesena, Faenza, Rimini, Urbino, Pesaro, Piombino and through all Romagna, the Marche and Tuscany. Cesare Borgia furnished us with all our needs and a passport fit for a king.

All I could do I did to speed his purposes. I could not teach him how to kill and neither can I teach a scorpion how to sting.

I found much to my satisfaction in the company of Niccolò Machiavelli, a Florentine adviser to my patron. This was a man of great wisdom and sometimes of great error as is given to all who have the darkness and the light of genius in their souls, where all the mountains and the plains are one landscape.

To Machiavelli, such a man as Cesare can be seen as a saint and he explained it thus: 'Till its conquest by the duke, Romagna was under the yoke of a number of petty tyrants, and full of disorder, plundering and violence. To end this state of turbulence Cesare appointed his astute and faithful servant, Don Ramiro, as his lieutenant. This man accomplished his task; he inspired the people with a salutary terror, and established perfect tranquillity throughout the country, but he did it by a long series of cruel punishments. When the prince saw that his object was gained he determined to destroy the instrument of his severity. Don Ramiro has been seized, on the grounds of extortion, and executed; his dead body lies exposed to public view. This terrible spectacle has at once gratified and awed the people. The duke's action has been wise, for he has reaped three clear advantages. First, he has slain the

tyrants; secondly, by condemning Ramiro he has disassociated himself from his lieutenant's ferocity and so has gained a character for gentleness; thirdly, by sacrificing his favourite servant he has set an example of incorruptible equity.

'In politics, the difference between the way men should and the way they do act, is so great, that to forget it means to expose yourself to certain ruin. For all men are by nature evil and vicious; they are virtuous only for advantage or through fear. A prince who would avoid ruin, must at all hazards learn the art of appearing virtuous. He must disregard all uneasiness of conscience as to those secret measures without which the preservation of power is impossible.

'. . . That a man be half god and half beast is the genius of a true leader. The question is one of saving your country – not one of betrayal or of loyalty, of good or evil or clemency or cruelty. All means are alike provided the object is gained.' So spoke Machiavelli and in his cold logic he was right when living in a world of absolutes but living in a world of men it oft appears that saving country and the like is but an act to serve the one who wishes to be God. But I digress . . .

My use to Cesare Borgia ended as abruptly as it had begun and I returned to Florence which was at this time beset with thoughts and schemes to divert the Arno river on its way to Pisa and the sea – to dry it up and so to thwart the Pisans with whom they were at war.

I devised a machine that maybe would alleviate the need for countless men to carry out the task of moving nearly half the earth of Tuscany.

Only God attempts such schemes and when he does, they are the work of moments in his fashion.

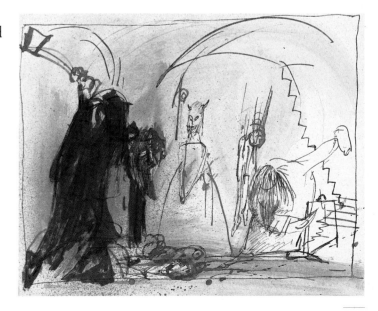

* Cesare Borgia was set upon making himself sole and absolute ruler of all Italy while ostensibly recovering for his father, Pope Alexander VI, the ancient states of the church claimed to have been conferred on the papacy by Constantine the Great.

I now had rooms amply to take my household and myself,* and set about to organise a studio and begin to paint again.

I had accepted then to do a portrait of a lady of unearthly countenance. She bore a likeness to one Isabella, wife of the ill-fated young Duke of Milan, and she I had painted some years before.

The husband of this woman begged me paint a portrait that would serve to adorn his house as though it were a piece of furniture. Such is the way that old men see their wives, as ornaments for others to admire.

I found the softness of her smile was best endowed in sombre light and I engaged to have it so that she did visit for a sitting always at the end of day.

If you have a courtyard which, when you so please, you can cover over with a linen awning, the light will then be excellent. Or when you wish to paint a portrait, paint it in bad weather, at the fall of the evening, placing the sitter with his back to one of the walls of the courtyard. Notice in the streets at the fall of the evening when it is bad weather the faces of the men and women – what grace and softness they display!

And I became enamoured of this lady for she left me with a vision and I found refuge in the work and so I

* In the Via Martelli

prolonged her sittings until she found herself of like habit and came quite readily to sit as though it were a visit to the church to kneel in prayer at just that time of day.

To entice her and to keep her contented I did hire some minstrels who could sustain the smile upon her face but mainly in her heart.

The more I painted, the more my household did remark that what they saw resembled me as well. I was perturbed because I counsel that painters who wish to give a pleasing air to their subjects should always take the best parts of many beautiful faces of which the beauty is established rather by general repute than by their own judgment. For you may readily deceive yourself by selecting such faces as bear a resemblance to your own as it would often seem such similarities please us – and if you are ugly you would not select beautiful faces, but would be creating ugly faces like many painters whose types often resemble their creator. So therefore choose the beautiful ones as I have said, and fix them in your mind. But my household assured me that the face I painted was indeed full of beauty and I must agree for I saw it with my own eyes and what I saw before me was a vision and I could no longer let it go and I dallied with the painting many years for fear the husband of this woman should think that it was finished and wrest it from me. I made excuses and found other work to do.

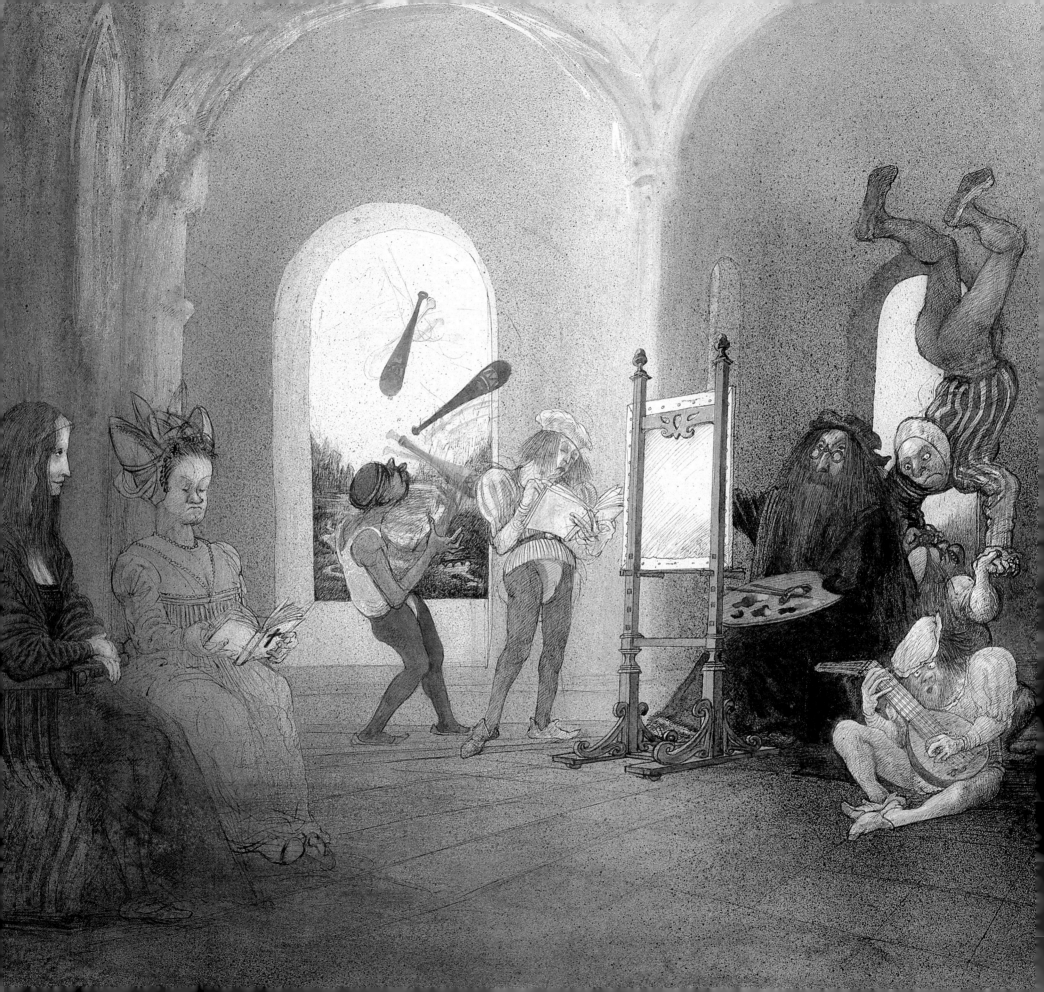

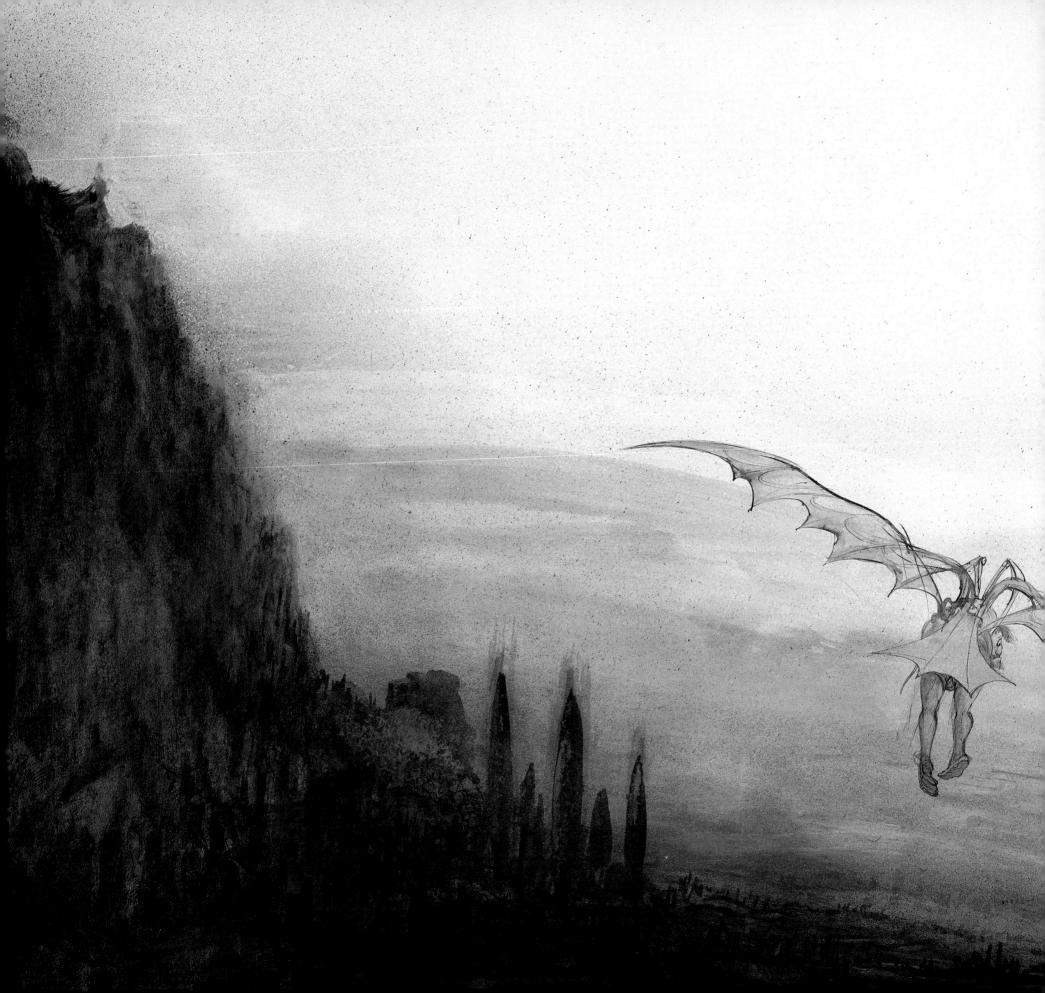

I had been still engaged in painting my Madonna Lisa and had at this time gathered all my notes on birds and flight that took my attention in a very serious manner. It was my intention to make a book and so I prepared a Treatise on Birds.

It was divided into four books; of which the first treats of their flight by beating their wings; the second of flight without beating their wings, and with the help of the wind; the third of flight in general, such as that of birds, bats, fishes, animals and insects; and the last of the mechanism of this movement.

I returned again and often to the swan mountain of Fiesole as guest of a step-uncle.* I sought his company to ease the despair that my work would be for ever named a worthless mess.

Each day I stood and looked across the plains and down on Florence and each day a great bird came to me and each day showed me just how man can fly.

Zoroastro beckoned to me soaring past and I did grasp him and together now with the strength of two men we rose beyond the tops of mountains higher than the swan to fly with eagles as I always knew we would. We became as one, a glorious bird of infinite splendour.

* Alessandro Amadori

I visited my father at this time and he was old and he had leisure now to talk. His life had been one full of steady progress and success where mine was torn with failure and loss and a lack of will to put my house in order. I was beset with requests from Isabella d'Este yet again who pressed for things for which my heart had got no feeling. Perhaps I did seek refuge in my father's house and he was not disturbed to see me. It was at this time that I drew him in a manner to record the age he had achieved and more to show the strength of life's achievements. I did also hope that it would serve as silent tribute and a bridge between us for words are sometimes empty vessels in the face of all that goes between a father and his wayward son.

I was as well engaged in making drawings that would serve as studies for a commission I had previously received from the Florentine Signoria to paint a battle on the walls of the great hall inside the Palazzo Vecchio. I believe my good friend Machiavelli had guided them to me. I worked the drawings in red chalk and thus I had about my person many pieces which came readily to hand and so I drew my father in this manner.

It seemed an act of providence for shortly after on the 9th July 1504, Wednesday, at the seventh hour, died at the Palazzo del Podesta Ser Piero da Vinci, Notary – my father. He was eighty years old; he left ten sons and two daughters.

And so in the drawing I had a memory of my father that no power of litigation could take from me – although those other children of my father, my stepbrothers and sisters, did initiate against me a fetid process, of disinheritance.

Jibes and contemptuous declarations came my way from Michelangelo. He was by now a man obsessed by confirmations of his genius. His great and wonderful sculpture of David – which declared itself a miracle – was being discussed by all the artists of Florence and myself and there was great consternation because of it.

It was for all proud Florentines a statement of political importance and one which therefore must be set upon the place that served it best but as to what that might be, no two persons were of one opinion.

I suggested that it be placed in the Loggia della Signoria on the square beside the palace. Michelangelo demanded that it should stand outside the entrance to the Cathedral on the Piazza del Duomo for all to see. He saw it in his own eyes as a symbol of religious spirit.*

I was accosted often on the subject but had nothing to reply. The painting I was now engaged upon absorbed my thoughts. It was the Battle of Anghiari in which the Florentines against heavy odds defeated the Milanese in 1440. It interested me because of one incident involving horses in a fearsome struggle for the battle standard. This I made the centre of my composition and it gave me comfort for the desecration of my Cavallo which lay in hopeless ruin in Milan. Michelangelo had used my disappointment in a hurtful way and chided me by telling all that I could not cast my work when it was done and am not worthy to be trusted with another work however insignificant.

* The 'David' eventually came to rest by the entrance to the palace, in the Ringhiera or haranguing place where people rose to speak their minds, on the Piazza della Signoria. It stood there from 1503 to 1873, when it was moved to the Academy Gallery for safekeeping after a copy was made to stand in its place.

Patience protects us from wrongs just as clothes do protect us against the cold; as with the heaping on of clothes with the growing cold, do you likewise increase your patience in face of great wrongs, so that they are powerless to vex your mind? But I digress . . .

He did insist however, that since I do a wall in the great chamber of the palace with a battle, he, the creator of David, should be entrusted with a wall exactly opposite to mine to prove his superior skills in the art of painting.

I had hoped to do the whole chamber myself but now the Signoria were powerless in the face of such a man and he was granted this commission – enough to vex me well beyond my patience.

He chose as if it were a challenge to me to paint a scene of victorious Florentine soldiers surprised while bathing by the Pisans called the Battle of Cascina.

I would continue with my work in slower fashion than my rival and did experiment with walnut oil and pigment for the paints that I should use upon the wall. I chose the west wall for my painting and even then was chided for my choice, for that too was the very wall that he had wanted but I held my ground. Such was the fervour with which Michelangelo attacked the work, he brought his bed along as well. It vexed him that I had commenced with my work months before and he felt even that was more than insult and attempted to surpass me not only in excellence but also in speed of execution.

This was the spectacle that truly won the attention of the populace who daily came to be observers of our work.

I fear we came to speak of one another in derogatory fashion urged on by those who would regard us as two starving dogs out on the street who fought upon a bone.

Thus we proceeded in our ways and I began to paint upon the wall itself on the 6th June 1505 at the stroke of the thirteenth hour. At the moment of putting the brush upon the wall the skies darkened and the bell started to toll.

The cartoon came loose that I would transfer to the wall and water poured down. The weather worsened still more and a very great rain came until nightfall and it was dark as night.

The air was filled with a dampness that affected my paint so much that it began to slide down all in ruin.

I had braziers of hot coals brought in to dry the wall but to no avail.

The fear that attacks me when I commence a task had seized me once again and I was forced to abandon everything that I had done. Michelangelo blamed me for the ill luck that dogged our work believing that I was beset with devils or the like who would affect all those about me – but he was then summoned to Rome to serve the new Pope whom no one could refuse.*

 * Pope Julius II

The work could never then be recommenced for this was dark omen enough to drive away the will.

I had at least delivered to my patrons the cartoon on the date agreed and in that way I had discharged my duty.

But I tried again upon the wall and it shrieked back at me and mocked me in my wretchedness. I continued with the central scene of raging horses. I did not succeed.

I was in Milan again a short period when word came that my uncle Francesco had died which filled me with great sadness. It severed all that I had known and then my stepbrothers began a most foul slander to strip me of my inheritance again. I accepted all about my father, but with my uncle I knew it was unjust and I fought them with the help of those who would enlist my services in art, who wrote for me some letters.

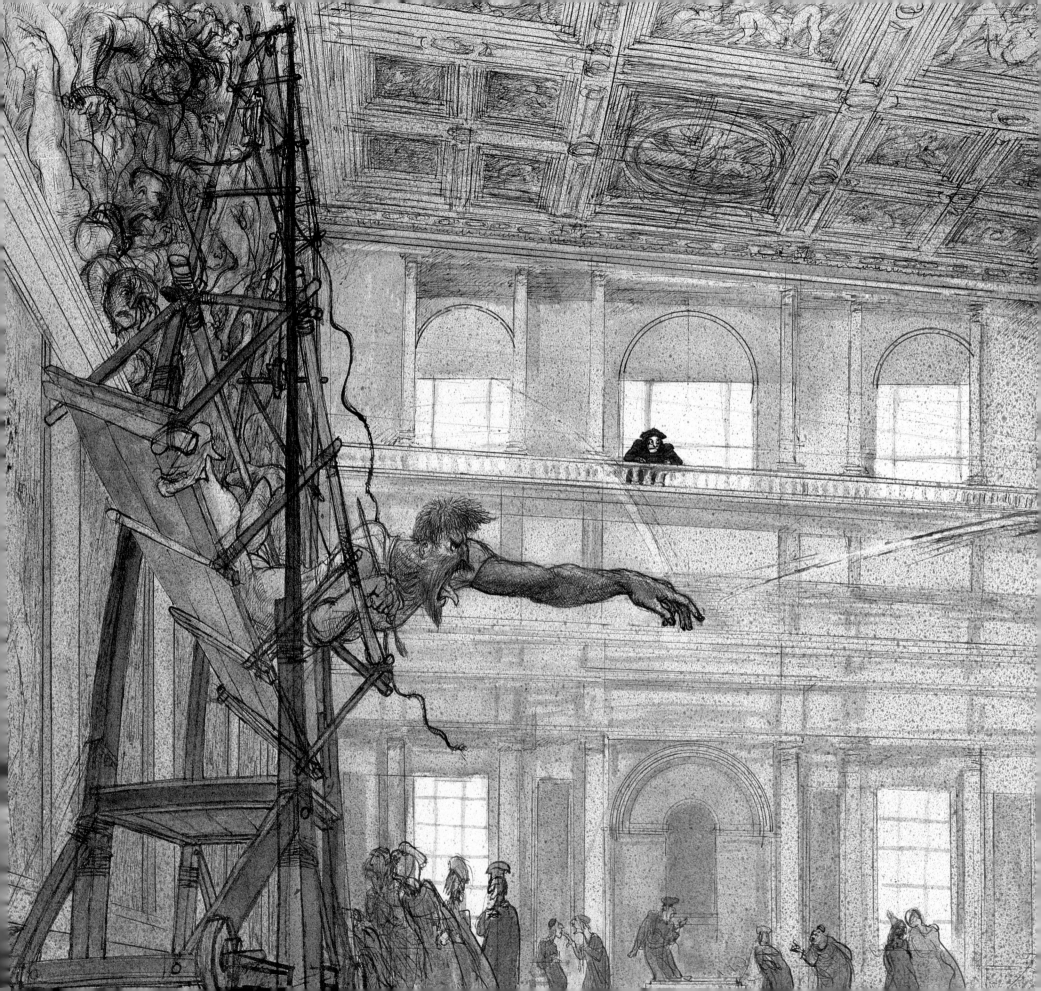

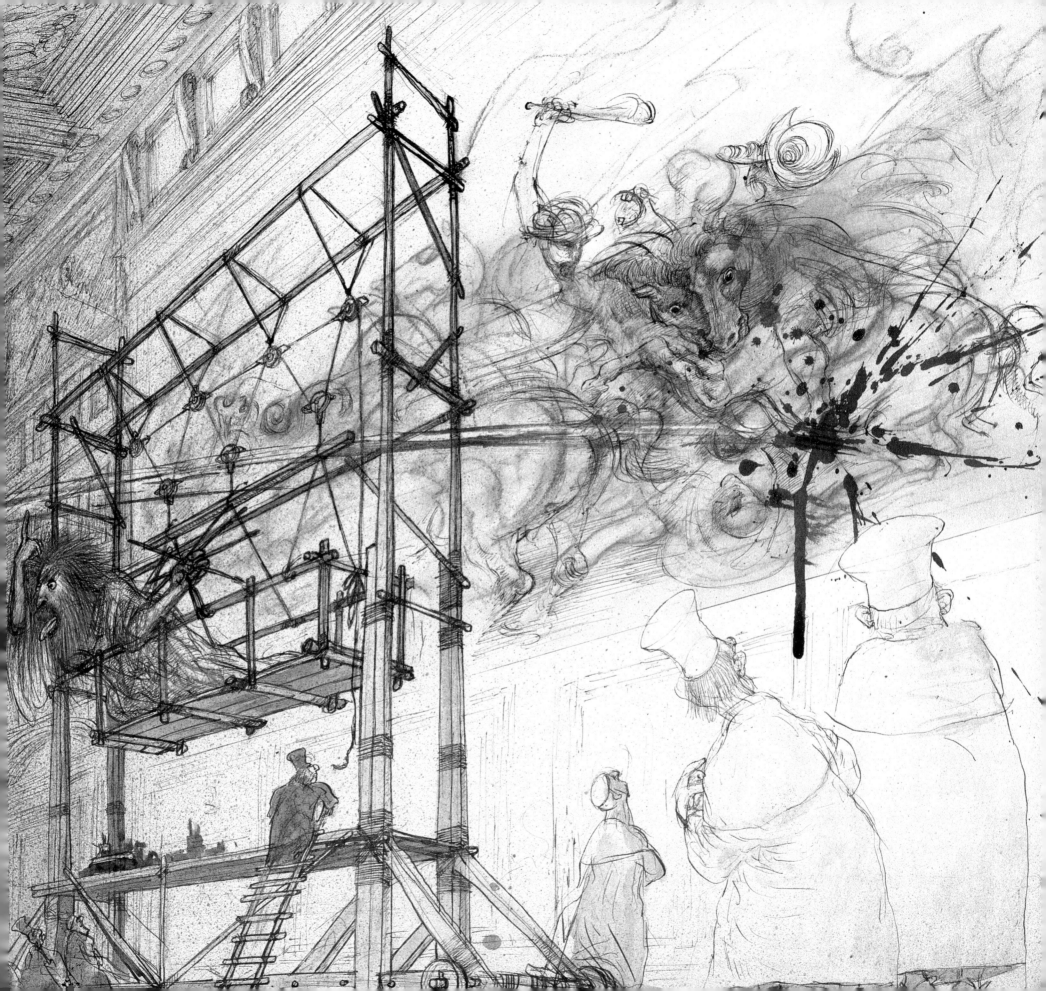

But I did finally return myself to Florence to clear the matter but found now as always how the wheels of justice grind slower than those made for war and other sport. I was enraged but helpless still.

My friend Rustici,* a gifted sculptor and painter bade me stay with him on the Via Martelli. This I did and I found much to my amusement in his house. Not least a porcupine he kept there on a lead which startled visitors who stayed to eat by pricking them about the legs beneath the table.

Also a tame eagle who flew freely through his large rooms, and a talking raven who would interrupt the conversation of Rustici's guests in the most hoarse manner.

To pass the time while waiting for some sign of settlement about this wretched litigation I gave help to Rustici in the course of his casting and found myself again inside the mortuary of the hospital where I had spent much time.

And so began in Florence in the house of Piero di Braccio Martelli, on the 22nd day of March 1508, a treatise on anatomy. And this was to be a collection without order, taken from many papers which I had copied here, hoping afterwards to arrange them according to the subjects of which they treat.

I had a mind one day to publish all I had discovered throughout my life. The problem was not that I had kept all things but so much had accumulated through the years and sometimes I have written things more than once to ensure that nothing ever will be overlooked.

What complex task it was to put all things in order. In this I felt alone. Salai would not help me – could not help. What would become of him when I die? Find some other no doubt. And Zoroastro, a cripple now because of me.

Again there were requests from that accursed woman Isabella d'Este for paintings to adorn her palaces as though the very stuff of painting were a bauble for a rich child's toy box.

Would I could have done it for the money – and all the time I devoured my own meagre savings.

My litigation in Florence against my brothers was impossible to resolve and put my spirits into disarray. I sent Salai off with a letter to divine the feelings of the rulers of Milan for my return again.†

So we returned and found accommodation on a tiny street, the Via Montebello at no. 27, loaned to me by a physician I had met at the Santa Maria Nuova, called Giovanni Gandini – a generous soul who esteemed my drawings of anatomy to be, as I myself had thought, a contribution of great worth to knowledge, and he had given me assistance in dissection where speed and expertise were vital.

I spent much time outside Milan also at the house of a friend of Gandini, where there was space for all. I had known this friend Girolamo Melzi briefly at the court of Lodovico

* A former pupil of Verrocchio but much younger than Leonardo

† Milan was now ruled by Charles d'Amboise, Viceroy to Louis XII of France

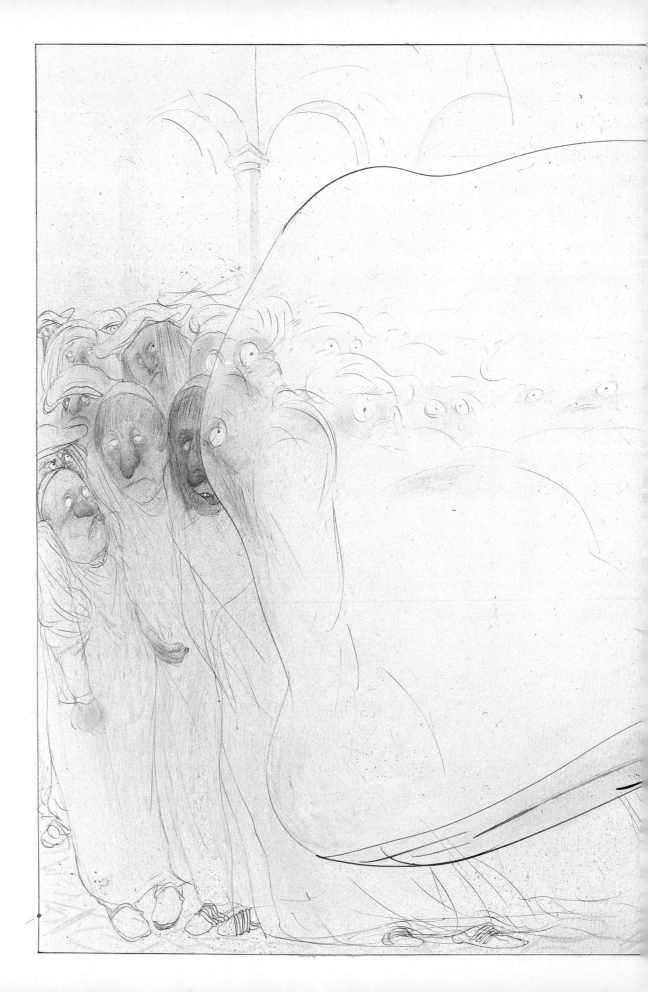

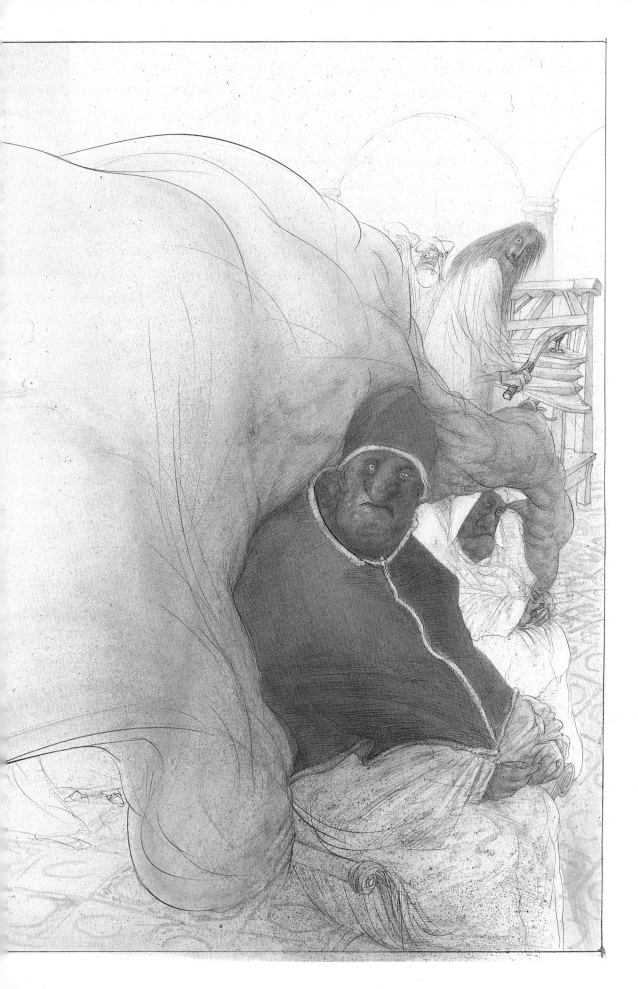

Sforza as a military man with whom I spoke about my weapons and devices made for war.*

There are connections of pure chance that form a framework like a spider's web and all connects as life goes by, for by these chance meetings sometimes bonds are struck and thus I found a second home and a new companion in the son of Girolamo, one Francesco. For now at fifty-six years of age in this year of 1508 I had another thought within my mind of quite a different nature.

I think I longed for a son and heir and in this boy who was just fifteen I saw all manner of qualities that I would like to see within a son of mine.

I had his father's blessing and so we made a contract that I might teach him and care for him as though he were my own.

This winter of the year 1510 I looked to finish all my anatomy. Luca Pacioli had stayed in Florence but I now kept a house of students and the housekeepers Maturina and Battista.† With Salai, there were Boltraffio, Lorenzo di Credi and Il Fanfor, Marco d'Oggiono, Cesare da Sesto, Franco Cavalloni and now Francesco Melzi.

And so some years passed in a place where I could be at peace and if I so desired away from demands made frequently by noble folk and kings who would use up my time as though it were their own.

Then came a moment in our times which made all artists see a ray of hope. A new Medici, patron of the arts, was made a pope and his brother, Giuliano, Lorenzo the Magnificent's own son, ruler of Rome, remembered me and invited me with many others to join him.

And so I left Milan again and gave up peace and pleasures at the House of Melzi and set out for Rome with my household, on September 24th 1513.

This was my undoing.

When I heard Bramante was now a powerful man in Rome I was overjoyed that we would meet once more and I perhaps would only need to say my name to find myself endowed with every thing that I could want to carry out great works again.

My energies revived as I imagined all that I might do to show my worth.

And Michelangelo had laboured in the Sistine Chapel and received 3,000 ducats in each month. A newer painter, Raphael, an admirer of mine was also there painting every room in the Vatican for 12,000 ducats each!

* The house was at Vaprio d'Adda, about twenty miles east of Milan

† Battista de Villanis – a faithful servant who inherited Leonardo's water rights on the canal at San Cristoforo given to him by Louis XII plus half of Leonardo's property within the walls of Milan near the Vercellina Gates. (Salai, also referred to as a servant in the will, received the other half on which he was already settled. Maturina, the cook, received a cloak of good black cloth lined with fur and two gold ducats.)

Now I would show the world the meaning of the word divine. I had faithful students all around me. Giuliano welcomed me warmly. I was given a workshop in the Belvedere and while I waited to begin renewed my studies in optics, distorting mirrors, machinery for making metal concave mirrors for telescopes, metal screws and thread cutters. I was allowed access to the Hospital of San Spirito to continue my studies in anatomy. I was hungry for books on astrology and sought them out. I felt a new surge of power within me and happily complied with requests before the new court of Pope Leo X to create fantasies to surprise and delight. I devised a favourite which was to take a bullock's bladder or the lungs of a pig and inflate them till they filled the room. This jest became a symbol of virtue, for what at first may seem insignificant is capable of infinite growth.

To his credit the blessed Pope had ordered the creation of a great menagerie of animals such that I had never seen the like before. They had been gifts sent by nobles from far-flung places and together created such wondrous cacophony and plethora of shapes I thought of all the courts that I attended and all the vanities that they display. For they were like these animals.

The Pope received from Portugal a white elephant which was a favourite of the court and everyone would crowd around it when it was shown. They used it as a plaything and for gross buffoonery. Sad to relate it died of too much kindness as one dies of neglect.

It aroused my boyhood interest, in strange animals and the differences between them all.

Dragons did appeal because they were the creatures of the dark recesses of our minds and once to surprise my visitors I did take a lizard and cover its body delicately with scales filled with quicksilver and then attach some tiny wings and little horns. I kept it in a box and showed it to my guests with little warning.

It would wobble and change form before them as the lizard came to rest quite suddenly. The quicksilver would continue to move for that is its nature.

I constructed other creatures out of wax and entrails that would stretch. I could inflate them and release them and they would fly. I was a boy again.

This place seemed destined to be at last my promised land – an Eden fit for artists. It was proposed that I receive 33 ducats a month.

I was requested by the Pope through his brother to do a portrait of the man and so I began my work in earnest. In this I was concerned to ensure that this picture would outlast all others against the ravages of time and set about inventing a varnish from the juices of plants which were in abundance in the gardens.

It proved to be an action that His Holiness could not withstand. I was dismissed with an accusation that I would never finish anything because I always thought of the end before I began.

It was unfair and such a bitter blow. The way I work should be no one's concern save mine alone until the work is done.

All those coarse jests inside the court serve now to lash my pride. His Holiness the Pope surrounded himself with none but craven guzzlers, gross pretenders and a host of fawning dignitaries who grimaced through their days at court with no more grace than beggars I had entertained in days gone by – though they had neither choice nor wit to rise above themselves and in that they had a reason.

Oh that I had ways to surely serve their putrid masquerades and twittery to make a dragon from the very menagerie within the Vatican itself.

If I could take for its head that of a mastiff or setter, for its eyes those of a cat, for its ears those of a greyhound, with the eyebrows of a lion, the temples of an old cock and the neck of a water tortoise.

O vile monster! How much better were it for men that thou shouldst go back to hell! For this the vast forests shall be stripped of their trees; for this an infinite number of creatures shall lose their lives.

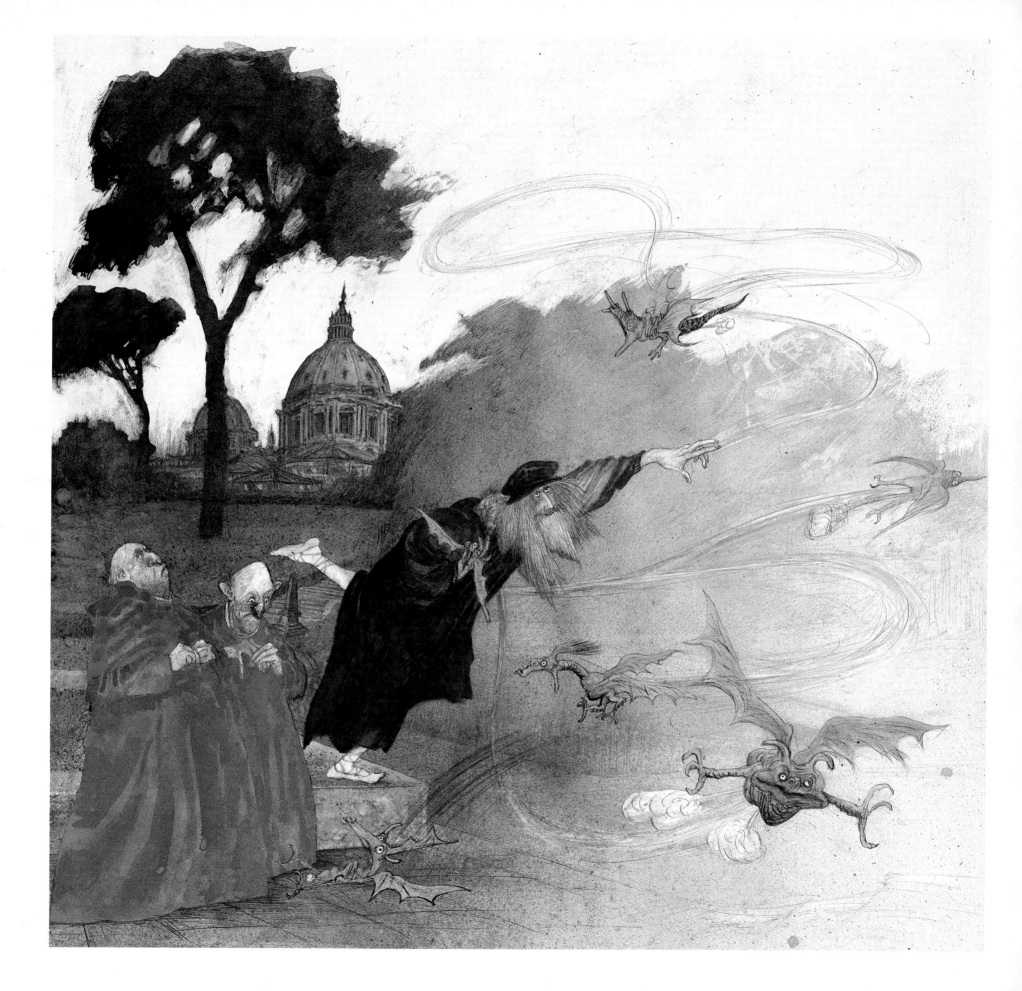

Francis I King of France
died 1546

The Queen

It was finished here in Rome and so we left – back in Milan now conquered yet again by France. The changing fortunes of men come and go like tides. The Medici raised me up and cast me down!

We stayed, Melzi and I, upon the little estate left to me by Lodovico Sforza and also at his father's house at Vaprio.

I felt weariness of spirit and I longed to rest there. Salai came and departed and so did those who were my students – Cesare da Sesto left to work for Raphael.

The Madonna Lisa – where was she? Gone? But I had her painting still. It would never leave me and neither would Astro. Melzi always by my side. To stay there and to tend a vineyard – a more fruitful pastime than the rest. I had my notes, my books, my crucibles and retorts, my embryos and woodpecker's tongue preserved in spirit, globes and balances and telescope, all around me.* My Madonna Lisa. My angel, my crocodile's jaw . . .

It was sometimes pleasant just to sit with these effects which are like clues to one's existence. If perhaps one thousand years from now they were dug up from where they lay and knowledge still poor sister to an ape, what would they think if they did think at all? Time, the destroyer.

* Francesco Melzi was to inherit all Leonardo's books, papers, scientific appliances, machines and the remainder of the salary from the King's Treasury

Then just as I was settling in that place there came an envoy from the King of France, Francis I, explaining that he wished me to leave this place and go to France and take with me all my effects including 6 paintings (one madonna and the Yarnwinder) and those that were a charge upon my household.

Six carriages were needed to contain all that I had left in the world, and I became first painter, engineer and architect to the court of King Francis I.

We could not cross the Alps through Piemonte unless we could fly. Winter was approaching and so our journey took us to Genova on the coast and Savona, Alassio, then to Antibes and then inland, skirting the Alps of Provence above Marseille, then westerly into the flatlands along the great Rhone river at Avignon to travel north along its banks to Lyon, then westward again through Roanne, Vichy, Moulins, Nevers, Bourges, Vierzon, Romorantin, Chenonceaux, and finally to Amboise where I was welcomed as a lord.

We were ensconced inside a palace of its kind, Le Clos Luce, set peacefully behind the Château d'Amboise which itself lay directly by the Loire.

It was built of brick and sandstone in a castellated decorative manner with pointed towers. It was pleasing to the senses.

Entrance to Le Clos Lucé
22.4.81

Leonardo drew this view of François I Château.

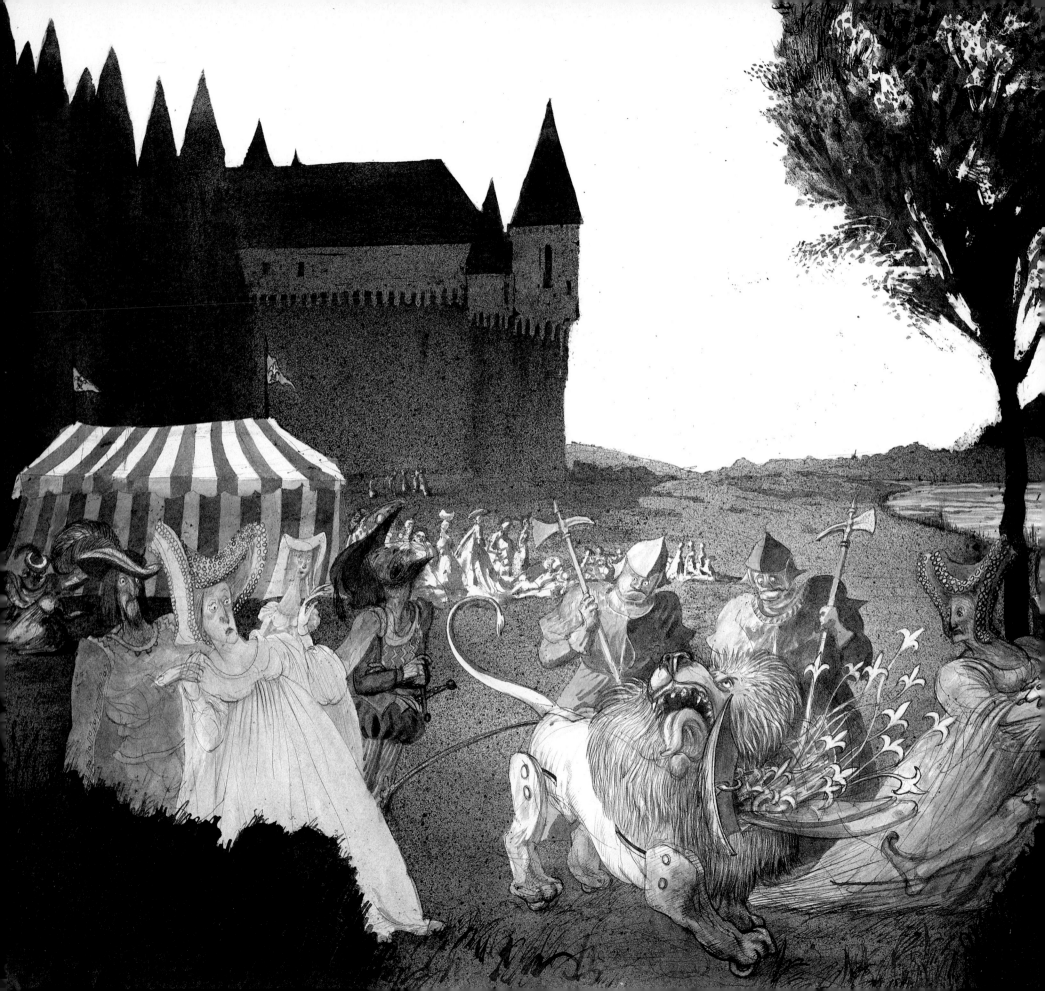

The courtiers of King Francis lived for gaiety.

Of course I was engaged to feed their whims with devices both decorative and mechanical. I knew I was treated more kindly than was normal. I was amused to notice how much the smile of my new patron resembled that of my Madonna Lisa. Each time he came to visit in my rooms and he did often I would engage him in a cunning way to stand beside it, so that I could see the striking likeness, much to the delight of Melzi who I think had never dared before to see that I too saw amusement in the smile of my Madonna.

Infected strangely by the lightness of the French court I devised on the first anniversary of our arrival here a mechanical lion, which would present itself to the King at celebrations arranged at the Château of Argenton in Normandy.

I was myself not well enough to travel but was told of the delight it brought to all those present when it stepped forward and opened its breast to display a bouquet of fleurs de lys.

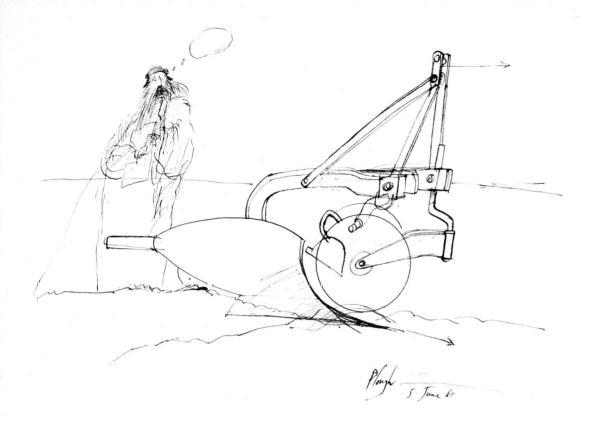

Plough

5. June 81

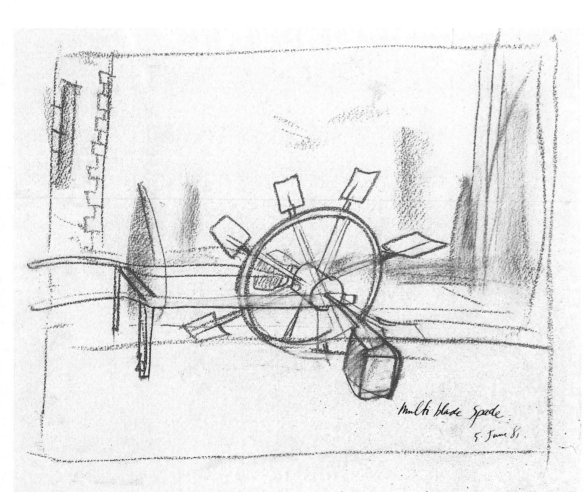

multi blade spade.

5. June 81.

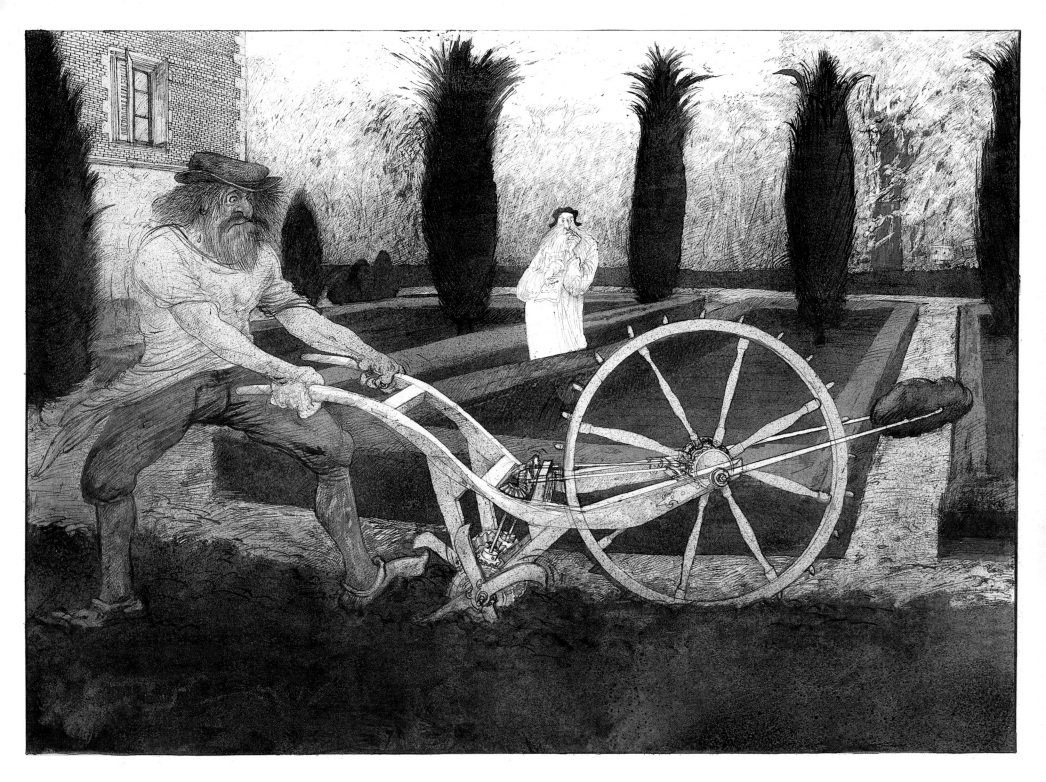

I made a contraption for the garden that sorely strained the loins of those who tried to push it. It was invented as an aid to gardeners in their work.

It was a simple mechanism and effective in its way. By using a spiked driving wheel much leverage was obtained and with the application of a stalwart energy great quantities of soil were moved in little time.

It worked so well I had six made but strangely I did note it brought a grimace to the face of some who used it.

The sight I think surprised the King the most was myself upon nothing but two wheels, not merely balancing but going forward too, supported as if by magic. I had it made for him for his esteemed visits but he could not find it in himself to touch it and to ride it would have invited ridicule for a King. He anyway preferred to come on foot by secret tunnel between the Château and Le Clos Luce. The contraption was possessed for him and so I gave it to the gardener, he who had liked my spade.

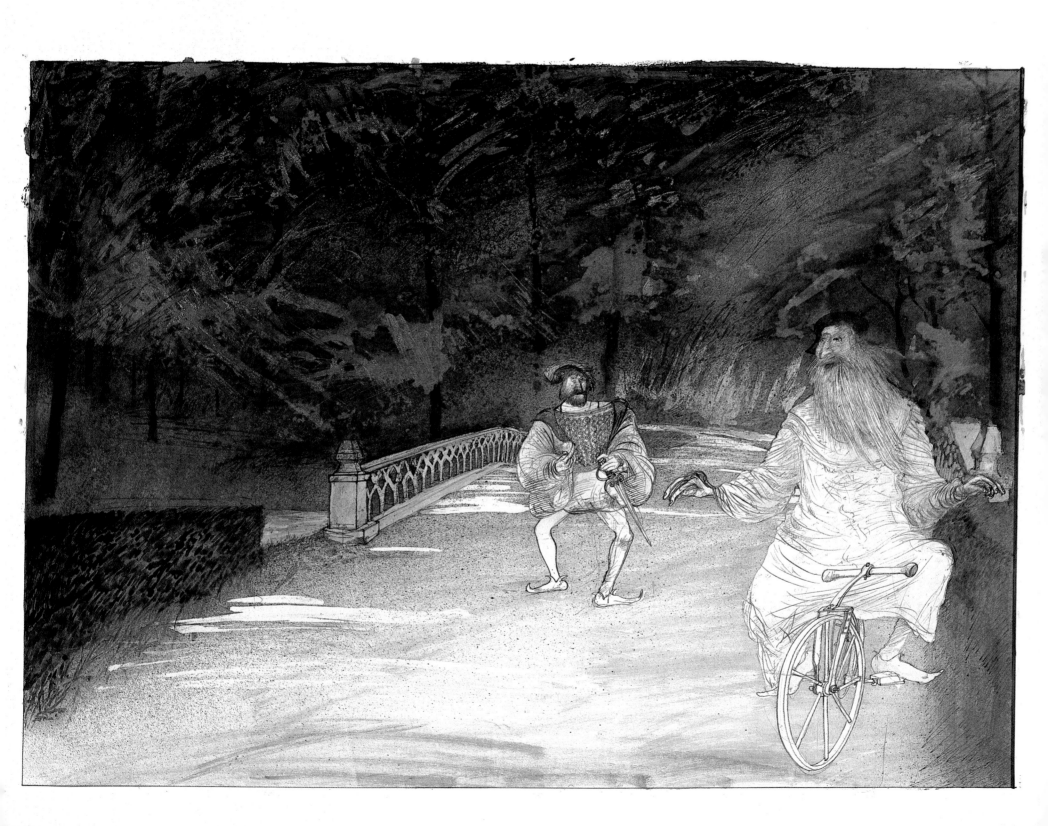

My wheeled toy was a folly, also the idea of floating out beyond the battlements under a tent made of linen of which all the apertures had been stopped up – the structure to be twelve braccia across and twelve in depth, that I might attempt to throw myself down from a great height without sustaining injury. I could not make a thing that was so big and so I made one for the lapdog of the queen but she was taken suddenly with child and with excitement. My experiment, like all else it seems, was abandoned in the rain.

I continue with my painting. It is all that I can do. My right hand trembles and refuses to hold the brush. I use the left and try to find a transition through the single figure in the painting.*

I do not like it. The arm is badly drawn. It has no form, save that which suits the painting and that is not what I intend. This puny limb needs strength to bear the upraised hand that points its way to paradise.

The face! It looks like me! There is no miracle in self-serving satisfaction and that is how it seems.

It shows no torment, no presence of the man who made it. It mocks me for its own dark reasons, for if you have the means to make an image, better that you make it something you can live with. Otherwise you die each time it is uncovered and all you see is habit, all your mannerisms, all the things that you yourself despise.

Time that consumes all things. Envious age, that destroys all things and devours them with the hard teeth of the years, little by little, in slow death. Helen, when she looked in her mirror and saw the withered wrinkles which old age had made in her face, wept, and wondered to herself why ever she had twice been borne away.

But wrongfully do men lament the flight of time, accusing it of being too swift, and not perceiving that its period is yet sufficient; but good memory wherewith Nature has endowed us causes everything long past to seem present.

* 'The Angel' or 'St John the Baptist'

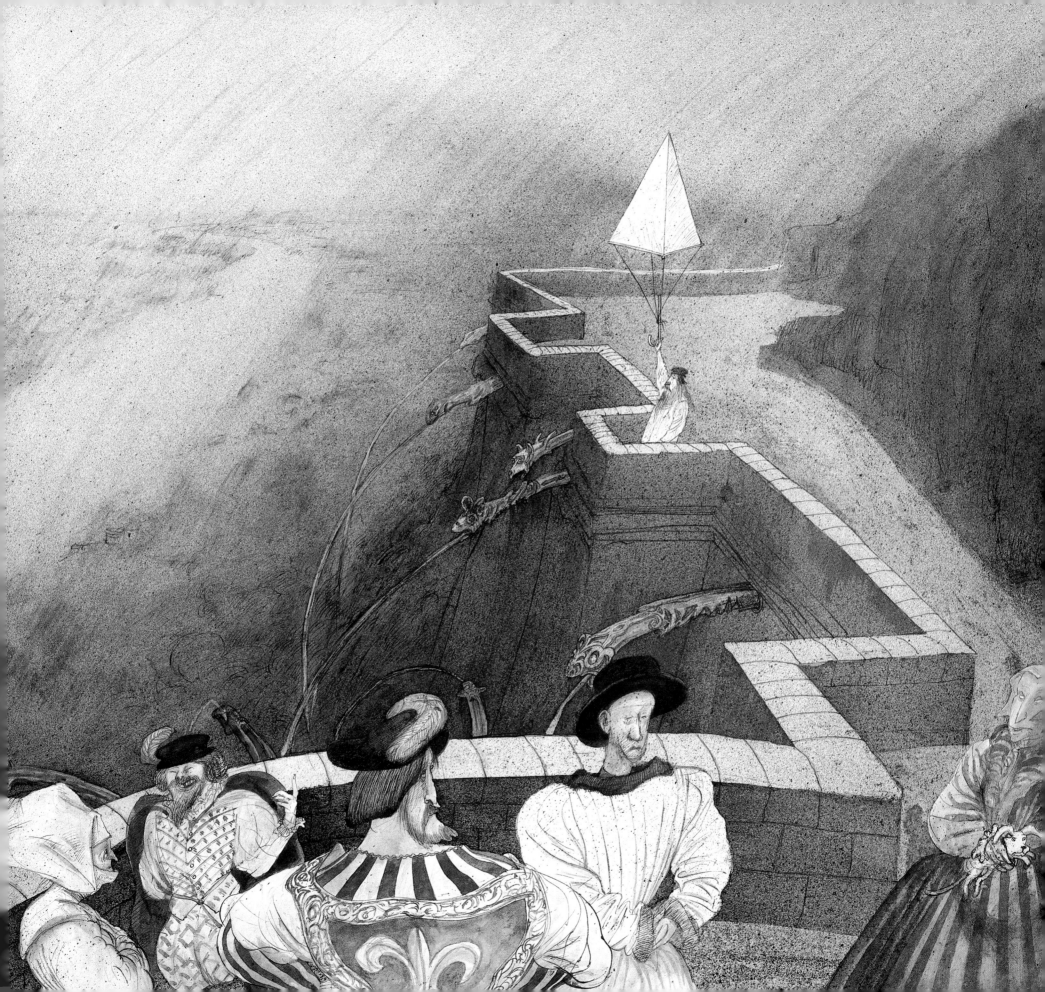

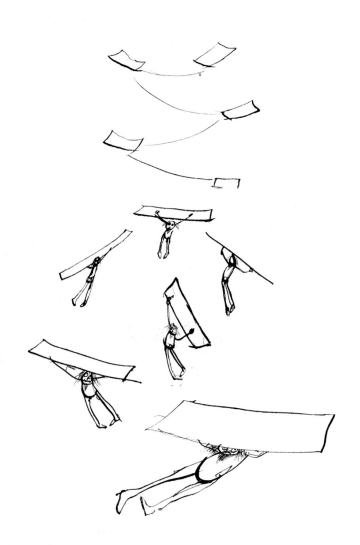

The King employed me when I was recovered to travel in his dominions along the Loire and to the marshes of Romorantin. It was here he had a project to design a town, a castle and gardens. There were great possibilities for canalisation of the rivers in this place and I willed myself to try to organise such things which once engaged my every nerve.

I grew tired and slept much in the day – and Francesco played about the grounds and helped me to and fro when it was needed.

Strange to relate, a castle to the south of Amboise called Loches became the last refuge, so I learned, of my old patron Lodovico Sforza who spent those days before he died with paintbrush in his hand to decorate his prison and carve into the wall a damning declaration, for it said 'I am wretched.'

Then came the deluge: my mind was filled with
torment.

Let the dark, gloomy air be seen beaten by the rush of
opposing winds wreathed in perpetual rain mingled with
hail, and bearing hither and thither a vast network of the
torn branches of trees mixed together with an infinite
number of leaves. All around let there be seen ancient trees
uprooted and torn in pieces by the fury of the winds.
Fragments of mountains, which have already been stripped
bare by the rushing torrents, fall headlong into these very
torrents and choke up the valleys, until the pent-up rivers
rise in flood and cover the wide plains and their
inhabitants. Huddled together on the tops of the
mountains are many different sorts of animals, terrified and
subdued at last to a state of tameness, in company with
men and women who have fled there with their children.
And the fields which are submerged by the waters have
their waves covered over in great part with tables,
bedsteads, boats and various other kinds of rafts,
improvised through necessity and fear of death, upon
which are men and women with their children, massed
together and uttering various cries and lamentations,
dismayed by the fury of the winds which cause the waters
to roll over and over in mighty hurricane, bearing with
them the bodies of the drowned; and there is no object that
floats on the water but is covered with various different
animals who have made truce and stand huddled together
in terror, among them being wolves, foxes, snakes and
creatures of every kind, fugitives from death. And all the
waves that beat against their sides are striking them with
repeated blows from the various bodies of the drowned,
and the blows are killing those in whom life remains.

Some groups of men you may see with weapons in their
hands defending the tiny footholds that remain to them
from the lions and wolves and beasts of prey which seek
safety there. Ah, what dreadful tumults you may hear
resounding through the gloomy air, smitten by the fury of
the thunder and the lightning flashes forth speeding
through it, bearing ruin, striking down whatever
withstands its course! Ah, how many may you see
stopping their ears in order to shut out the loud uproar

caused through the darkened air by the fury of the winds
mingled together with the rain, the thunder of the heavens
and the raging of the thunderbolts! Others are not content
to shut their eyes, but place their hands over them, one
above the other, covering them more tightly in order not to
see the pitiless slaughter made of the human race by the
wrath of God.

Ah me, how many lamentations! How many in their
terror have flung themselves down from the rocks! Huge
branches of the giant oaks laden with men are borne along
through the air by the fury of the impetuous winds. How
many boats are capsized and lying, some whole, others
broken in pieces, on the top of men struggling to escape
with acts and gestures of despair which foretell an awful
death. Others with frenzied acts are taking their own lives,
in despair of ever being able to endure such anguish; some
of them are flinging themselves down from the lofty rocks,
others strangle themselves with their own hands; some
seize hold of their own children, and with mighty violence
slay them at one blow; some turn their arms against
themselves to wound and slay; others falling upon their
knees commend themselves to God.

Alas! how many mothers are bewailing their drowned
sons, holding them upon their knees, lifting up open arms
to heaven, and with divers cries and shrieks declaim
against the anger of the gods! Others with hands clenched
and fingers locked together gnaw and devour them with
bites that run blood, crouching down so that their breasts
touch their knees in their intense and intolerable agony.

And above these horrors, the atmosphere is seen covered
with murky clouds that are rent by the jagged course of the
raging thunderbolts of heaven, which flash light hither and
thither amid the obscurity of the darkness.

I put my hands together but they feel nothing.

My papers – I must arrange my papers. Francesco will help.
Maturina. What now – a visitor? The King? Show him in at once.
No sire, you cannot buy my Madonna Lisa.

Friday morning one florin to Salai for expenses – he had three soldi left. For bread, wine, eggs, mushrooms, fruit, bran, for the barber and for shoes ... Francesco! Have you called the notary?

Man is a lesser world breathing like an ocean of blood.
The sun does not move. In nature nothing is lacking and nothing is superfluous. Movement can acquire infinite degrees of slowness.
Why bring a crucifix into the room? Not yet! Save my papers first, Francesco. Then I will do as you ask. Call the priest. I will confess and take communion if it pleases you.
Flying creatures will support men with their feathers. The body gives expression to the inner spirit.

Do not weep, Francesco – wisdom will build your house.

Have we done the will? Care for Zoro, Francesco.

Why do the circles of water not break when they intersect?

If you would keep healthy, Francesco, do not eat unless you feel inclined, and sup lightly; chew well, and let what you take be well cooked and simple. Rest your head and keep your mind cheerful; shun wantonness.

Those who have done best will be most beaten. Alas! Whom do I see? The Saviour crucified again? All Madonnas weep inside a smile.
Why is my will not completed? Francesco, wax candles for the churches – more candles – give my brothers light – do not blame them.

Read to me, Francesco. Just one more time.
And feed the swallow.

Who fires cannon balls at this late hour? Must I do more painting? As the great Mover willed it so ... close the windows – all that noise – surely the festival is over!

The great bird will take its first flight ... eternal glory to the nest where it was born. Quick, Zoro, climb on the back of the swallow – he will take you to the eagles.

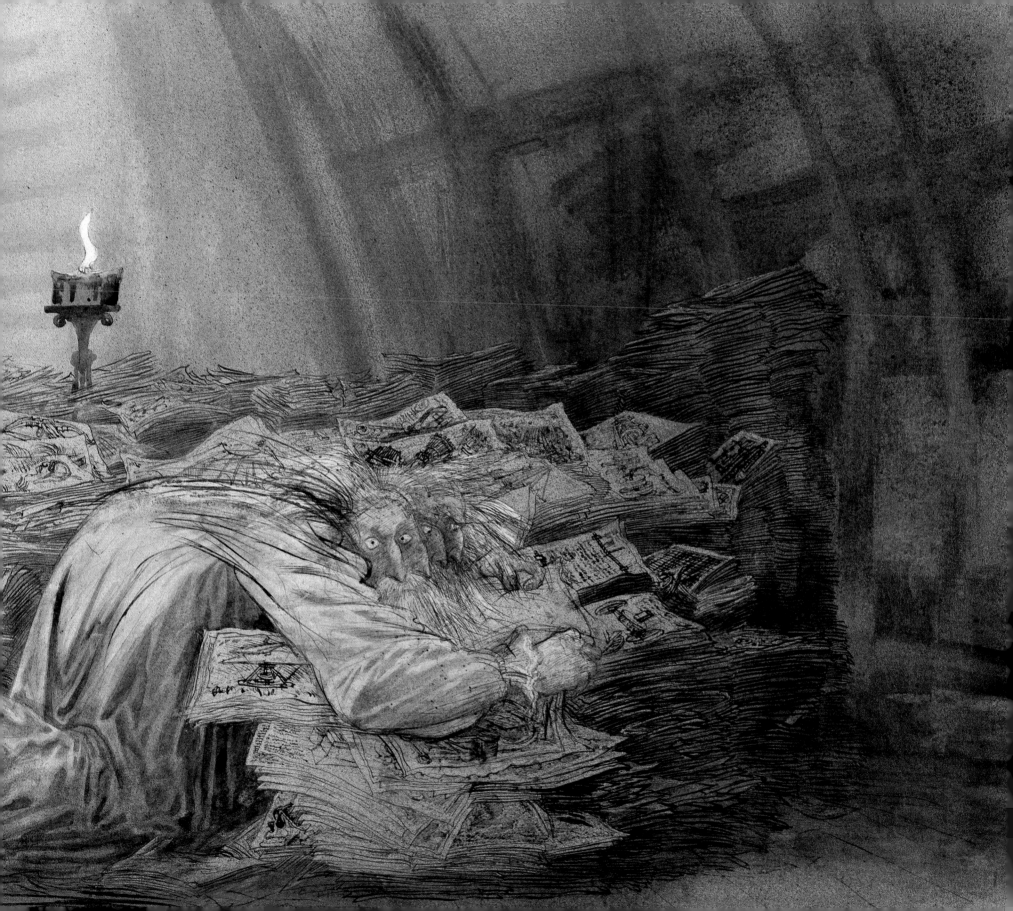

I HEARD AND SAW
NOTHING ELSE,

THEREFORE THERE IS
NOTHING

NOW I AM FORSAKEN